John Vernon Lord

DRAWN TO DRAWING

JOHN VERNON LORD

For my grandchildren:
Freya, Fin, Inigo, Jake, Hannah, Sam, and Theo.

MIX
Paper from
responsible sources
FSC® C101807
FSC
www.fsc.org

Drawn to Drawing is © 2014 Nobrow Ltd.

This is a first edition.
All artwork and characters within are © 2014 John Vernon Lord.
Edited by Gavin Lucas.
Photography by Travis Hodges.

Published by: Nobrow Ltd. 62 Great Eastern Street, London, EC2A 3QR
Order from www.nobrow.net
Printed in Belgium
ISBN: 978-1-907704-65-9

DRAWN TO DRAWING

JOHN VERNON LORD

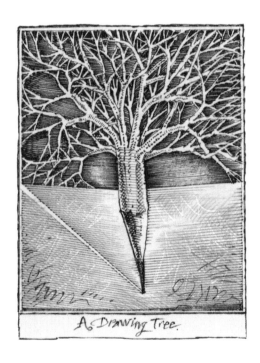

A Drawing Tree.

NOBROW PRESS

LONDON – NEW YORK

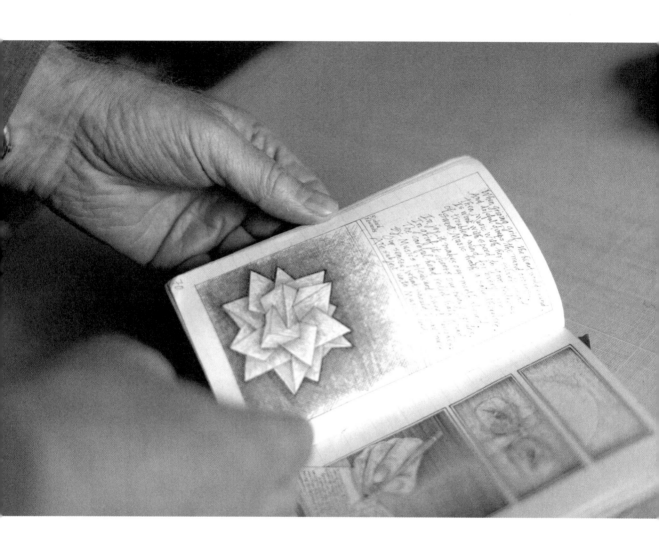

A book of drawing by John Vernon Lord is more than just the work of a master draughtsman, it is a house filled with windows onto worlds where the commonplace becomes suddenly extraordinary and the bizarre and the inexplicable seem surprisingly familiar. An artist of impeccable skill, he can create pen and ink designs filling the page with a staggering complexity of detail that recall the engraver's craft or, by turn, execute elaborate dances of form and space that reveal him as a supreme choreographer of the drawing board that is his stage.

Brian Sibley — Writer and broadcaster

This book enables its reader to enter the mystical and magical world of John Vernon Lord: strange, beautiful, surreal and sometimes quite frightening, but always fascinating. He sees mystery in the most banal everyday objects and places, such as ordinary interiors of a house or a ramshackle garden shed. Some pictures were drawn as doodles to relieve the tedium of long academic meetings. It is an astounding achievement to have held those two worlds together at one and the same time: debating clauses about budgets and educational matters, whilst mentally escaping into his own interior dream world. Some pictures are incredibly intricate designs worthy of a medieval manuscript. It's a wonder that someone living in the hectic world of today could produce work of such concentration. A monk slaving away in the silence and peace of a remote monastery is the only artist you could imagine being able to do it. There are other pictures which are in the same vein as modern abstract art. If they were greatly enlarged, framed and mounted on an art gallery wall, they would hold their own in comparison with anything being produced today. When they put down this book after reading it, the reader will emerge as if from a dream or a magical, fantastical journey.

Raymond Briggs — Illustrator and author

John Vernon Lord is an author, illustrator and teacher, who studied at Salford School of Art and later at the Central School of Arts and Crafts in London. Beginning his career as a freelance illustrator in the early 1960s, he carried out commissions that covered a wide spectrum of work for books, magazines and advertising. His impressive body of work has been exhibited throughout the world and he has contributed illustrations to a number of Folio Society publications.

His books have been published widely and translated into several languages, including the children's picture book, *The Giant Jam Sandwich*. First published in 1972 it remains in print today and is recognized as a children's modern classic. Lord's acclaimed illustrated edition of *The Nonsense Verse of Edward Lear* was published in 1984 and received two national awards.

As a university professor, John Vernon Lord has lectured on the art of illustration for over 50 years in the UK and abroad and was Professor of Illustration at the University of Brighton, where he is now Professor Emeritus. In 2000 he was awarded an Honorary DLitt. He is married with three daughters and seven grandchildren.

JOHN VERNON LORD
by Posy Simmonds

The dictionary defines illustration, in its third meaning, as "pictorial matter used to explain or decorate a text." Illustrator comes next, defined as "one who gives or draws illustrations". Illustration has often suffered from a lack of esteem – "mere illustration" is a term of derision for outmoded, representational art. And, in a world where an artist's work lies in creating concepts for others to carry out, skill and craftsmanship (which are requisites of illustration) are less valued.
The word "illustrator" can also have a pejorative ring, conjuring up cosy images of paints and crayons, of afternoons spent drawing mice in pinafores – illustration as mere decoration. John Vernon Lord, however, is an illustrator whose work confounds this view. He can, of course, decorate beautifully but his drawings do many other things: they describe, invent, interpret, comment, document, probe, analyse and, in doing so, demonstrate how disciplined and multifaceted illustration can be. In addition, his work is laced with humour, often biting. John can draw anything.

A recent pleasure has been to examine some of his small diaries (they are roughly 4 inches × 6 inches). The pages are dense with immaculate handwriting, lettering and drawings

of rooms, views, his desk, his responses to music and the colour yellow. He draws words and writes pictures. He is a draughtsman of philosophical reflection. Two of my favourite pages show 42 different illustrated versions of the number 42, which serve as examples of his great skill as a penman. He is not the only illustrator who works from black line, but he is one of the few who uses it with such virtuosity, building his subjects and their setting from a full range of graded tone to solid black. In most of his illustrations very little paper is left blank.

Having had two livelihoods, teaching and illustrating, time became a very important consideration for John. Division of time meant strict discipline, but a discipline that never made his published work look hurried or restrained his graphic imagination. Recently, he described to me how his notebooks and diaries, gave him the opportunity to 'draw for the sake of drawing'. Drawing that is free from the restraints imposed by commissioned work.

Many of the illustrations in this book were drawn and written during committee meetings at the University of Brighton, where he taught for many years. "Doodles", he calls them, describing how the process of doodling was both calming and an aid to his concentration. Here was a teacher/artist where the teacher focused on the meeting, while the artist kept his own minutes, translating the proceedings into a private language of image and metaphor. The resulting drawings are by no means aimless doodles. They are full of comment, puns (visual and verbal), and crackle with energy, the same energy that characterises all of John's work. (I have often wondered what effect his busy pen had on his colleagues at all these meetings).

Following the word illustrator in the dictionary, comes illustrious, meaning (1) glorious or great or (2) shining; words which perfectly describe the work of John Vernon Lord.

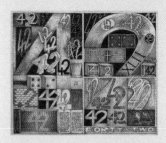

Two of my favourite pages show 42 different illustrated versions of the number 42, which serve as examples of his great skill as a penman.

DRAWN TO DRAWING:
a Selection of Drawings from the Attic & Plan-Chest

by John Vernon Lord

As you become an older illustrator there is a tendency to
worry about being trapped within your own mannerisms.
You are desperate to avoid tumbling into your own clichés.
There is also a dread of dull expectation when really it is a
surprise that you are hoping for each time you make an image.
There is also the fear that you may have reached the limit of your
ability. I suppose there comes a point when you have to recognise
that there is an ultimate limit to one's own ability as a draughtsman.
This is something you have to face up to and come to terms with.
But can we ever know when the full extent of our ability has been
reached? Will we ever reconcile ourselves to our limitations?
Perhaps our limitations, as folk that draw, can also be our strengths.
Is it, in fact, a combination of our strengths on the one hand and
our weaknesses on the other that creates an individual spirit in our
drawings? Is it this that gives a distinctive signature to our work?
I find that I am constantly wondering how to draw, despite having
done so many drawings over the last 50 or so years. Finding it
'difficult' to draw is perhaps just as interesting as having a certain
amount of natural talent for it. Any deficiencies we may have in
drawing and the way we overcome these inadequacies, can bring
about a unique character to our images. Sound draughtsmanship
can be extremely dull if conventionally wrought. Individuality is as
much about the shortcomings in our nature, or weaknesses, as
much as our strengths. Awkwardness in drawing is as interesting
as fluency.

I have always liked the comment that Ruskin made about ideas, in a chapter on 'Definition of Greatness in Art' from *Modern Painters*:

> The picture which has the nobler and more numerous ideas, however awkwardly expressed, is a greater and better picture than that which has the less noble and less numerous ideas, however beautifully expressed.

Mervyn Peake made some interesting comments about drawing in his little manual *The Craft of the Lead Pencil* (published in 1946). What he says in it is very characteristic of the kind of things he would say during my brief encounters with him at the Central School of Art in London. In a section on 'Clumsiness' he says that being clumsy as a draughtsman is:

> No bar to excellence, it is less hampering to the growth of the artist than a too dextrous hand. To find it difficult to be expressive forces the tyro to be scrupulous in deciding what it really is that he wants to express… Hurried drawings are worse than useless, for they can become a habit. Your hand must follow and not precede your idea.

Drawing is all about interpretation; putting down on paper what we see – what we think about or imagine – and, sometimes, a depiction of what words have to say. When we are drawing something that is in front of us we try to make sense of what we can see, and convey this graphically on a flat surface for others to see. When we draw from our imagination we try to interpret something that lurks inside our head and transmit this into an image on paper. And when we are illustrating from a text we are turning words into pictures. To put it another way, we are changing something 'from one thing to another'; a kind of metamorphosis. Ideas are paramount.

A drawing (like any creative endeavour) is created during a passage of time. It fascinates me that the word 'drawing' is both a present participle (and gerund) as well as a noun. So the active word 'drawing' describes both the process of making the image as well as being the result of the final image itself. "I am drawing a drawing", as it were – the same word used as a verb and a noun. The activity of drawing is a mobile thing – a living process, something like a journey, whereas the finished drawing is when the journey has come to a halt; reached its destiny, completed its

life. The finished drawing has become its own static memorial. We see the final drawing, but not the journey undertaken by the artist. Paul Klee memorably called the process of drawing, 'taking a line for a walk'.

Pictures (and I include photographs here) distinguish themselves from the other arts in that they do not move in time, as do music, theatre, film and literature. Drawings and illustrations are flat, still and silent and they are confined within boundaries at the edges. This is their special virtue. All drawings are abstract and everything in them is a symbol of something; symbols of objects and symbols of space, and even symbols of themselves.
Another distinguishing feature of the pictorial arts has been nicely put by Matisse, when he said, "Whereas the writer has to use the shared language of speech every artist uses his own self-invented visual language".

The challenge of drawing involves: fathoming shapes; probing, measuring and adjusting; working out comparative proportions; highlighting and shading; emphasising and diminishing; composing; combining intuition and thoughtfulness; fumbling and stumbling; the sorting out of marks; the cursing; the rubbing out; the hesitations; the adjustments; the decisions; the hopes and anticipation; the heartache; the overcoming of weaknesses; the hoping for control; the taking of risks; reacting to unexpected developments that may arise; getting the desired expression and mood; establishing the content; getting to grips with the subject; inventing – and the whole process of reaching towards a visual conclusion. This all involves interpretation and adaptation. However, there is often a gulf between intention and accomplishment.
I know this might be an obvious thing to say – but you don't really know what your drawing is going to look like until it's finished – that curious moment when you actually decide to stop doing the drawing.

 I love the solitariness of drawing and illustrating – being on your own, with head, heart and hand, something to draw with, something to draw on, and something to draw about.
What is this impulse to draw? It is the urge to visualise thoughts and ideas and describe observations. Describing something in

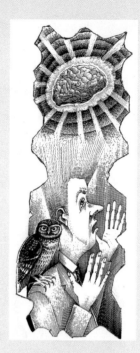

I used to have brainwaves in the old days, but not anymore. I only hope that experience and wisdom rests on my shoulders.

Pen and ink
1980s

What is this impulse to draw? **It is the urge to visualise thoughts and ideas and describe observations. Describing something in front of me in visual terms gives me that feeling of — "I was there and this is what I saw".**

front of me in visual terms gives me that feeling of — "I was there and this is what I saw". The drawing becomes a kind of record but also a representation that projects my own state of mind about what I think I saw, rather than what the subject actually looked like. When trying to draw from the imagination, attempting to evoke something visual that lurks inside my head, I still say to myself, "I was there and this is what I saw".

For me, drawing has become, and indeed remains, a compulsion. I never feel in tune with life if I am kept away from the drawing board. I often draw automatically during conversations with the family and you'll even find a drawing in this book carried out when I was in bed with flu. I have wanted to redraw or tweak almost every illustration and drawing that I have ever done. There is always the chance that the next one might be better.

I have been through hundreds of drawings to put this book together. Over the years I have got rid of many of them. Plan chests, cupboards and the roof-space get to a point when they can no longer take the spillage of creative activity. A fairly regular clear-out is necessary and a good bonfire of past detritus cleanses the spirit. What is intriguing to me is what I have kept. Yes, I have got rid of what I think is much of my worst work but on the other hand I have saved a few pieces that I have either a sentimental attachment for, or because they were landmarks for me at the time. Sometimes I have regretted chucking some of my work away on bonfire heaps because you come to appreciate certain earlier work later on in life. Personal judgement of your current work is more precise simply because you have just done it and you know what you were aiming for. Drawings of the past lose the memory of a distinct purpose that you may have had at the time of producing it. They seem to take on the nostalgia of family photographs, when you no longer judge them on their intrinsic merit in terms of quality but are more interested in having glimpses of times gone by.

I think the work changes direction rather than improves. In some cases, I am envious of how I drew long ago. There is something about youthful ardour, which is full of zest and eager to experiment. Earlier drawings now become the tattered remains of one's youth. Such drawings may not be accomplished but they may have been breakthroughs at the time of execution and treasured. I often

cherish the drawings that were turning points in my development and that had an impact on me long ago that today may look so mediocre.

Hardly any of the drawings included here were drawn with a publication in mind. In most of these examples there was no requirement to respond to a given text, a brief, or to solve a problem. Most of these images were carried out without the kind of tension that is so often the case when carrying out commissioned work. There is a certain intensity about drawing illustrations, with the knowledge that they are going to be published, which isn't quite the case when sketching, doodling or drawing for the sake of it. It is the difference between a rehearsal and the possibility of having stage fright during a performance. In any case it is important to carry out work, which allows you to make mistakes. What has been chosen here is a broad sweep.

This is a representative collection of my work at different stages of my life, from art student days at Salford (in the late 1950s) and the Central in London (1960–61), to the present day. They range from rough sketches, drawings from direct observation, imaginative drawings and doodles done during meetings. There are occasional pieces here that were trial drawings or roughs for possible future projects which I didn't take any further or which never came off. In any case drawing is a way of exercising, a way of looking and thinking, and trying to make sense of things.

The earliest drawings here were done in 1957 and the last one was produced in 2013, a period of 56 years. Some are elaborate, whilst others the product of being dashed down quickly. Most of them are in pen and ink but some are painted in gouache. Amongst them you will find the occasional print and collage.

The only incidences of including actual illustrations are when a rough drawing has been compared to a finished illustration, such as *The Giant Jam Sandwich* (published in 1972) and a couple of limerick illustrations I did for *The Nonsense Verse of Edward Lear* (1984). There is also a comparison showing rough drawings of the White Rabbit in Carroll's *Alice's Adventures in Wonderland* (2009). Drawings that were characteristic at the time have been included. They have been presented chronologically, in a loose kind of way. Sometimes we have brought themes together which breaks the sense of chronology, but it is hoped that the book shows some sense of how my work has gone through different preoccupations over the years.

1950s

The teaching of art at my secondary school in Colwyn Bay wasn't particularly enlightening. The subject was mostly taught on Friday afternoons at school and it was not taken very seriously. So-called 'academic' subjects were seen to be far more important. Not once did we discuss any painting or drawing by the Old Masters or current artists, designers and illustrators, for that matter. The art teacher would either give us a theme to work on or set up a still life and tell us to get on with it. He handed out paper and materials to draw or paint with and that was that. Now and again he would look over our shoulders and simply murmur platitudes. Mind you, he was a very nice person and I enjoyed school life very much.

There were certain teachers at Salford Art College who were very helpful but the structure of the course was rather random. I studied there for four years between 1956 and 1960. Bill Hodgson taught us outdoor sketching and he was very good at telling us how to observe sharply and watch out for the unusual. He would always suggest we took a note of the darkest and lightest aspects of what you were looking at. Frank Charlson would urge us to depict the space in between objects as importantly as the objects themselves. Tony Ellis and Mr Eversedge would show us, and discuss, the work of interesting artists, architects and designers.

Much of the early work from the late 1950s in this chapter consists of drawings taken from my old student sketchbooks when studying at Salford. Sketching outdoors was always seen as being important, both at school and at art college. Indeed, as students we had to submit our sketchbooks for the Intermediate Examination in Arts and Crafts. We were also encouraged to make studies of objects in museums and copy other artists' and illustrators' work.

Art and Design education was organized in two parts in those days. Students took a Ministry's Intermediate Certificate in Art and Crafts followed by a National Diploma in Design (NDD). Each took two years to complete. Both required the submission of current sheets of work and sketchbooks, together with roughs and final pieces of work responding to set examinations. For the Intermediate Certificate we were examined in figure drawing, modelling in clay, still life and pictorial composition as compulsory subjects, together with a specialist subject – lithography in my case. The focus for all art and design students was that all those who passed the examination should demonstrate that they could draw. In those days drawing usually meant an accurate representation of the visible world, aiming for what might be described as the actual appearance of things. Students were expected to observe closely the measurement and proportion of the figure in the life drawing class. Training the eye to appreciate form and structure and assess relationships was seen as a basic necessity for all students in art and design. How times have changed. 'Objective drawing' was often given as a title for drawing classes in those days. Tutors often frowned upon distortion in drawing and cartooning. Comic type illustrations were seen as a carnal sin. Anything that smacked of decorative drawing tended to be criticised too, unless you were a textile designer. As for me, I enjoyed trying everything – from grotesque and decorative, to abstract and the 'objective'.

The only professional work I did during the late 1950s, while I was a Salford art student, was producing occasional illustrations and cartoons for Salford Tech's student union magazine, the National Union of Students and Manchester University.

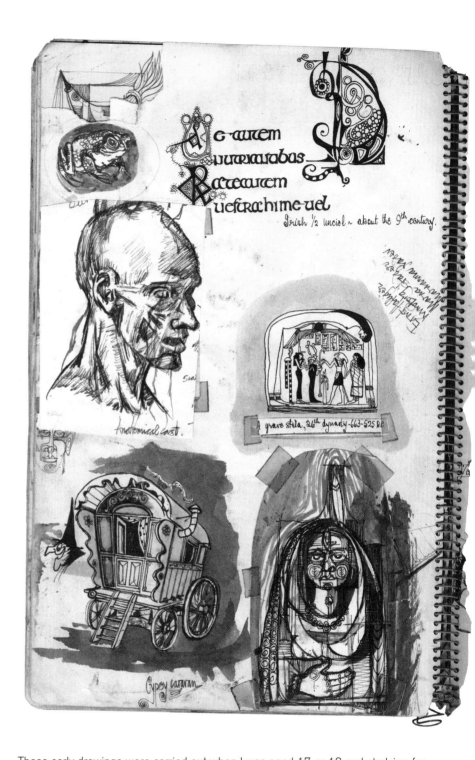

Student sketchbook
Mixed media

1957

These early drawings were carried out when I was aged 17 or 18 and studying for the Ministry's Intermediate Certificate in Art and Crafts. The course took two years to complete and was designed to provide a broad foundation, requiring the submission of current sheets of work and sketchbooks, together with roughs and final pieces responding to set examinations, which were assessed by external examiners.

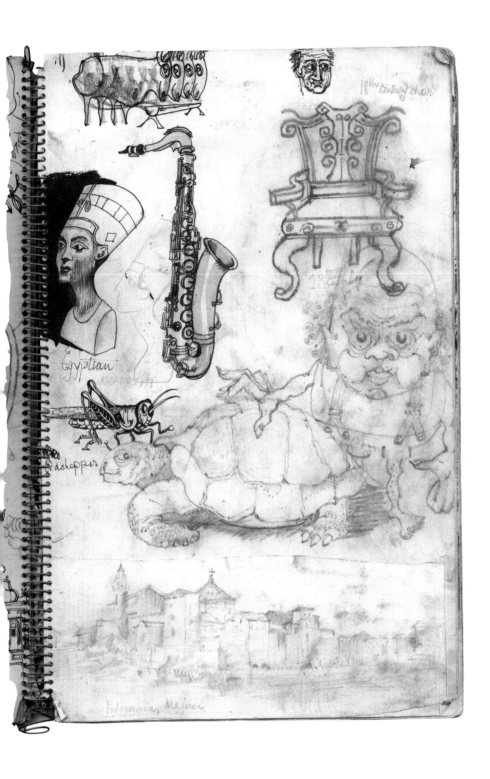

18th century chair

Egyptian
NEFERTITI

Grashopper

Palmanova, Majorca

29

**Portrait of Ian Walsh,
a fellow Salford
art student**
Pen and ink

Student sketchbook
1959

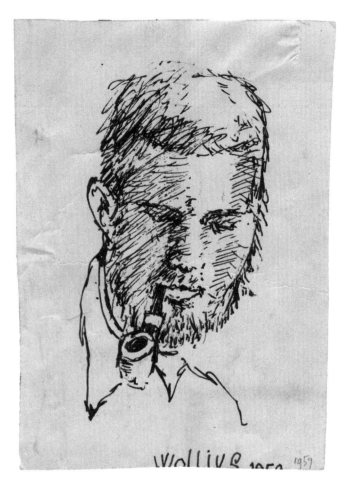

**A scene in Salford
or Manchester**
Pen, ink and wash

Student sketchbook
1958

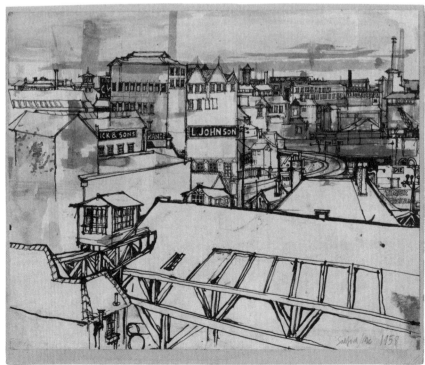

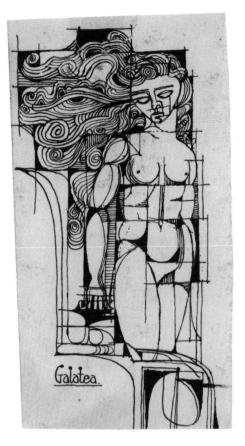

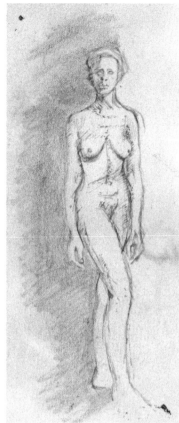

Galatea
Pen and ink

Student sketchbook
1958

Life drawing
Pen and ink

Student sketchbook
1957

Sometimes, in the life drawing class, we were told to draw in pen and ink so that we didn't have recourse to rubbing out any mistakes. The tutor said that it would challenge us to concentrate more, without having the safety net of erasing any errors. This drawing is just 5 inches (133 mm) high.

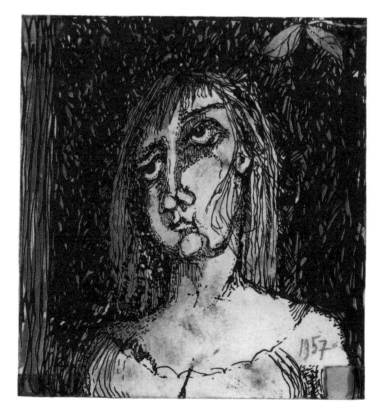

Portrait of a sorrowful woman
Pen and ink

Student sketchbook
1957

My father had a bakery and confectionery shop in Glossop and it also had a café upstairs. A regular diner there in the 1950s and 60s was the artist L.S. Lowry, who lived in Mottram not far away. When I was an art student, studying at Salford School of Art, I met Lowry quite often in the shop and I had many a chat with him, mostly about music. He loved the bel canto repertoire, particularly the operas of Vincenzo Bellini. At one time I had an exhibition of my student work in my father's café and Lowry took a great interest in this particular drawing when he looked through my sketchbooks.

Still life with white mug and potatoes

Ink washes, gouache and collage

1958

We had regular still life classes at Salford and this is an example of an image in which we were instructed not to use lines.

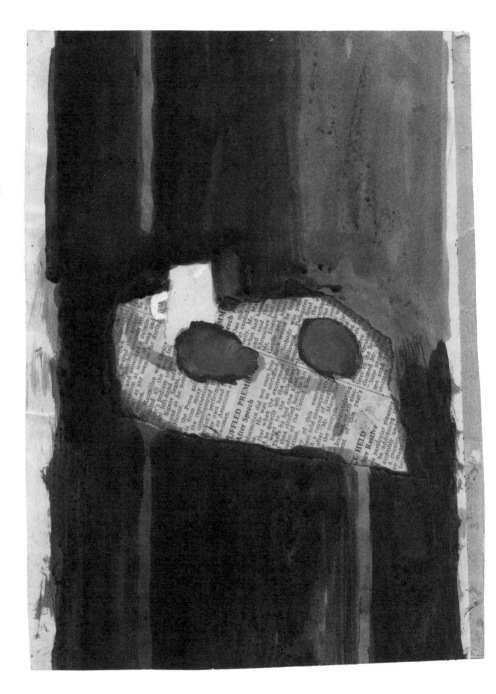

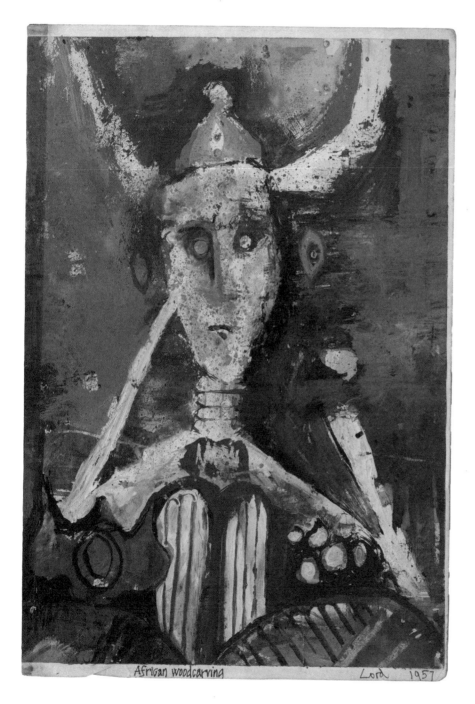

African woodcarving

Lord 1957

Study of an African woodcarving
Gouache

Student sketchbook
1957

Grotesque head with bird sitting on an egg
Pen and ink

Student sketchbook
1957

These grotesque drawings
were typical of the ones
I carried out in my first year
at art college. The tutors
soon tried to stamp out
such drawings.

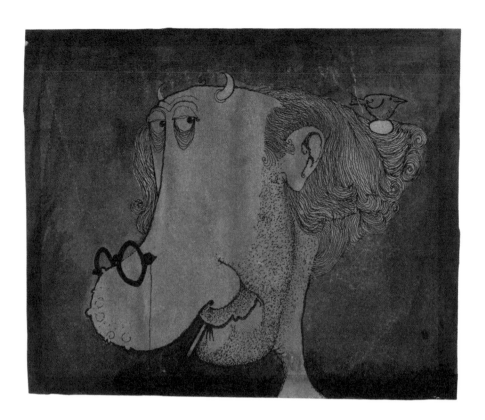

Grotesque figure with damaged arm
Pen and ink

Student sketchbook
1957

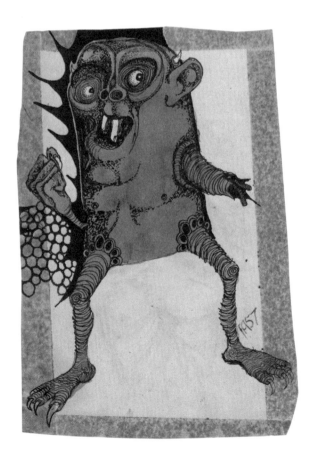

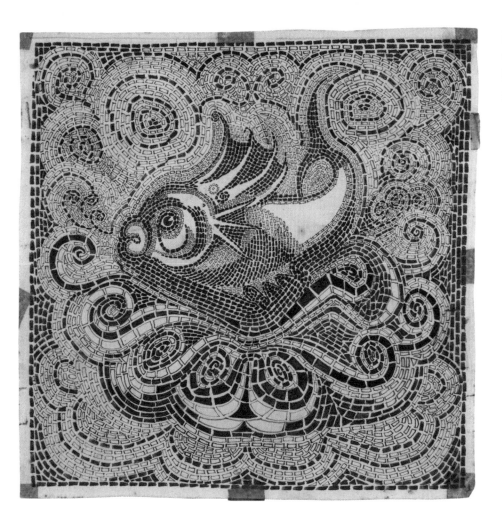

**Mosaic design
of a fish**
Pen and ink and wash

Student sketchbook
1957

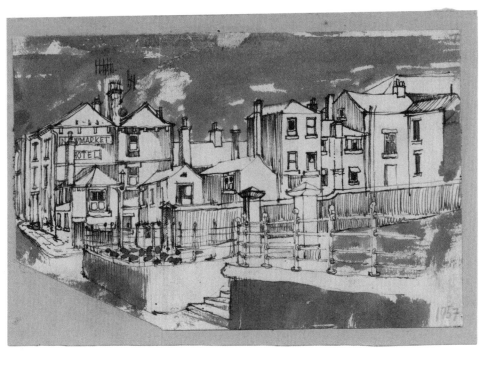

**Market Street,
Glossop**
Pen and ink

Student sketchbook
1957

This is an area in the town
of Glossop, Derbyshire
where I was born and
lived, on and off, until
I was aged 20.

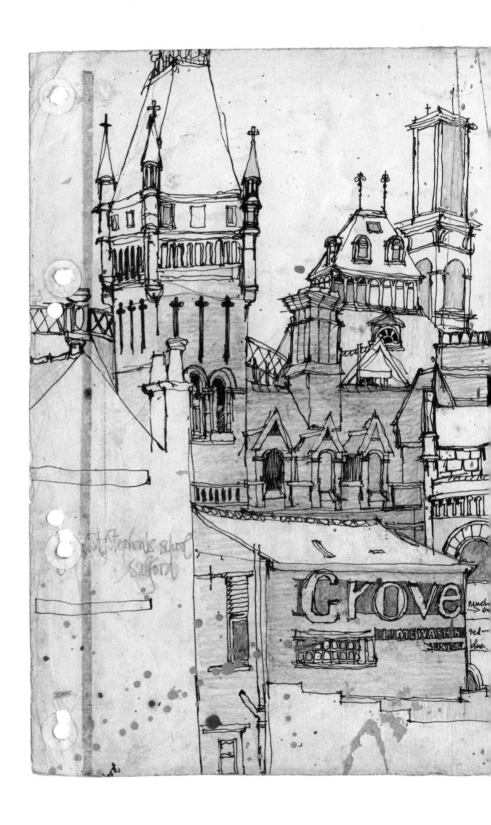

St Stephen's school
Salford

Grove
LIMEWASH HB
SERVICE

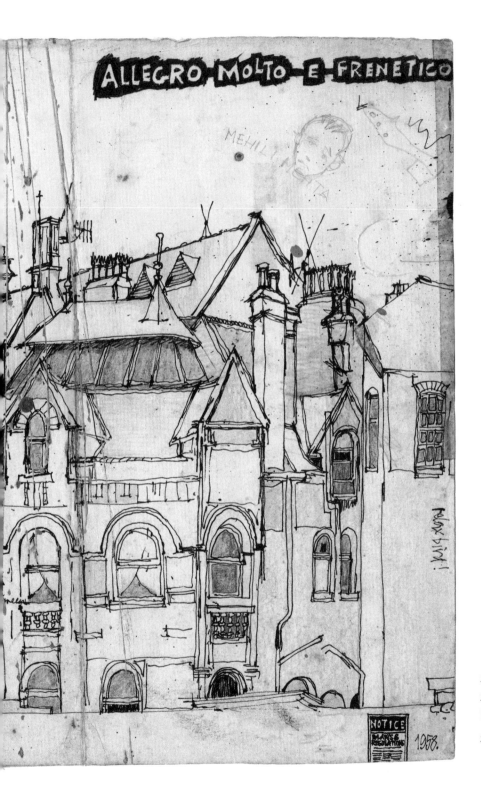

St Stephen's School, Salford

Pen, ink and pencil

Student sketchbook
1958

A town perched upon a precarious set of pillars

Pen and ink

Student sketchbook
1958

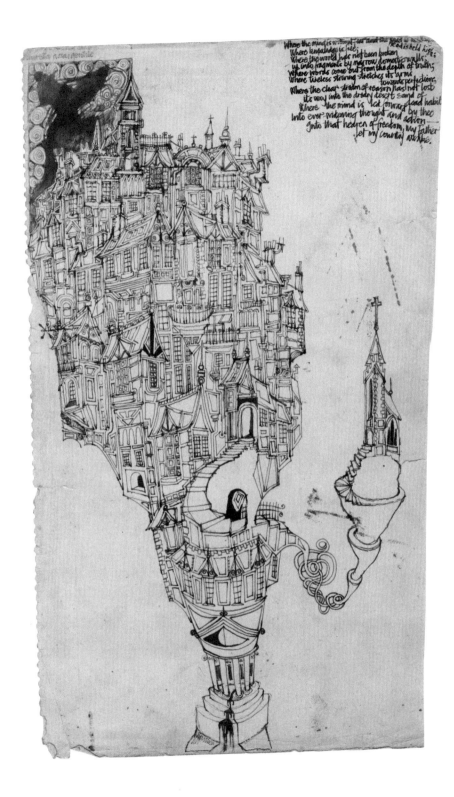

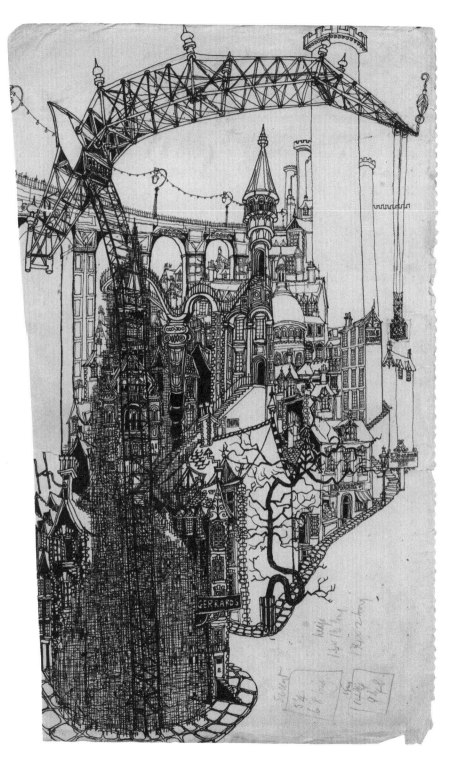

A fantasy town
Pen and ink

Student sketchbook
1959

1960s

In 1960 I left the North and moved to London to study at the Central School of Arts and Crafts (now Central Saint Martins) for a year and a term. My main tutors included Stanley Badmin, Bernard Nevill, Mervyn Peake, Alan Reynolds and Laurence Scarfe. We also received fascinating lectures from Aaron Scharf and I attended a few classes run by John Burningham. Nevill promoted decorative drawing and Scarfe encouraged the grotesque, something that had been discouraged at Salford. My brief encounters with Peake were always profound, he was keen to discuss the content and atmosphere that was put into a drawing.

Badmin, Burningham and Scarfe were three tutors who put me on the road to working as a professional illustrator and teacher. Burningham encouraged me to leave art college and seek work as an illustrator and Badmin recommended me to Saxon Artists, who became my agents for 13 years. And it was Scarfe who thought I should take up part-time teaching, recommending that I go for an interview with John R Biggs, Head of Graphic Design at Brighton College of Art. Over the next few years the team of illustrators teaching at Brighton included Raymond Briggs, Leslie Cole, Walter Hodges, John Lawrence and Justin Todd.

It was only when I had gathered the drawings together for this book that I noticed that there was an emphasis on those that I produced during the 1960s, when I was in my twenties and setting out on a career as a professional illustrator. This is the stage when most young illustrators are uncertain of the direction they are headed in and to a certain extent the marketplace tends to influence this. Art directors and publishers have a tendency to typecast you if you are not careful – they usually want the same kind of work that you did last time. You can also be seduced by what the marketplace wants in order to earn a living. I was determined to be flexible with regard to any direction I might be going in and perhaps there is a greater range of expression in my work of the 1960s than in any other decade of my life.

So, in 1961, I started work as a freelance illustrator and, at the same time, I was appointed part-time drawing tutor at Brighton College of Art and Crafts. In both cases it was the drawings in my sketchbooks and diaries that secured my teaching post at Brighton and for Saxon Artists to take me on. I accepted every freelance job that came my way and many of them taxed my drawing ability.

I started off by carrying out commissions for Carter's Little Liver Pills. I was asked to draw a notion of what a stomach might look like

when suffering from indigestion and then another drawing next to it showing a soothed stomach after it had received a pill. The person who commissioned me liked a drawing I had done of a duodenum and pancreas (see page 69). Then followed numerous other commissions such as a decorative map of Ireland for an invitation launch of The Shell Guide, drawing the entrance hall of the new BBC Television Centre for the Listener, covers for New Society, and a complicated commission required me to draw a series of recommended Christmas gifts. These ranged from a vegetable strainer to a knife sharpener, a biro holder, a Flexi car brush and flower arranging equipment.

I was mainly carrying out work for advertising and editorial illustrations for newspapers and magazines and it astonishes me now when I look at the list of what I was commissioned to illustrate in the 1960s. Among this extensive list, I drew anything from a ball of string in a corrugated box, buildings of all kinds, recommended school equipment, a traction engine; spraying machines and their attachments; an aerial view of Durham, to designing a record sleeve for Deep Purple's album, *The Book of Taliesyn.*

1964, in particular, was something of a fertile period for me. At 25 years old, I'd just moved from London to Brighton and the variety of work I did that year indicates both a struggle to find an identity and a willingness to experiment technically. Busy as I was with freelance work, I always made a point of working on independent drawings and images that hadn't been commissioned. My agent at the time (Cara Strong of Saxon Artists) was always encouraging me to provide her with fresh samples of work to show advertising agents and book and magazine publishers.
In early 1965 I was commissioned to design and illustrate a 16 page booklet *A Visit to Bedsyde Manor* for Guinness Publications. The fee was 500 guineas, an enormous sum of money at the time, which enabled my wife and I to put a deposit on our first house in Brighton. Guineas were the customary form of payment in those days, worth £1 and 1 shilling (valued at £1.05 today).
By the end of the 1960s my work was moving towards book illustrations; something I had always wanted to do. For Heinemann, in 1967, I carried out illustrations for *Biology and the Social Crisis* by J.K. Brierley and a year later, for Penguin Books, 99 simple illustrations for *Success with English* by Geoffrey Barnard. In 1968 and 1969 I was commissioned by Klaus Flugge (then at Abelard Schuman, now still going strong as Publisher of Andersen Press) to illustrate my first two books for children. These were black and white illustrations and endpapers for *Adventures of Jabotí on the Amazon* by Lena F. Hurlong, and another set of illustrations for *Reynard the Fox* retold by Roy Brown. These books helped establish me as a children's book illustrator.

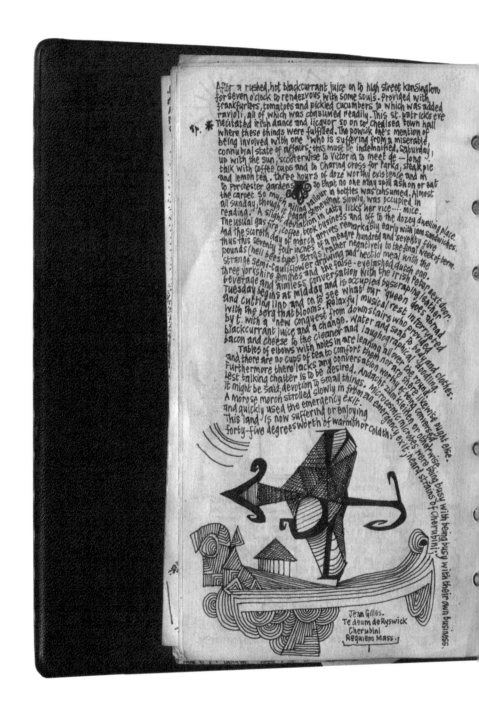

After a rushed, hot blackcurrant juice on to high street kensington for seven o'clock to rendezvous with some souls. Provided with frankfurters, tomatoes and pickled cucumbers to which was added ravioli, all of which was consumed readily. This St. Patricks eve necitated irish dance and liquor so on to' chealsea town hall where these things were fulfilled. the powick one's mention of being involved with one "who is suffering from a miserable, connubial state of affairs; this must be indemnified. Saturday, up with the sun, scooterwise to Victoria to meet de — long talk with coffee cups and to Charing cross for parka, steak pie and lemon tea. three hours of doze worthy existence and on to Porchester gardens so that no one may spill ash on or eat the carpet. So much ailing fallout in bottles was consumed. Almost all sunday, though it began somewhat slowly, was occupied in reading. 'A slight deviation in catty licks her rice ···· mice. The usual gas fire, coffee, book business and off to the dozey dwelling place. And the sixteth day of march arrives remarkably early with ian sandwiches. thus this seventy four inches of a meagre hundred and seventy five pounds (hell bees type) scrolls rather negatively to the final week of term. strange semi-cauliflower drawing and hectic meal with the three yorkshire femmes and the false - eyelashed dutch one. beverage and aimless conversation with the irish peter next door. Tuesday begins at midday and is occupied by scraping leather and cutting lino and on to see what our queen does abroad with the berg that blooms. Relaxful musical rest interrupted by t. with a 'new conquest from downstairs who provided blackcurrant juice and a change. Water and soap to boot and bacon and cheese to the cleaner and laughographical body and doodling.

Tables of elbows with holes in are leaning all over the round. and there are no cups of tea to comfort them nor are there much. Furthermore there lacks any conversation worthy, there likewise night else. lest talking chatter is to be desired. Andacht zum keinen or others; it might be said; devotion to small things. Microcosmic microbes or otherwise, were being comforted. A morose maron strolled slowly in from an emergency exit. and quickly used the emergency exit. i heard strains of cherubini; This land is now suffering or enjoying busy with being busy with their own business. forty-five degrees worth of warmth or coldth.'

Jean Gilles.
Te deum de Ryswick
Cherubini
Requiem Mass.

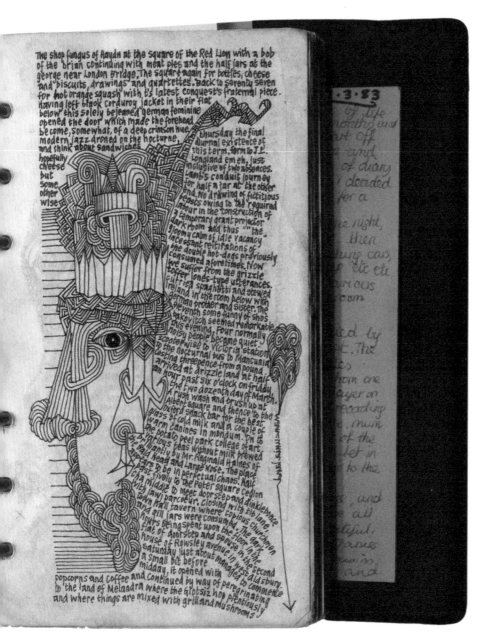

A king's head
Pen and ink
Diary March 1961

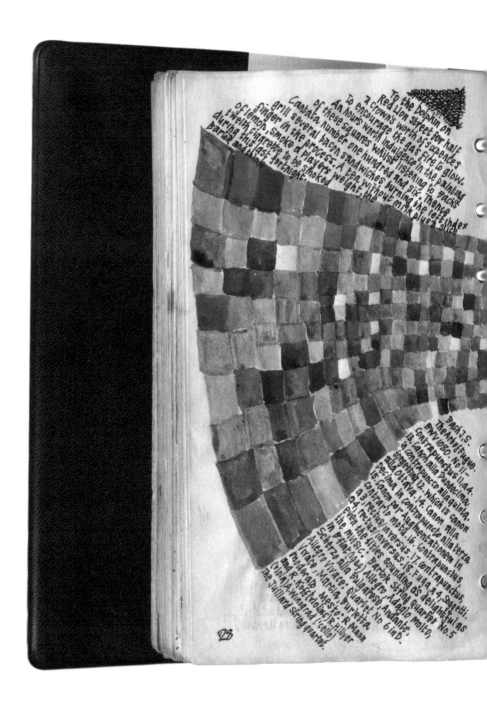

Tip the Dolphin on
Red Lion street for half
a crown's worth of sixpences
To encourage the gas fire to glow.
An hours worth of indulgence in the painting
of these squares whilst listening to Bach's
Cantata number one hundred and six. Then a
grill several bacon sandwiches to the left index
finger in the process. A tea without milk plus a slice
of lemon, smoke a Players cigarette to be smoked
twelfth cigarette to be smoked
during this last fortnight, the
Bartók and think.

Bach, J.S.
The Art of Fugue.
BWV 1080. No 11 -
Contrapunctus 11 a 4.
13. Canon alla Duodecima.
In Contrapuncto alla quinta.
Jorgesima 12. Which is canon
alla Ottava. 14. Canon alla
Decima. in Contrapuncto alla terza
15. Canon per Augmentationem in
Contrario motu. 16. Contrapunctus
a 3 Rectus inversus. 17. Contrapunctus
a 4. Rectus inversus. 18. Fuga a 4 Soggetti.
often the either Sounding as delightful as
the music. Bartók String Quartet No 5
in B flat (1934) Allegro, Adagio molto,
Scherzo alla bulgarese, Andante,
Allegro Vivace. Marcia, Burletta
Vivace, Mesto; R Hillyer
2nd R. Koff violins; R Mann
Viola A Winograd (cello)
The Juilliard String quartet.

28

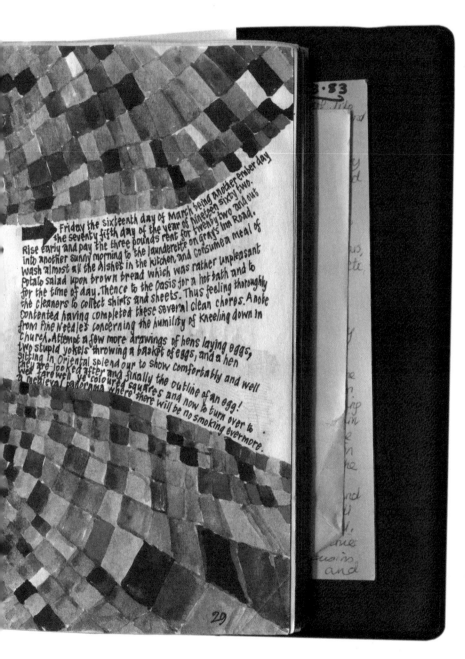

Friday the sixteenth day of March being another Ember day the seventy fifth day of the year of Nineteen sixty two. Rise early and pay the three pounds rent for twenty two and out into another sunny morning to the launderette on Grays Inn Road. Wash almost all the dishes in the kitchen, and consume a meal of potato salad upon brown bread which was rather unpleasant for the time of day. Thence to the Oasis for a hot bath and to the cleaners to collect shirts and sheets. Thus feeling thoroughly contented having completed these several clean chores. A note from Pine Needles concerning the humility of kneeling down in Church. Attempt a few more drawings of hens laying eggs, two stupid yokels throwing a basket of eggs, and a hen sitting in Oriental splendour to show comfortably and well they are looked after and finally the outline of an egg! Well fare well ye coloured squares and now to turn over to a medieval panorama where there will be no smoking evermore.

29

Coloured squares
Pen and inks

Diary 15 and 16
March 1962

To Evelina Hospital, Southwark to meet Fine Needles and eat at London Bridges La Spezia; stroll to Elephant and Castle and eat Steak and kidney pies and chips and then on opposite platforms one to Herne Hill and the other to Holborn Viaduct and cold walk to number twenty two Princeton Street, fall into bed and sleep.

The seventeenth day of March, yet another Ember Day this one being St. Patrick's Day. The sun streaming through the windows tempts an early rise. Three poached eggs upon toast for breakfast and outside to shop for eggs, lemons, potatoes, chops, milk and bread - all using eight shillingsworth of money. A half pint at the Lamb and back to twenty-two to cook a lamb chop meal and spend the next hour removing it from the teeth whilst listening to Lalo with lemon tea. Out for a walk to purchase a two guinea tape and return again to 22, consume several cottage cheese and pineapple sandwiches and thus to clear up the incredible mess in this place. Tom arrives from Wales - so out to the soup kitchen for a meal and the Lamb for a couple of pints. Return to twentytwo read Balzac, a rather droll Balzac. Listen to a strange piece of music by Klaus Huber scored for oboe and harpsichord, switch it off and bed.

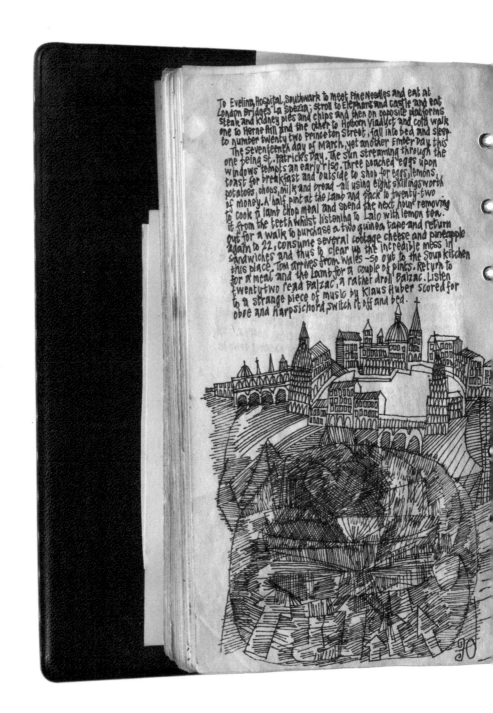

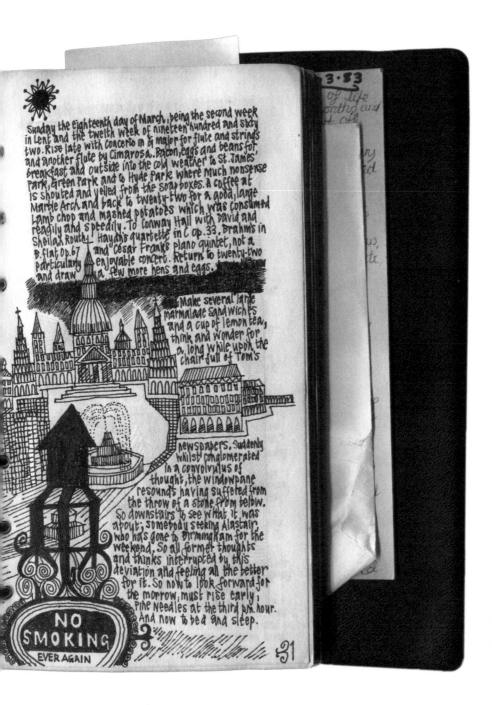

Sunday the eighteenth day of March, being the second week in Lent and the twelfth week of nineteen hundred and sixty two. Rise late with Concerto in G major for flute and strings and another flute by Cimarosa. Bacon, eggs and beans for breakfast and outside into the cold weather to St. James' Park, Green Park and to Hyde Park where much nonsense is shouted and yelled from the soap boxes. A coffee at Marble Arch and back to twenty-two for a good, large lamb chop and mashed potatoes which was consumed readily and speedily. To Conway Hall with David and Sheila Routh. Haydn's quartette in C Op. 33, Brahms in B. flat, Op. 67 and Cesar Franks piano quintet, not a particularly enjoyable concert. Return to twenty-two and draw a few more hens and eggs.

Make several large marmalade sandwiches and a cup of lemon tea, think and wonder for a long while upon the chair full of Tom's newspapers. Suddenly whilst conglomerated in a convolvulus of thought, the windowpane resounds having suffered from the throw of a stone from below. So downstairs to see what it was about; somebody seeking Alastair who has gone to Birmingham for the weekend. So all former thoughts and thinks interrupted by this deviation and feeling all the better for it. So now to look forward for the morrow, must rise early, pine needles at the third p.m. hour. And now to bed and sleep.

NO SMOKING EVER AGAIN

A city
Pen and ink

Diary 17 and
18 March 1962

Monday the second day of July, which is the one hundred and eighty third day of the year, which is exactly the middle day of the year. ⬦601⬦ The six hundred and first days' entry in this book. Rose to the ever repeating m'eeows of Fitzroy the cat. Completed another Austin Reed drawing which seems to be no better than any of the others. To Saxons to deliver it. A brief chat with Johns Lawrence and Burningham in the latter's Percy Street studio. Cook a meal at seventy-six and sort out nails, screws, safety pins, buttons, electrical gadgets, paper clips, cuff links, studs and divers, miscellaneous oddments. Landladys Norah Back and Gwyneth Johnstone have returned from their two months holiday in France, so no peace for a while. Francis is back playing on the kitchen piano rehearsing a Scriabin sonata for a broadcast on the radio on the twenty-seventh of this month. To ninety-two, Disraeli Road, Putney where Val is ironing much washing. Brother-in-law Chick arrives later- an egg sandwich and a hot chocolate and thence on a number fourteen bus (surrounded by the monotonous clapper of greek tongues) to Tottenham Court Road, to seventy-six, put Fitzroy in his box in the courtyard and myself to bed.

 Tuesday the third day of July. After a non-existent nights sleep, rise early and cheered by a lively letter from Denis, who will be working in 'The Angel', a hotel in Midhurst. Pay a months rent to Gwyneth, and brew a pot of tea. Several Beetrootoven piano sonatas and clear up the room.

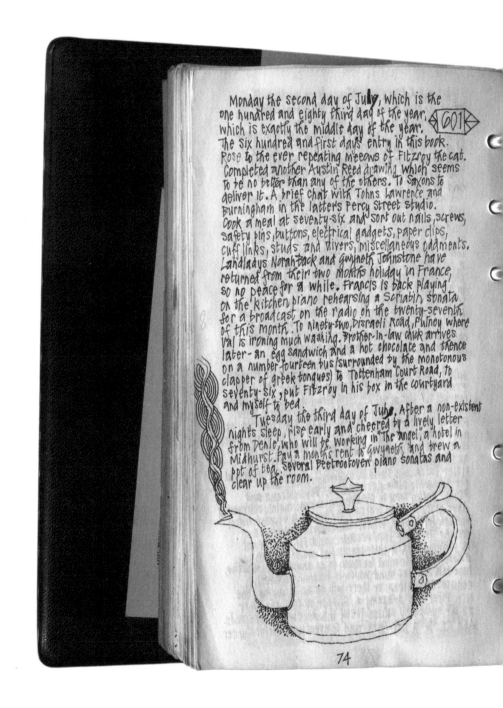

74

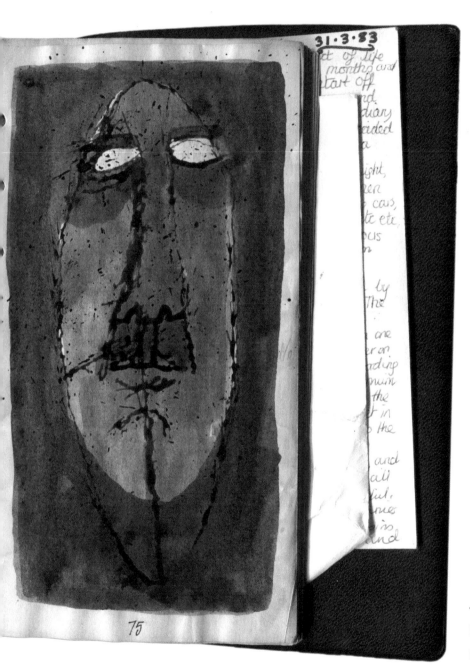

31·3·83

Teapot and face
Pen and inks
Diary 2 and 3 July 1962

49

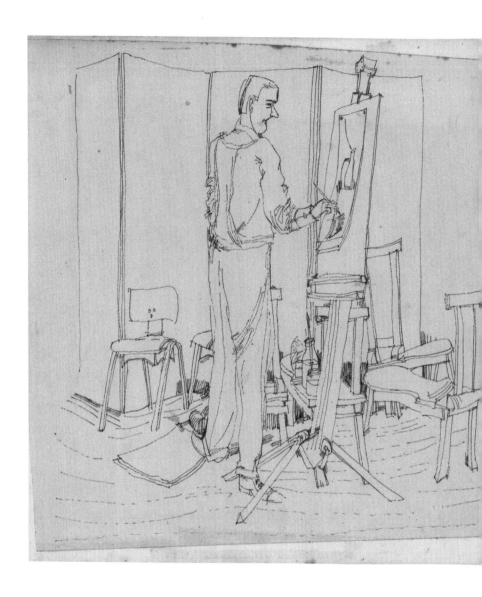

Life drawing studio at the Central School of Art and Design
Pen and ink

Student sketchbook
17 April 1961

Life drawing and still life drawing classes took place in this Fine Art studio at the
Central School of Art and Design when it was located in Southampton Row.
The tutors at this time were Stanley Badmin, Cecil Collins, Mervyn Peake and
Alan Reynolds.

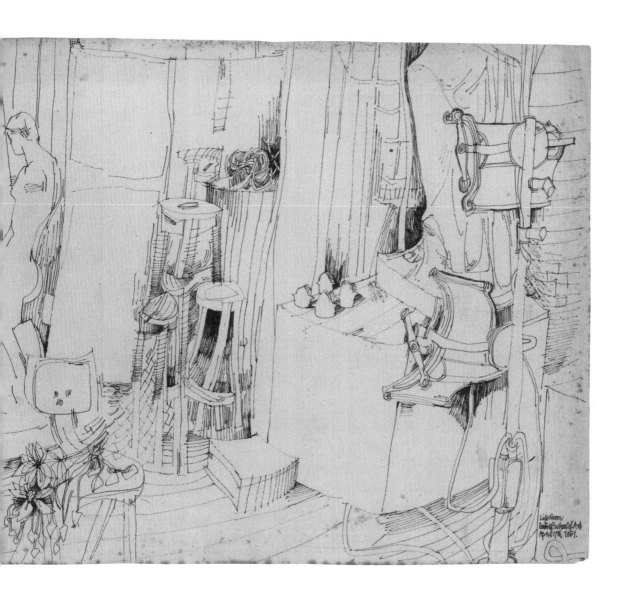

Life Room
Central School of Art
April 17th, 1961.

51

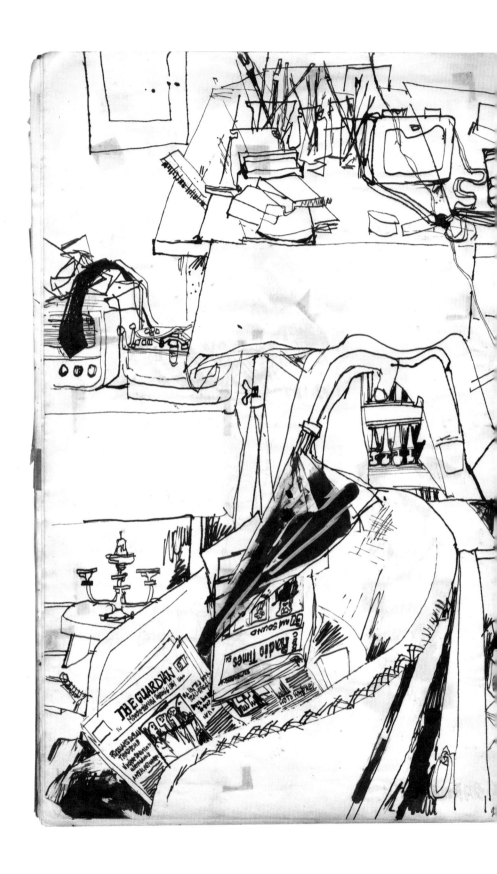

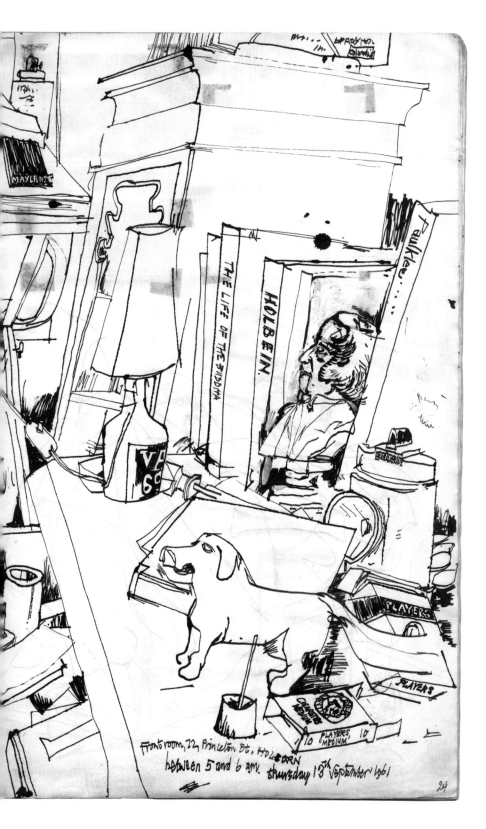

Front room, 22 Princeton St, HOLBORN
between 5 and 6 a.m. thursday 13th September 1961

Studio at 22 Princeton Street, Holborn
Pen and ink

Student sketchbook
13 September 1961

This is where I lived during my final year as an art student at the Central School of Arts and Crafts in London and where I started my freelance career as an illustrator. The exterior of the building is shown on the next page.

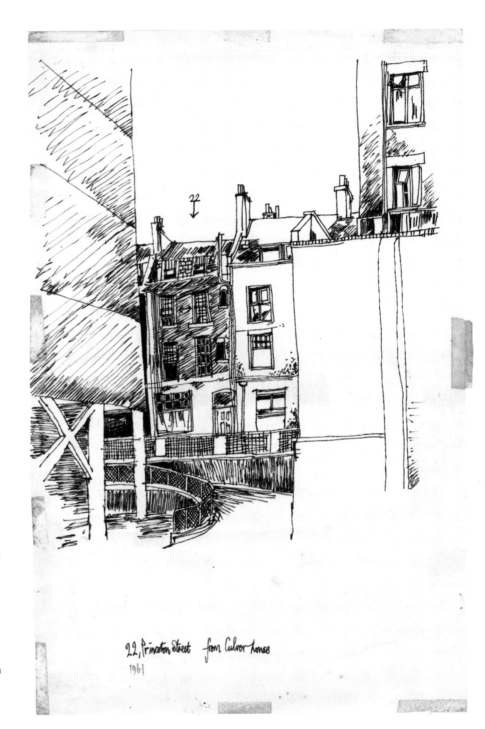

22 Princeton Street, Culver House

Pen and ink

Student sketchbook
1961

I lived in a flat on the third floor of this building, which has now been knocked down and replaced by a new one.

22, Princeton Street from Culver house
1961

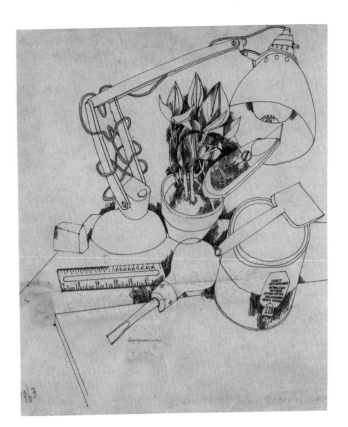

Still life: lamp, plant, ruler, screwdriver etc.
Pen and ink
1963

A person drawing, with plant, kettle and plug
Pen and ink

Sketchbook
3 January 1963

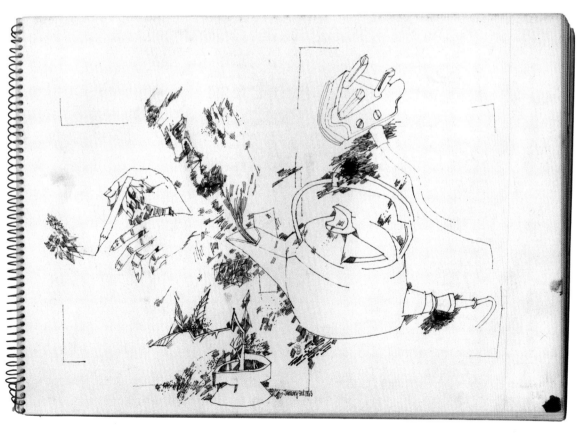

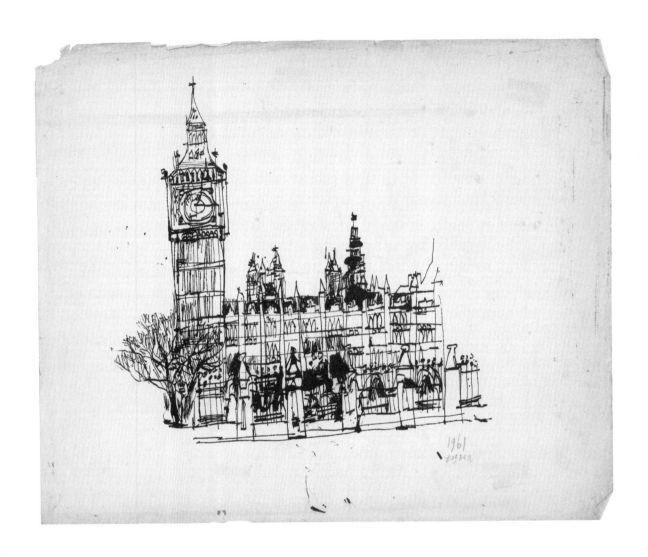

Big Ben
Pen and ink

Student sketchbook
1961

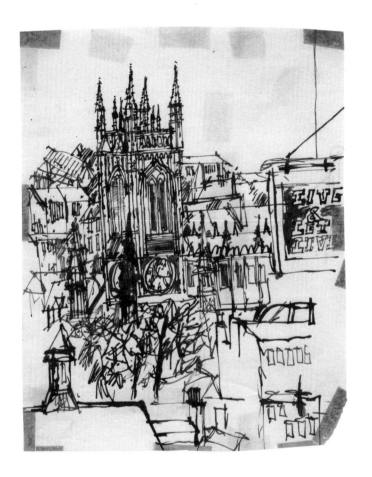

St Peter's Church, Brighton
Pen and ink

1962

This sketch was drawn when taking a group of Brighton art students outdoors sketching. The 'Live and Let Live' pub sign can be seen.

This pub was situated on Richmond Street and it closed down in 1964, just two years after this drawing, which is somewhat ironic.

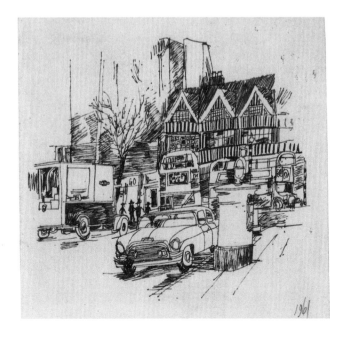

Staples Inn, Holborn
Pen and ink

Student sketchbook
1961

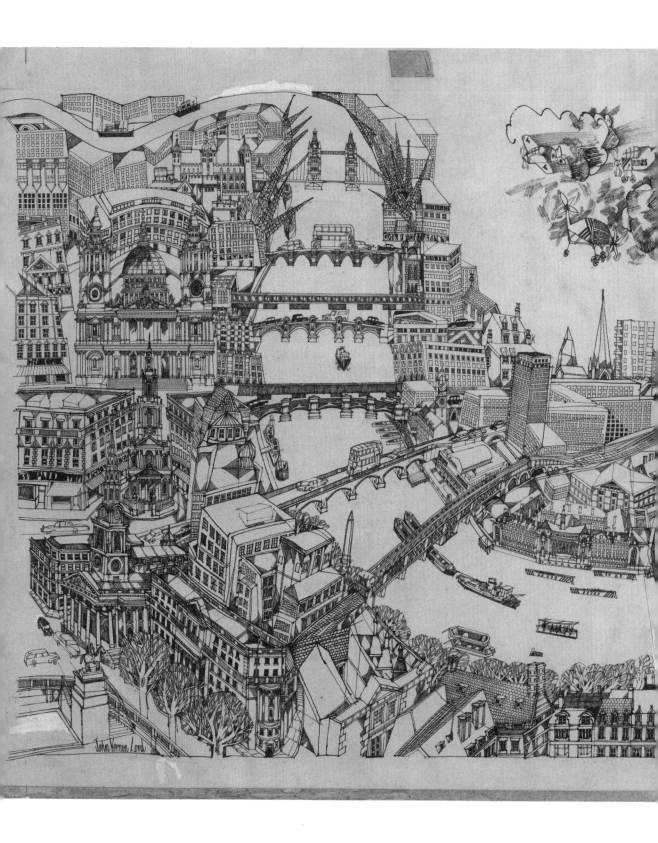

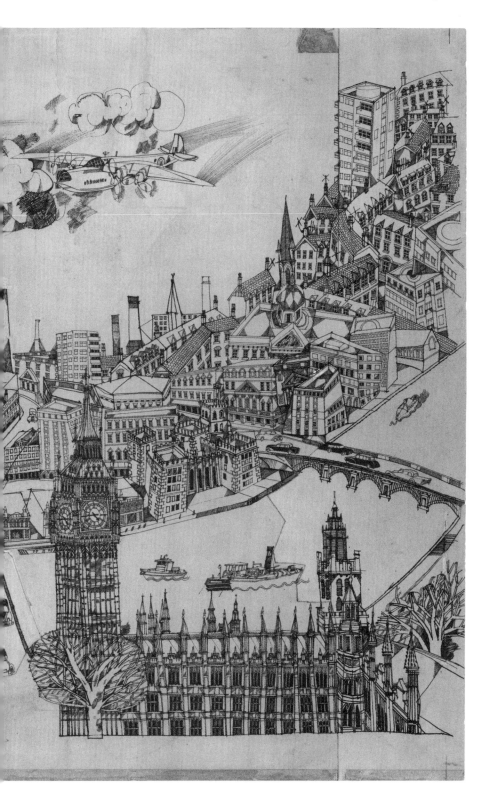

**An aerial view
of London**
Pen and ink

72 cm × 41 cm
(28 inches × 16 inches)

1965

Cathedral
Pen and ink

1968

From time to time, I would
set students short projects
when they had to draw
from their imagination.
One such brief was to
draw a cathedral without
using any reference.
I would sometimes react
to the same challenge
myself and this is one
such drawing.

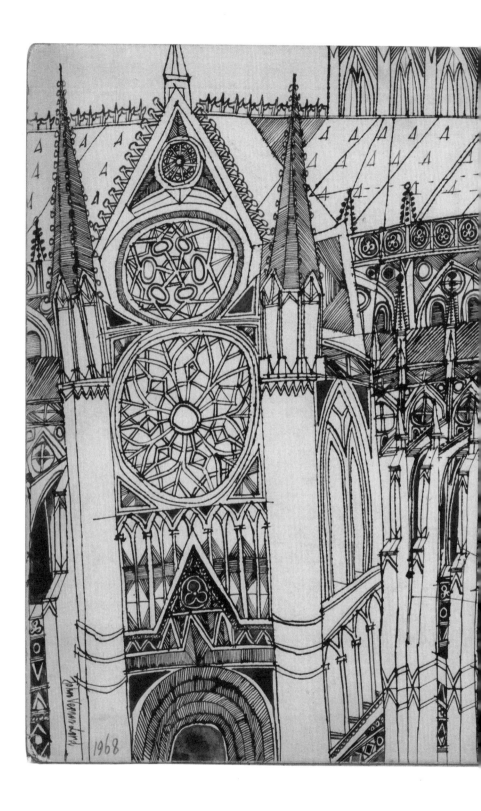

1968

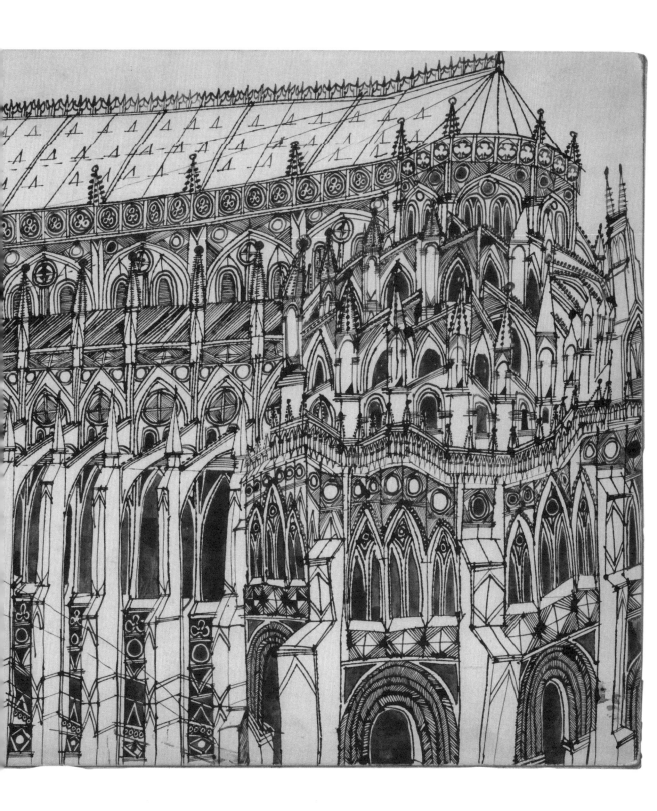

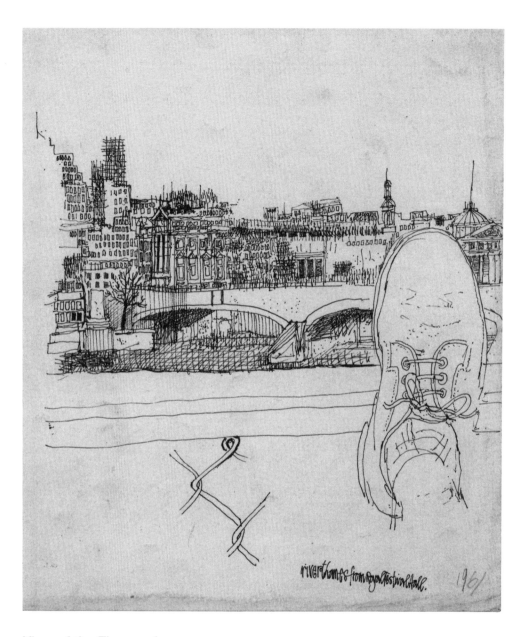

**View of the Thames from
the Royal Festival Hall, London**
Pen and ink

1961

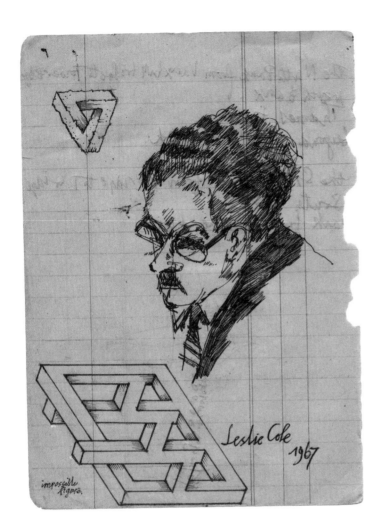

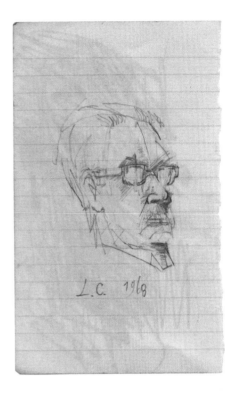

Two portraits of Leslie Cole (1910-1976)
Pen and ink

Notebooks
1967 & 1968

Leslie Cole (1910-1976) was a distinguished and productive war artist during the second World War. We shared drawing classes at Brighton College of Art throughout most of the 1960s up till 1974. He had a profound influence on me as to how drawing could be taught; showing me that students who had apparently less talent for natural draughtsmanship could become more interesting drawers than those who possessed natural ability.
He taught at Brighton from 1946 to 1976.

A church in London

Pen and ink

Student sketchbook
1960

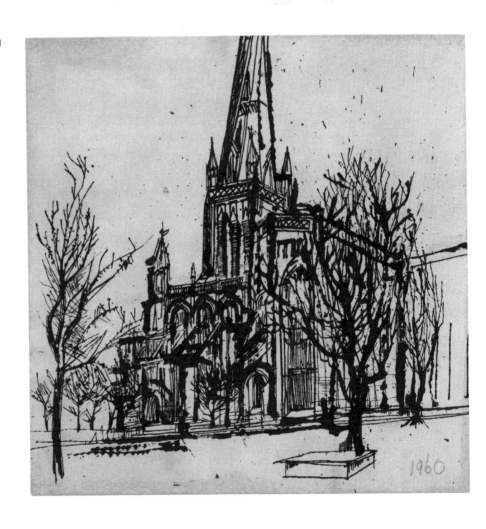

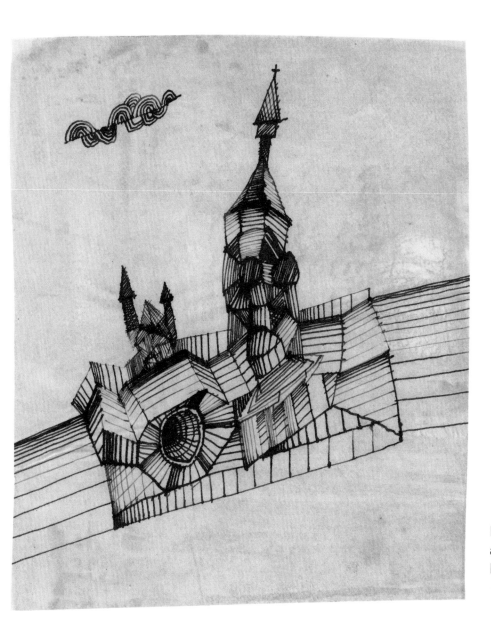

**Buildings in
a landscape**
Pen and ink

1961

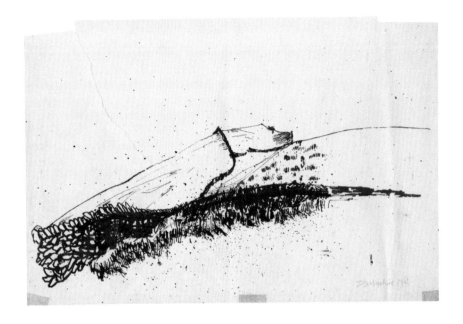

A piece of Derbyshire
Pen and ink

Student sketchbook
May 1961

Landscape
Pen and ink

Student sketchbook
1961

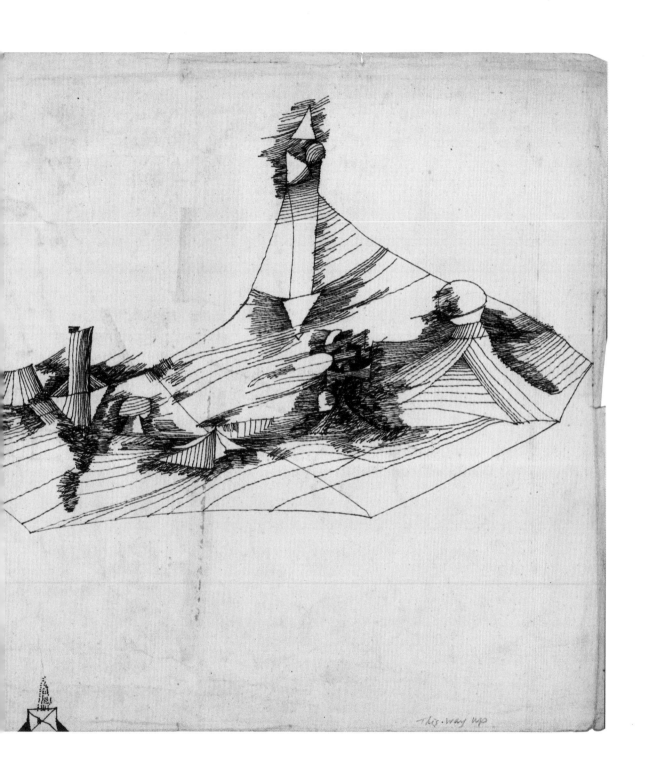

This way up

67

Stopwatch
Monotype and ink

1961

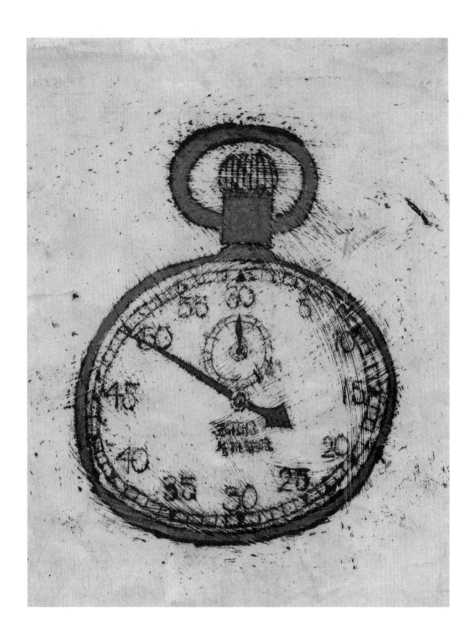

The duodenum and pancreas
Pen and ink

1960

I did this drawing when I was a student at Salford. It was based on an illustration in a medical book and it was an unusual drawing by me at the time, but, in a way, it has turned out to be a significant one – despite the fact that a tutor at Salford Art School soon put me off drawing like this. He didn't like it at all and advised me to give up this particular approach to drawing, saying it was 'old-fashioned' and 'far too tight'. Strangely, it was exactly this approach that I was ultimately to take up more seriously in the future. It was also a drawing that prompted an art director to give me my first freelance illustration job – an advertisement for Carter's Little Liver Pills. For this commission I was asked to draw two humorous illustrations in an anatomical manner such as this drawing. One was to show the intestines of a stomach suffering from indigestion and the other to show the same stomach having been relieved of the problem by taking the pills. I recall skipping down New Oxford Street in London at the time, gripping the illegible brief in my hand, and saying to myself –
"I'm a real illustrator at last".

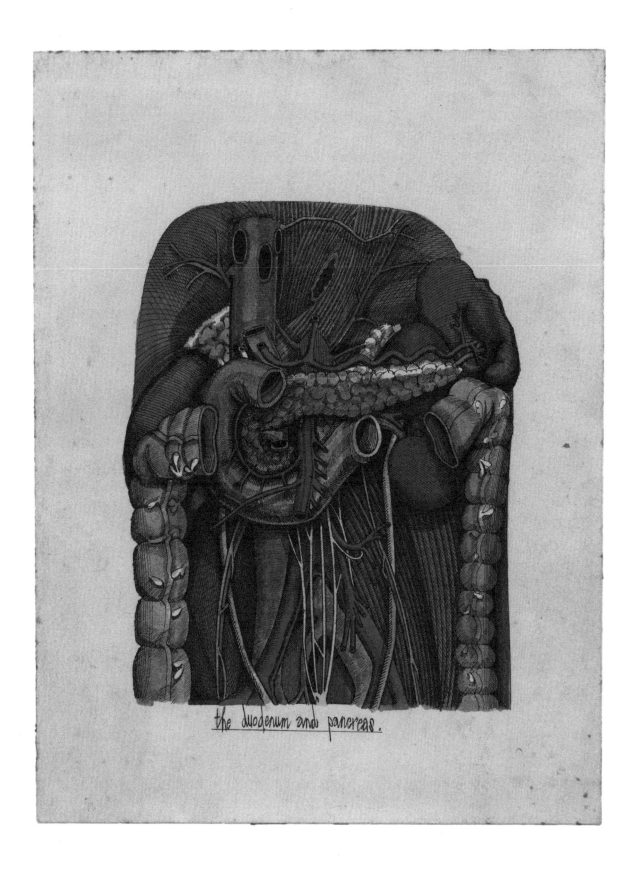

the duodenum and pancreas.

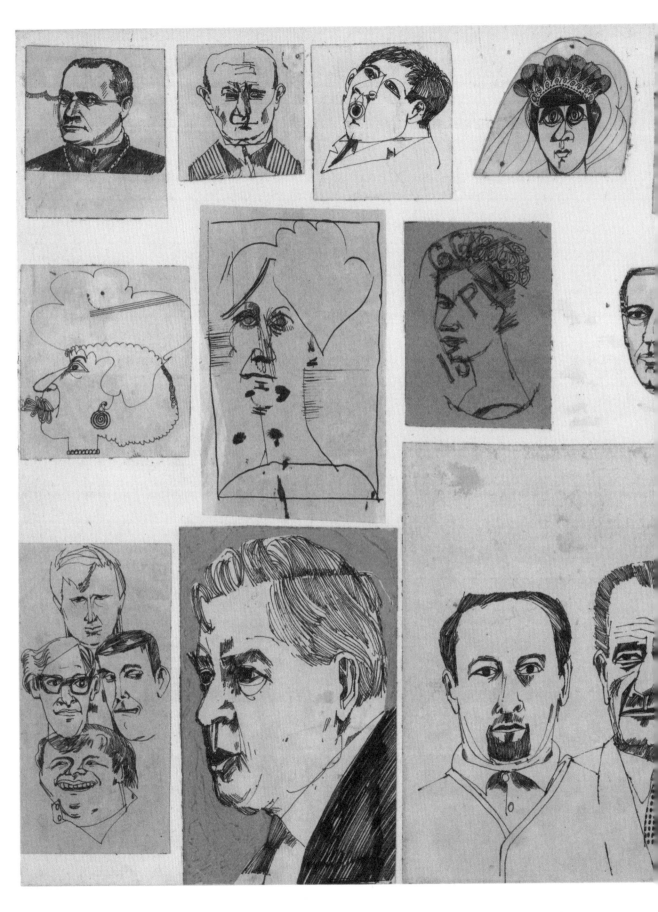

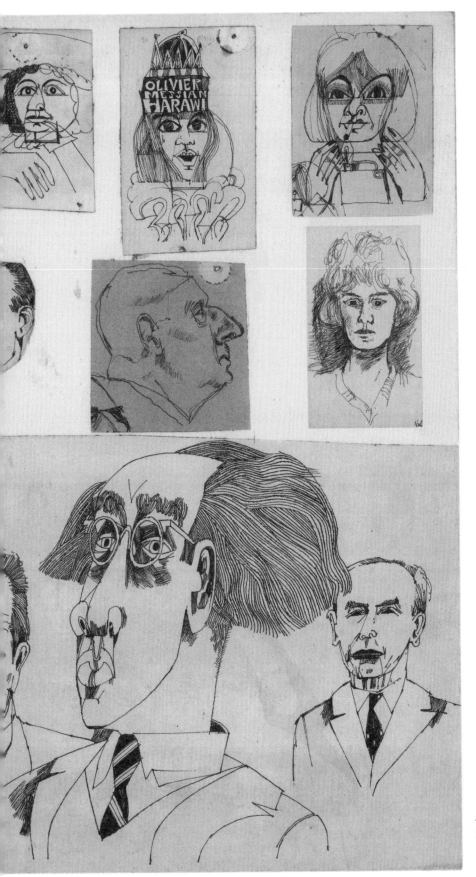

A group of heads
Pen and ink

1961

Self-portrait
Pen and ink

Sketchbook
1962

Man poking his eye
Pen and ink

13 October 1963

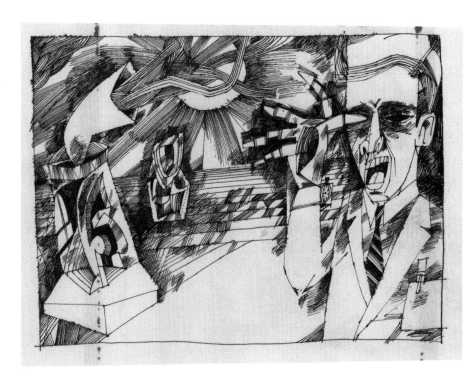

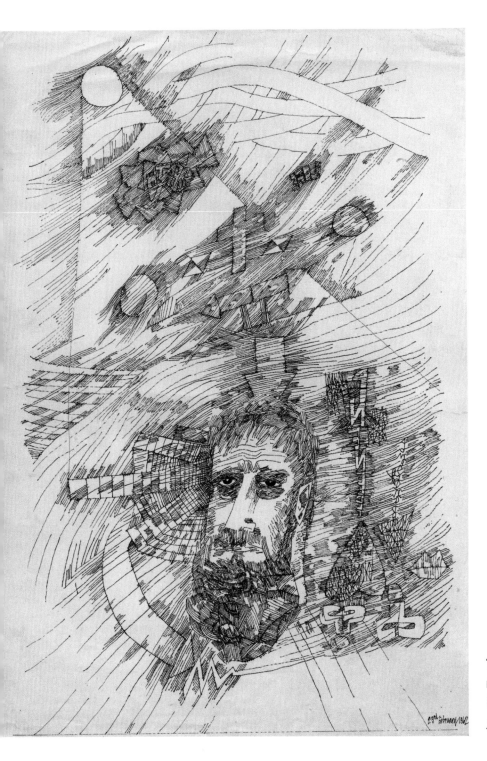

**The sun shines on a
man with a beard**
Pen and ink

23 February 1962

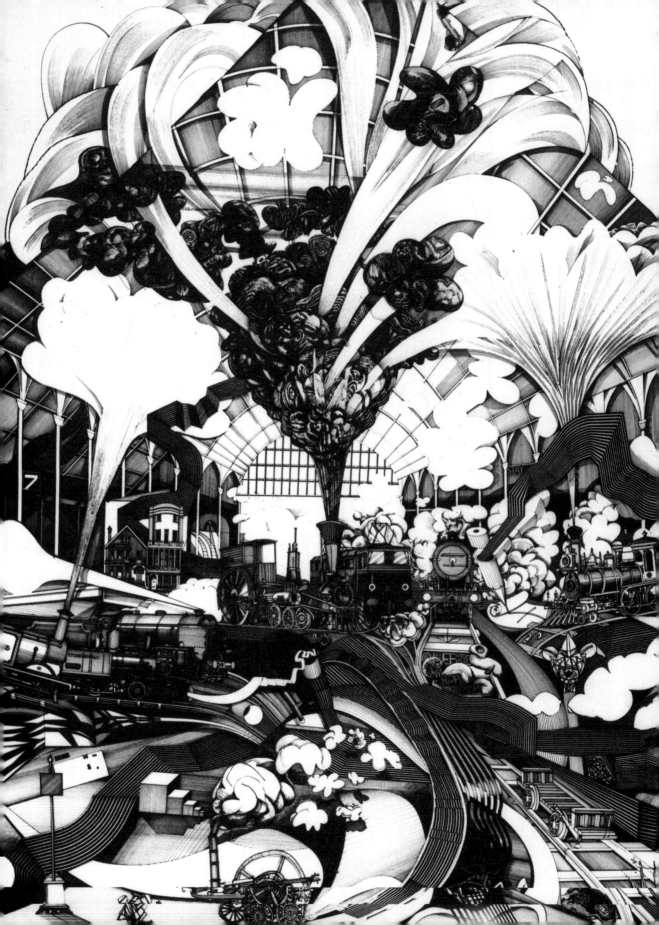

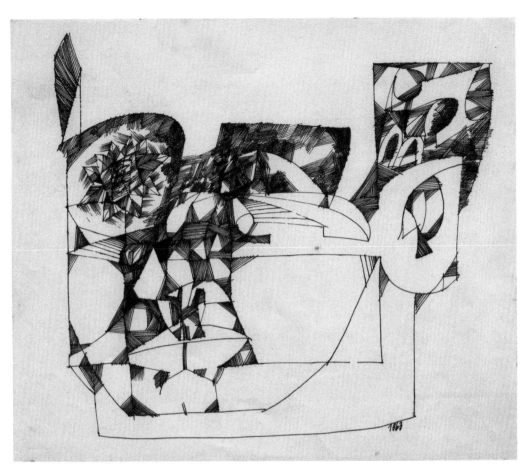

A head
Pen and ink
1963

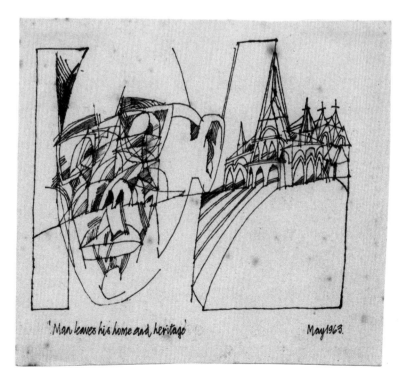

'Man leaves his home and heritage' May1963.

Man leaves his home and heritage
Pen and ink
May 1963

Railways
Pen and ink

25 × 30 mm
1963

Drawing commissioned by Peter Hay, an authority on British Steam Railways.

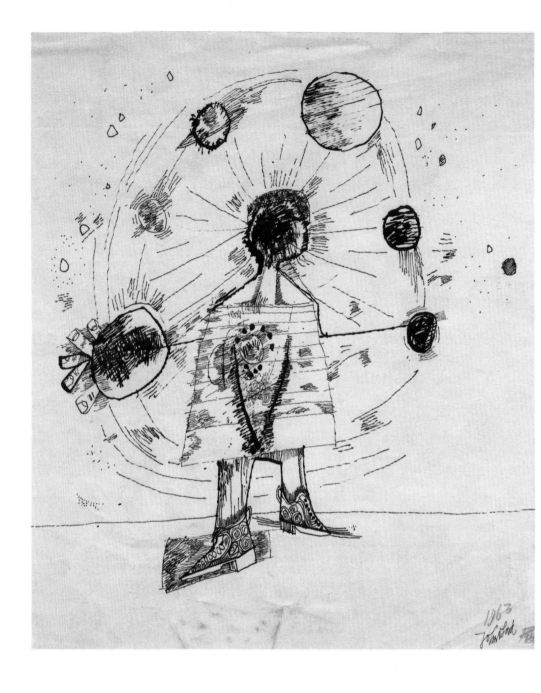

Juggler
Pen and ink

1963

Inside a head
Mixed media

1965

My agent's label is stuck on
the bottom of this drawing,
as it was kept in their
portfolio when they were
doing their rounds
in London.

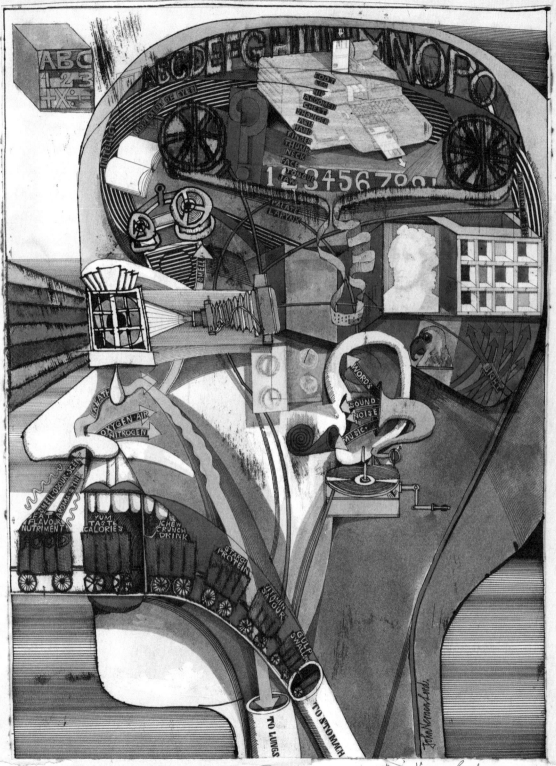

Celery
Pen and ink
1960

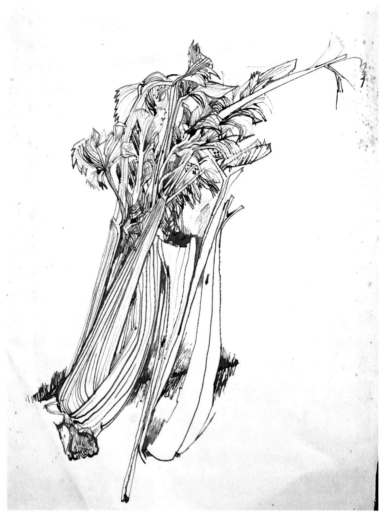

A cluster of plant forms
Pen and ink
14 July 1964

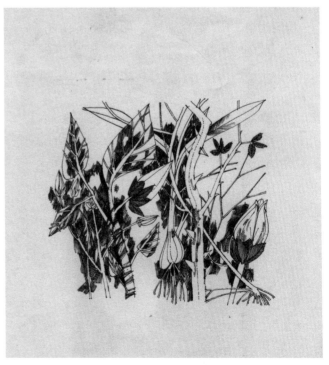

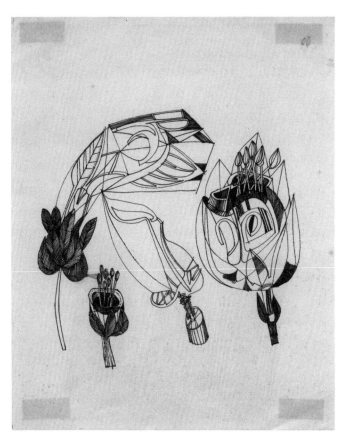

Four plant forms
Pen and ink

14 July 1964

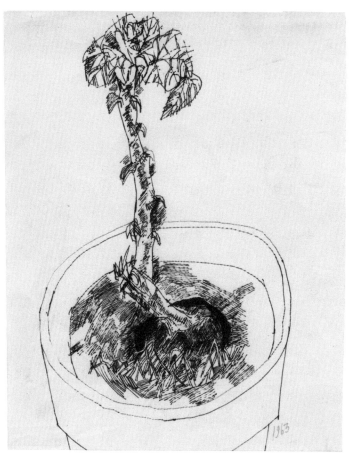

Begonia
Pen and ink

Sketchbook
1963

Abstract composition
Monotype and ink
1964

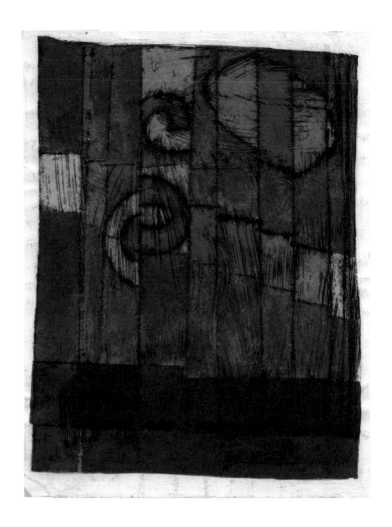

Lion's head
Monotype and ink
1965

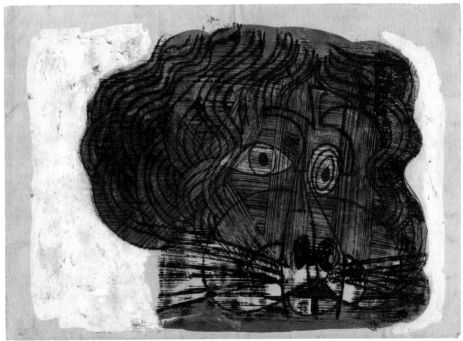

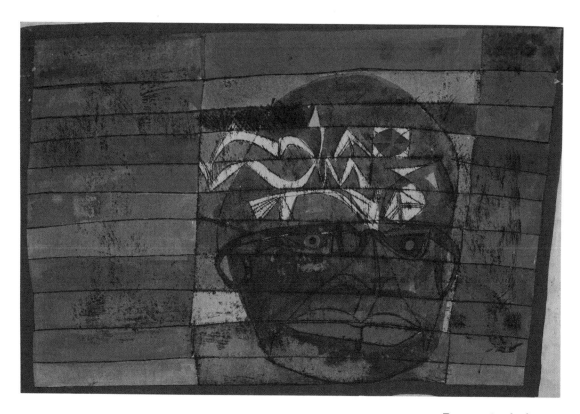

Bespectacled man
Monotype and ink
1964

**Back of an
alarm clock**
Monotype, ink
and gouache
1965

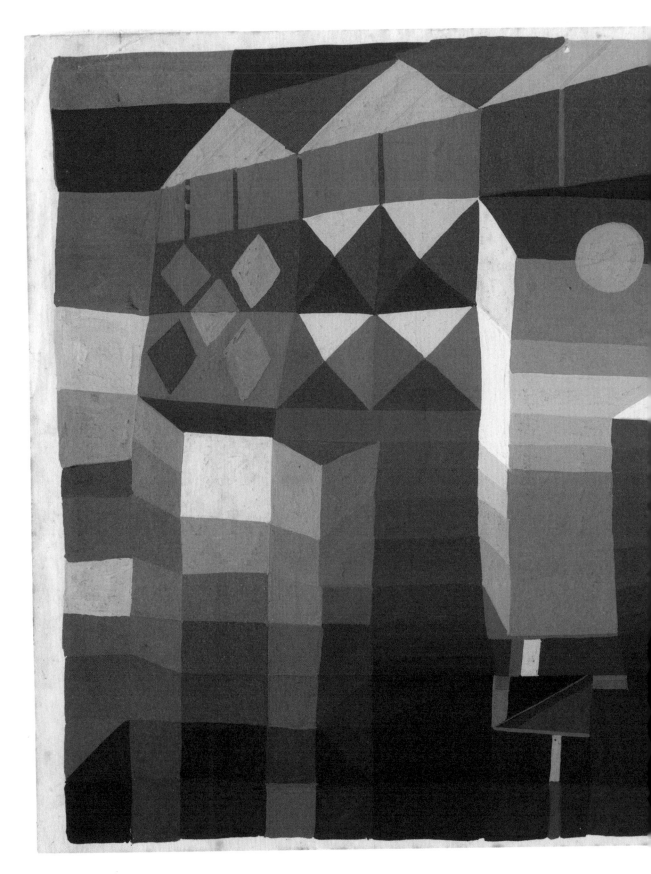

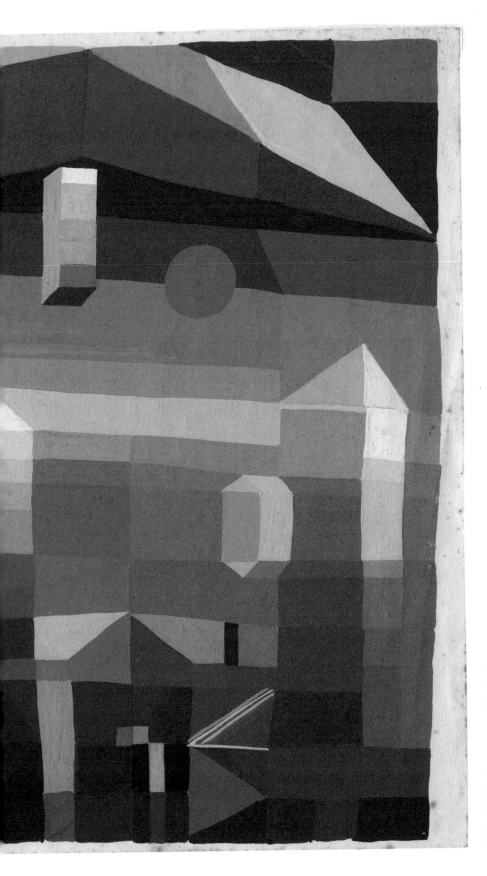

A student exercise in orange and blue
Gouache

1960

This exercise involved limiting the colour palette to just orange, blue, black and white in order to find out the range of colours you get when you mix them together in various degrees.

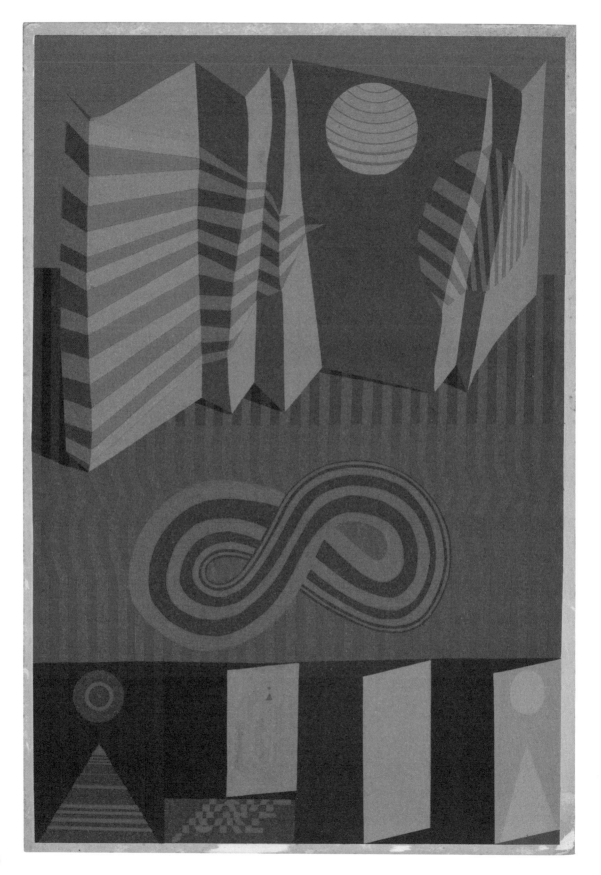

Red and green stripes
Gouache
49.5 cm × 61 cm
(19.5 inches × 24 inches)

1965

Joke
Gouache
52 cm × 77.5 cm
(20.5 inches × 30.5 inches)

13 November 1964

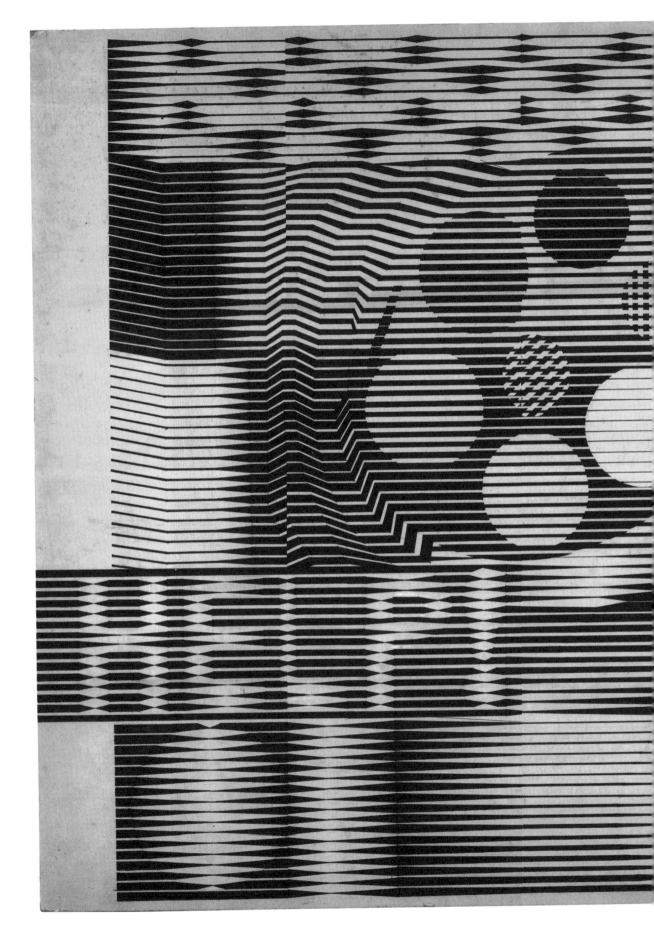

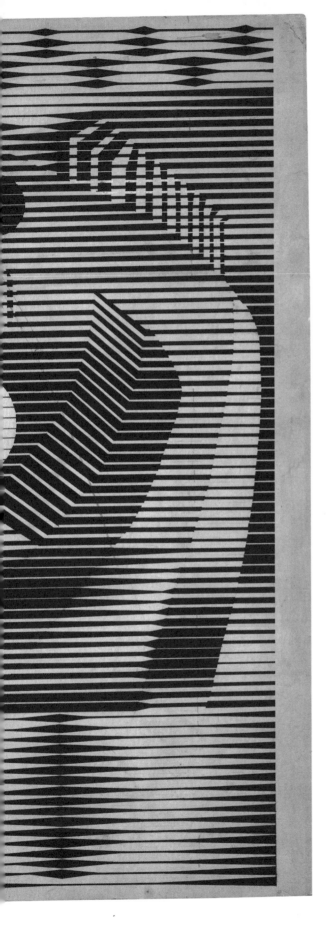

Help!

Pen and ink
60.5 cm × 52.5 cm
(23.75 inches × 21 inches deep)

29 October 1964

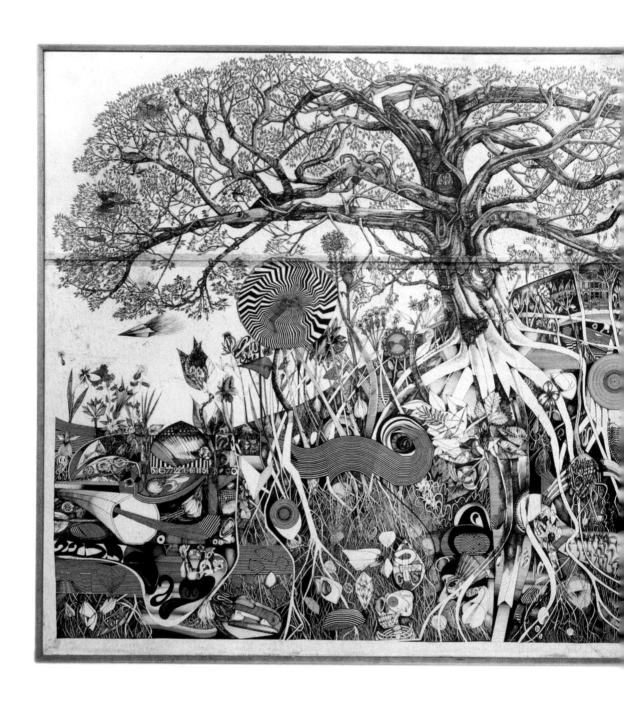

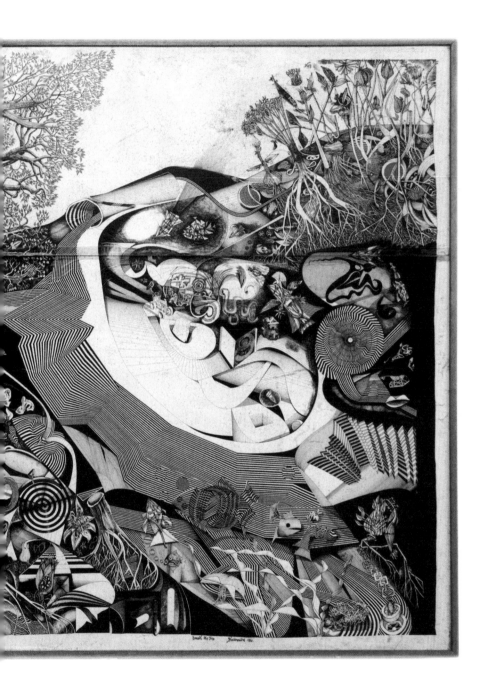

Beneath the Tree

Pen and ink
2.21 m × 1.19 m
(7 feet × 3 feet 11 inches)

20 February—3 November 1966

This drawing took 204 and ¾ hours to complete, over 48 days and 111 separate sittings. It is housed in the Aldrich Collection at the University of Brighton.

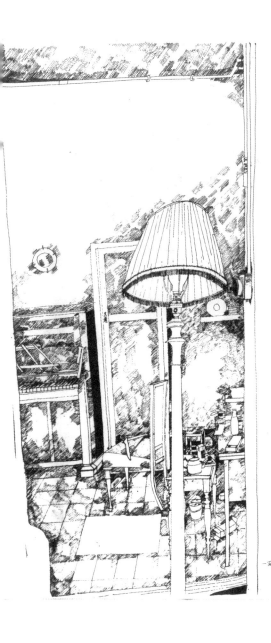
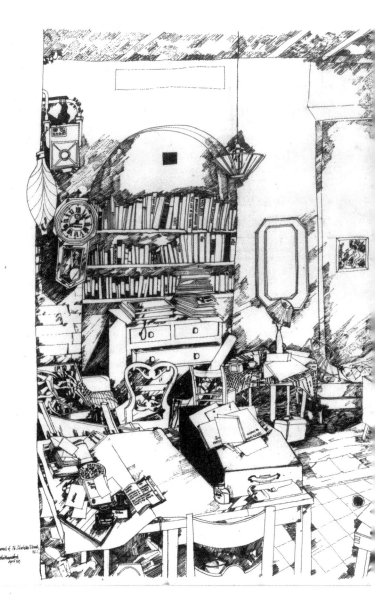

The touch-diorama of 76, Charlotte Street,
W.1.
John Hayward
April 2007

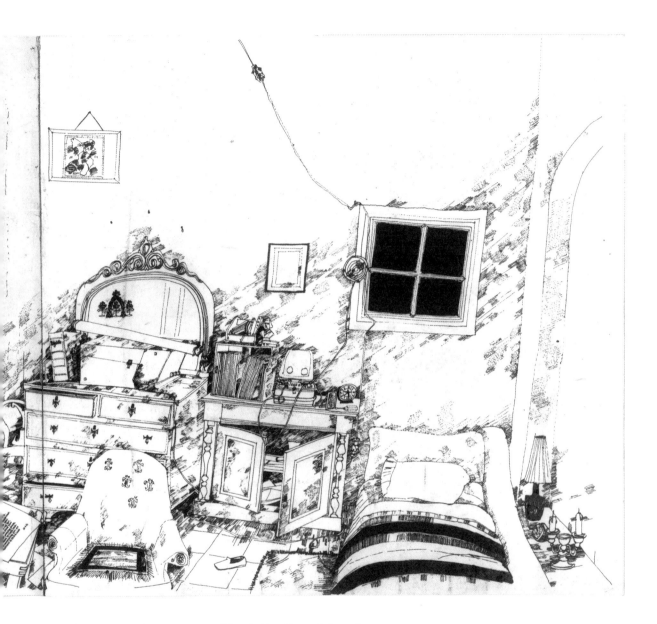

Studio/bedroom at 76 Charlotte Street, London

Pen and ink
2.01 × 0.94 m (6 feet 7 inches × 3 feet 1 inch)

April 1962

This drawing took 15 hours to draw during the course of three days. The location was a flat that I lived in during 1962. It was the back basement of 76 Charlotte Street, which was a house where the artist John Constable and his family once lived in the 1820s and the 1830s. Constable died in a little attic bedroom at 76 Charlotte Street, from an attack of indigestion on 31 March 1837. At the time when I lived here the landlady was the artist Gwyneth Johnstone, a daughter of Augustus John. Sadly, given its artistic heritage, the building no longer stands having been replaced by a new one.

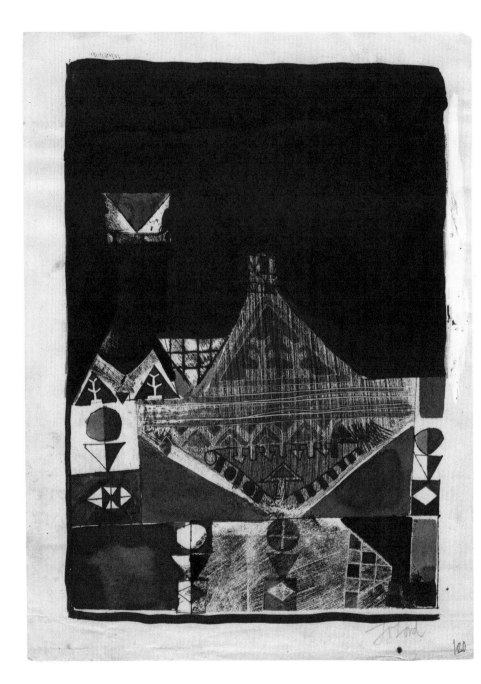

Abstract composition

Monotype and ink

January 1964

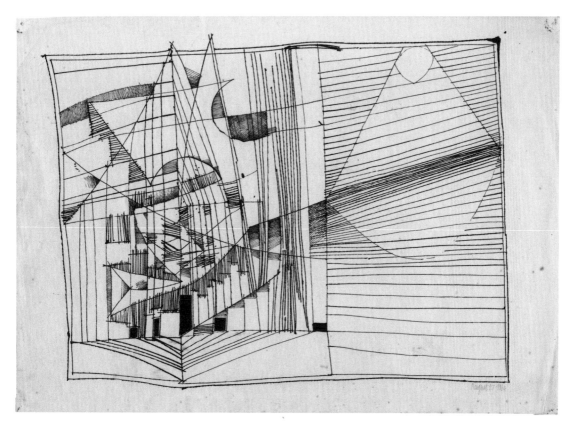

Abstract landscape
Pen and ink

27 August 1964

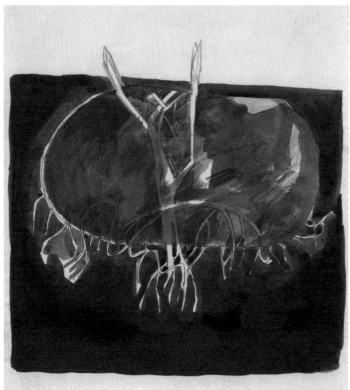

Begonia tuber
Ink and crayon

23 April 1964

Abstract composition
Monotype and ink

January 1964

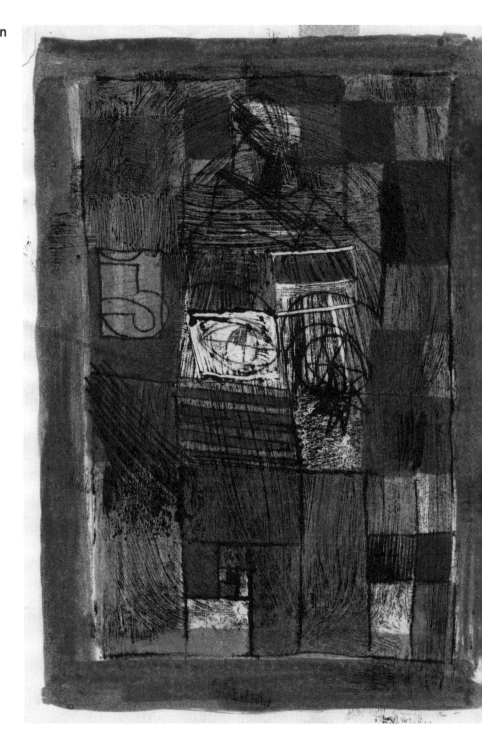

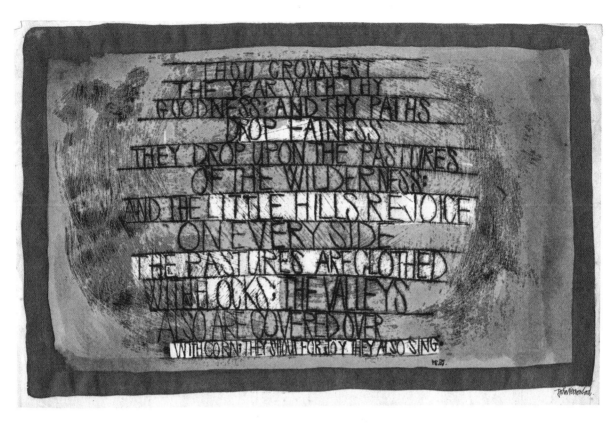

'Thou crownest the year with thy goodness'
Monotype and ink

1964

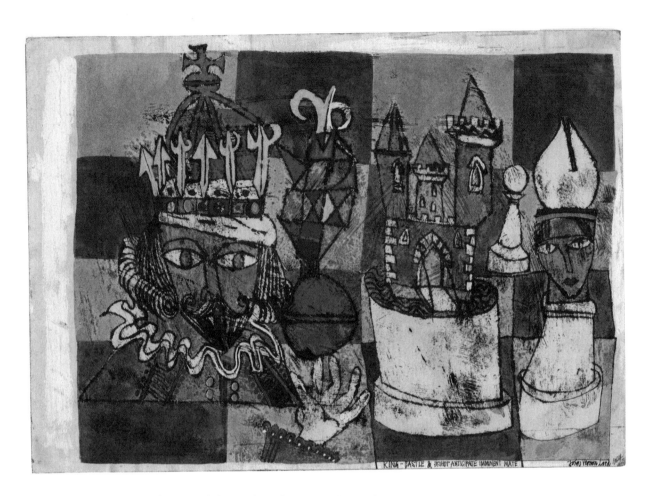

King, castle and bishop anticipate imminent mate

Monotype and ink

1964

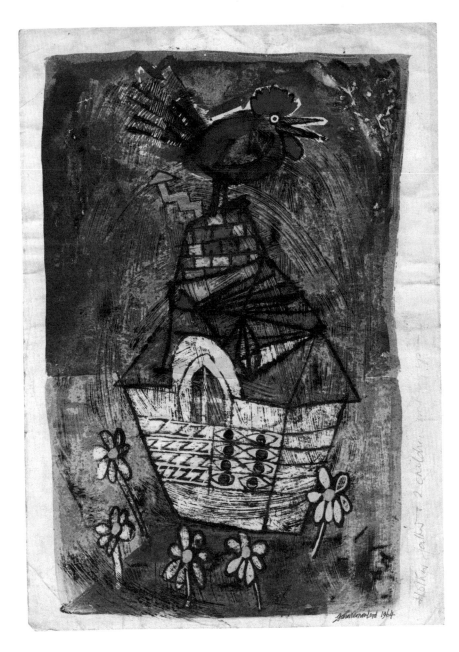

Cockcrow
Monotype and ink

1964

Duck
Monotype and ink
1964

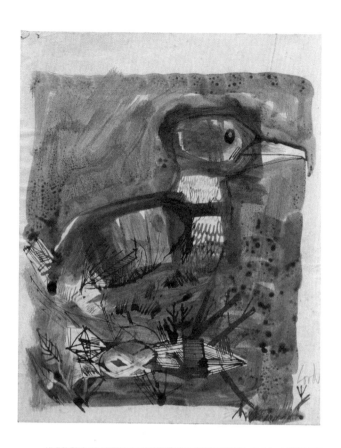

Orange bird
Inks
1964

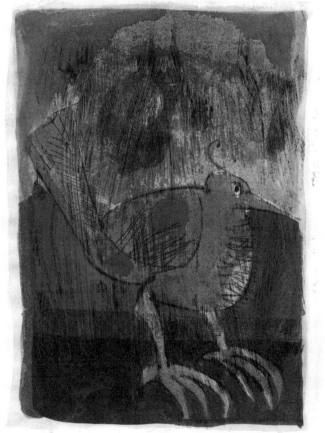

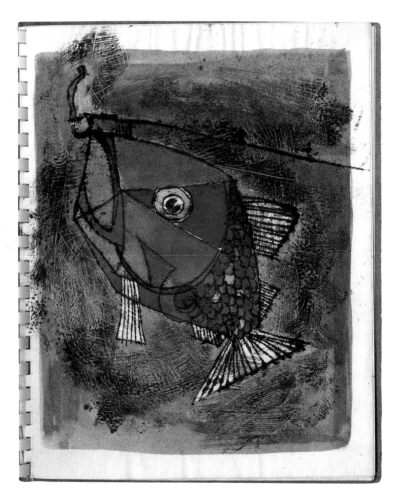

A fish close to the bait
Monoprint and inks

Student notebook
1961

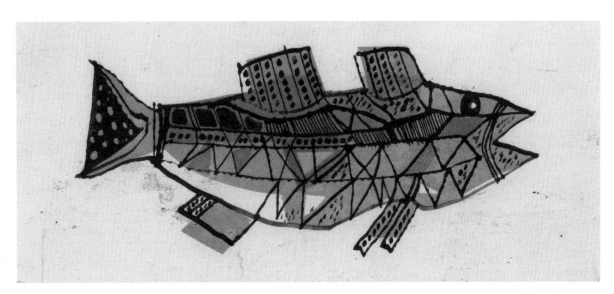

Blue fish
Pen and ink

1961

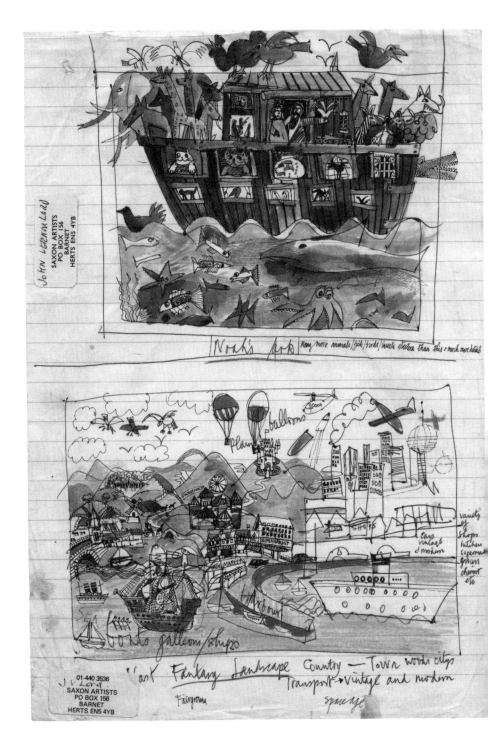

**Ideas for
children's posters:
Noah's Ark and a
fantasy landscape**
Pen, ink and crayon

1968

Reynard the Fox
Pen and ink
1968

**Ideas for a Noah's
Ark frieze – giraffes,
bison, armadillos etc.**
Pen and ink

1969

This and the following two
illustrations show a way of
drawing that I adopted much
later on when I illustrated an
edition of *Aesop's Fables*
for Jonathan Cape, 20
years later in 1989.

Ideas for a Noah's Ark frieze — camels, swallows, porcupines, dodos etc.
Pen and ink
1969

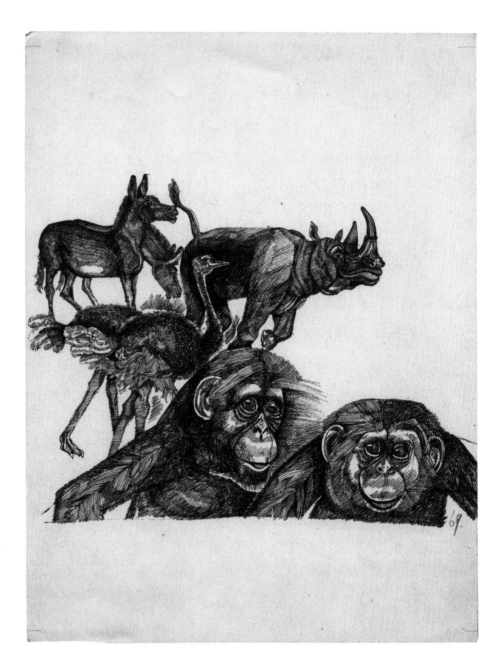

Ideas for a Noah's Ark frieze — donkeys, ostriches, rhinoceroses and chimpanzees
Pen and ink

1969

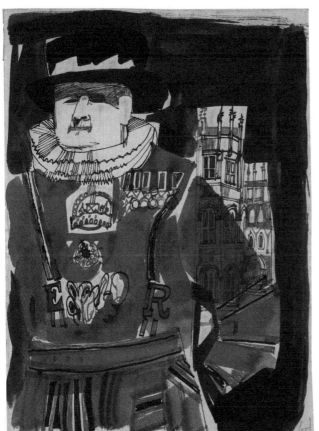

Beefeater
Pen and ink
1963

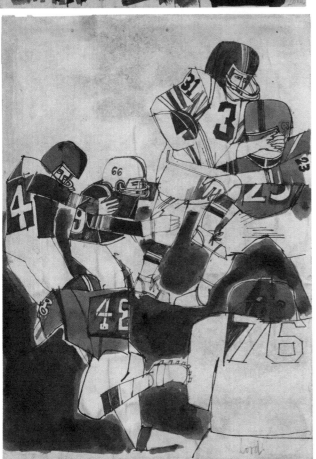

American footballers
Pen and ink
1963

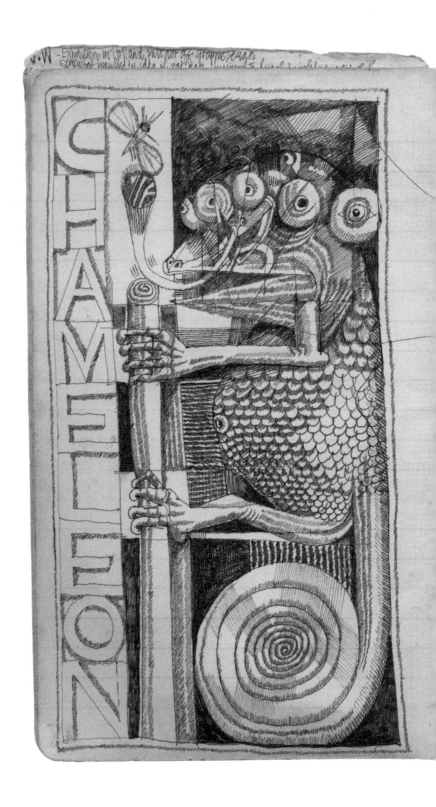

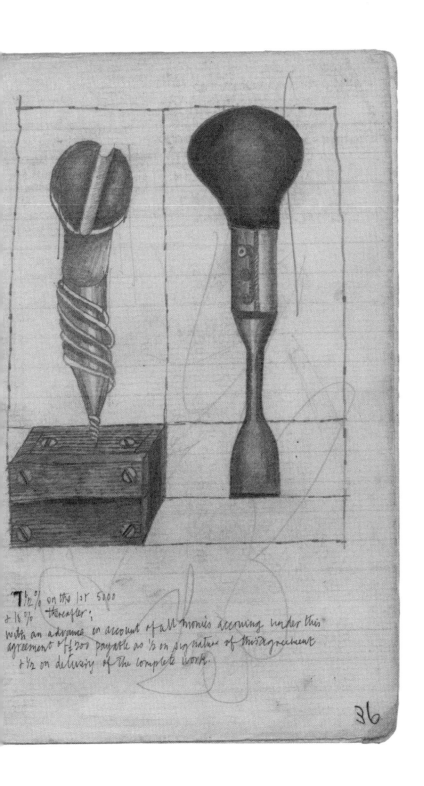

7½% on the 1st 5000
+ 10% thereafter;
with an advance on account of all monies accruing under this
agreement of £500 payable as ½ on signature of this agreement
+ ½ on delivery of the complete work.

36

**Chameleon, screw
and screwdriver**
Pen and ink

Notebook
30 May 1968

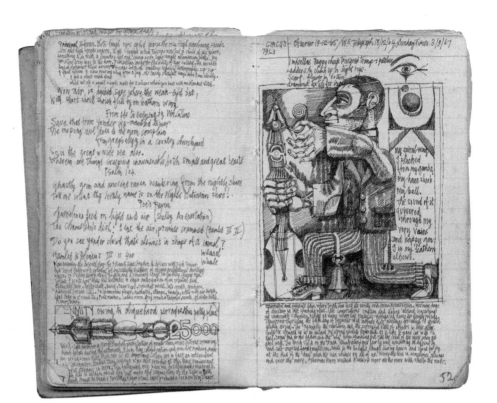

Principal 16 forms
Pen and ink
November 1968

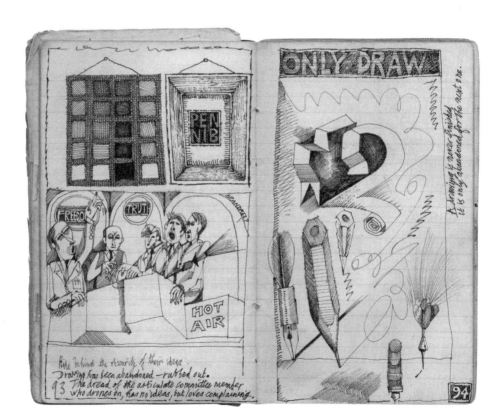

Pen nib/ only draw
Pen and ink
9 January 1969

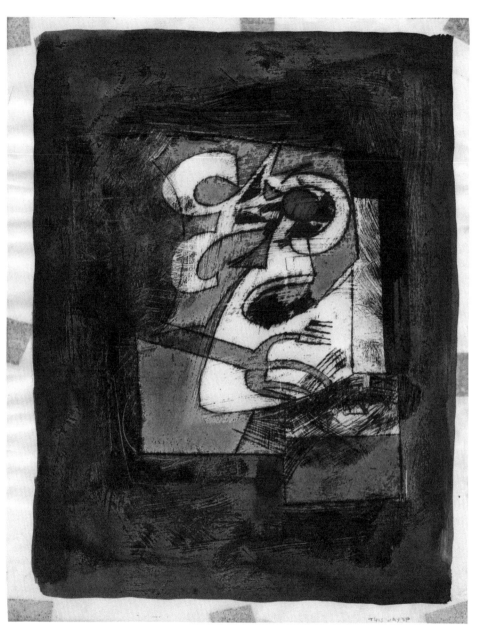

Abstract composition
Monotype and ink

January 1964

A galleon
Monotype

1964

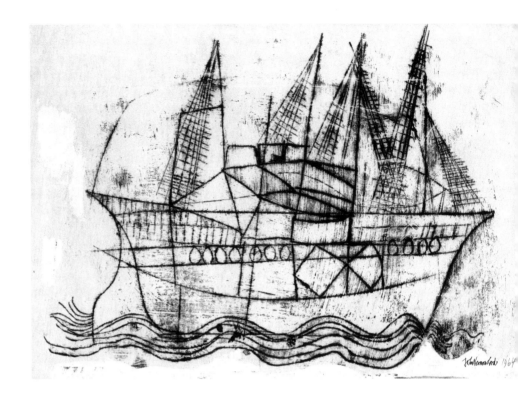

Don Quixote
de la Mancha
Monotype

27 August 1964

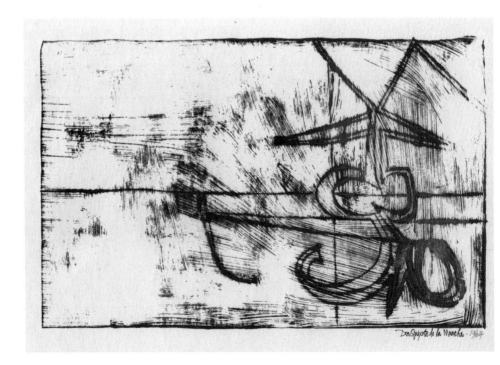

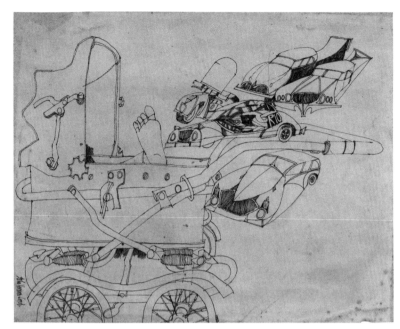

Pram and cars
Pen and ink

1964

A centaur
Monotype and ink

1964

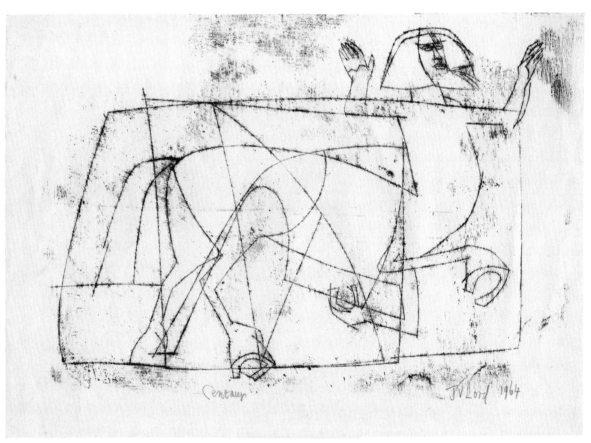

1970s

In 1970 I was appointed full-time Senior Lecturer in Drawing and Illustration at the newly designated Brighton Polytechnic, and in 1971 my family moved from Brighton to live in Ditchling where my wife and I still live. It was a busy decade trying to mix teaching with a busy illustrating schedule. It was a time when I carried out fewer advertising and editorial commissions and I found myself concentrating more on illustrating books. In the early 1970s I illustrated a series of Inquiry booklets edited by Simon Clements which accompanied a series of broadcasts provided by BBC Radio 4 for the School Broadcasting Council for the United Kingdom. They covered a range of social issues such as: people's prejudices, outsiders, the generation gap, the pop culture, fashion, the voice of protest, law and order, the problem of building new airports, work and leisure, and a sense of community etc. Another book I illustrated on social issues at this time was *A Natural History* of Man by J.K. Brierley.

It was also a decade when I illustrated and wrote a number of children's picture books. My first book was *The Truck on the Track* by Janet Burroway, published by Jonathan Cape in 1970. This marked the beginning of a very fruitful 20-year collaboration I had with the publisher Tom Maschler at Jonathan Cape and his colleagues Valerie Kettley and Ian Craig. Books produced in this period included: *The Giant Jam Sandwich* in 1972, *The Runaway Roller Skate* in 1973, *Mr Mead and his Garden* in 1974, *Who's Zoo* by Conrad Aiken in 1977, and *Miserable Aunt Bertha* in 1979.

While these books were full-colour picture books, I also worked on black and white illustrations for other books for other publishers, such as: *Dinosaurs Don't Die* by Ann Coates in 1970, *The Adventures of Brer Rabbit*, after Joel Chandler-Harris, in 1972, and *Sword at Sunset* by Rosemary Sutcliff in 1975.

There were other commissions including designing six mugs on the theme of 'Punch and Judy' for Staffordshire Potteries and book jacket commissions from book publisher Chatto and Windus.

My work was shown in the 'L'Enfant et Les Images' exhibition in the Palais du Louvre, Paris and I had my first solo show at Sussex University. In 1976, during the Brighton Festival, I had a joint show of 'Published and Unpublished Work' with Ralph Steadman.

In retrospect, the 1970s were a very busy time for me: in 1974 I was appointed Department Head of Visual Communication at Brighton Polytechnic. I also served as a Member of the National Council for

Diplomas in Art and Design (NCDAD) Graphic Design Panel and in 1978 I began to serve as a Member of the Council for National Academic Awards (CNAA) Graphic Design Board. I served on this board for the next ten years.

Another thing to mention at this point is that there are a number of drawings in this book which may be described as doodles, since they were drawn during committee meetings (I've attended hundreds of meetings at art college, polytechnic and university over the years) with little intent other than therapy. Most of these doodles (the first of which appears in this chapter on page 131) were drawn on A4 sheets of paper without any purpose other than occupying me (and keeping me calm) during what were often tense discussions in the boardrooms of academia.

These were times of trying to resolve how to deal with ever-decreasing budgets. Politicians at the time invented such expressions as 'strategic downsizing' or 'efficiency gains' as euphemisms for 'cuts'. Once, when the windows hadn't been cleaned for ten years, someone called it 'deferred maintenance'. Another delightful expression I recall was 'seagull management', referring to the attitude of those bosses who make a lot of noise, shit on you from a distance and then fly away.

My doodles are automatic drawings, usually executed with little thought. Such drawings are rarely completed. This is because the time taken producing them depends on the length of the meeting itself. When the meeting stops, the doodle stops too. There are few ideas here. Trying to think up ideas whilst doodling might well take your mind off the issues being addressed at the meeting and this, of course, might cause you to lose concentration on the discussion at hand.

For me doodling is a way of aiding concentration and it soothes any tension that sometimes arises during a discussion. Doodles are drawings for the sake of it, so I do not take them too seriously as to their quality. They must be aimless and I must not improve them or worry about how well or badly they develop.

Doodles have a private life of their own and they more or less draw themselves. Perhaps some of our creative expression comes from our unconscious minds. Working intuitively can open up unexpected results that may develop into something that you can adopt when working more purposefully. They allow for a great deal of intuition, which my illustrations often lack in terms of graphic approach. They release in me a kind of automatic drawing that is not always the case when I am illustrating.

One positive use of my doodles was exhibiting them for sale at Brighton in 1985. I managed to sell over a hundred of them and the proceeds of the sale went towards a student sketchbook prize. Many of my doodles appeared in a Camberwell Press limited edition publication a year later, entitled *The Doodles and Diaries of John Vernon Lord*.

Bust of a forgotten gentleman
Pen and ink

1970

In the collection of
Patrick Burke.

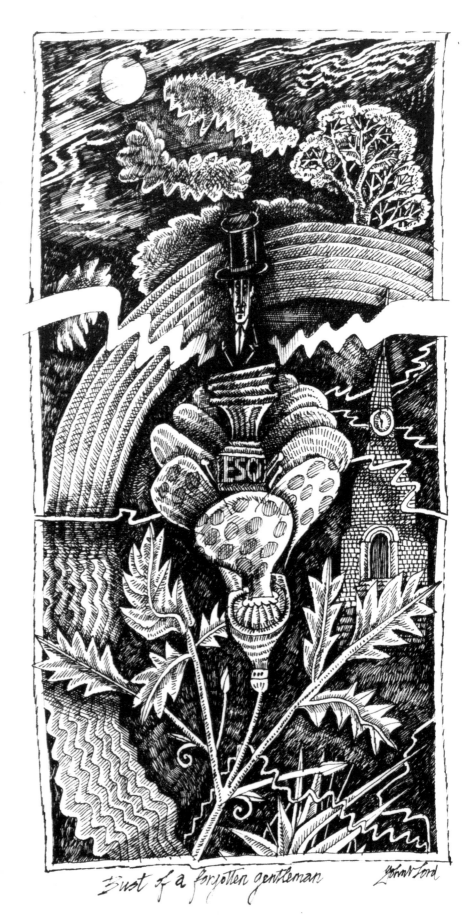

Bust of a forgotten gentleman

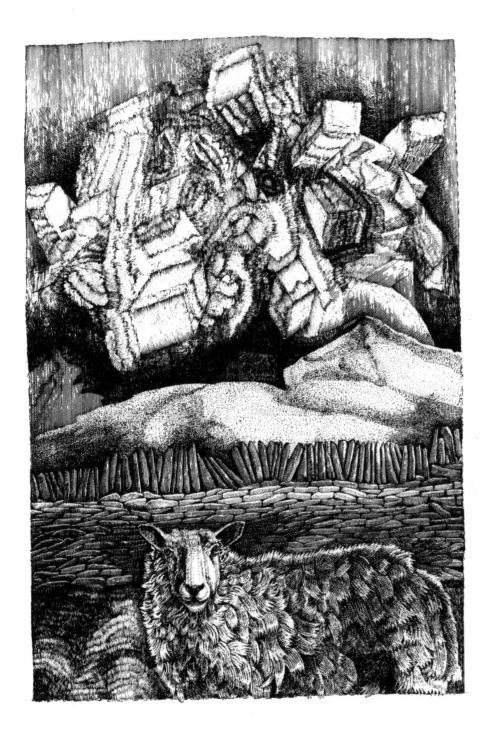

A sheep in Derbyshire
Pen and ink

1970

In the collection of Peter Cresswell.

Jack Snipe

Pen and ink

1970

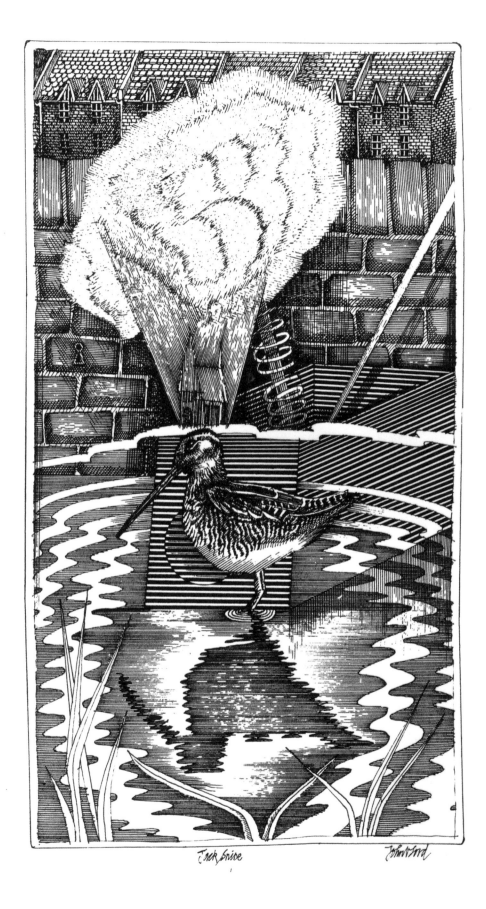

Jack Snipe John Ford

116

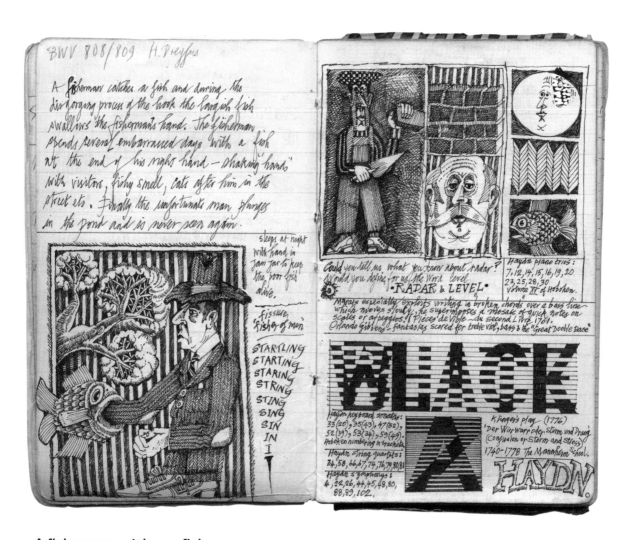

A fisherman catches a fish

Pen and ink

July 1976

Double page spread from *The Giant Jam Sandwich*, Rough dummy
Pencil

1971

The main difference between the rough and the finished illustrations is the eye level. I finally decided to adjust the perspective and project the viewpoint at a much lower eye-level in order to evoke a more monumental scale for the loaf of bread as it comes out of the oven.

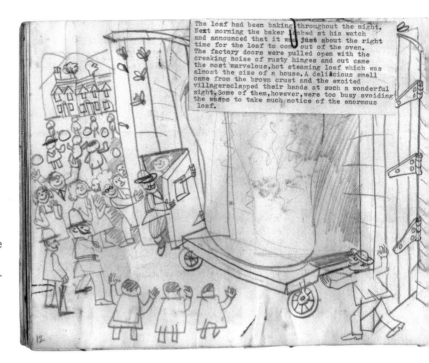

The loaf had been baking throughout the night. Next morning the baker looked at his watch and announced that it was just about the right time for the loaf to come out of the oven. The factory doors were pulled open with the creaking noise of rusty hinges and out came the most marvelous, hot steaming loaf which was almost the size of a house. A delicious smell came from the brown crust and the excited villagers clapped their hands at such a wonderful sight. Some of them, however, were too busy avoiding the wasps to take much notice of the enormous loaf.

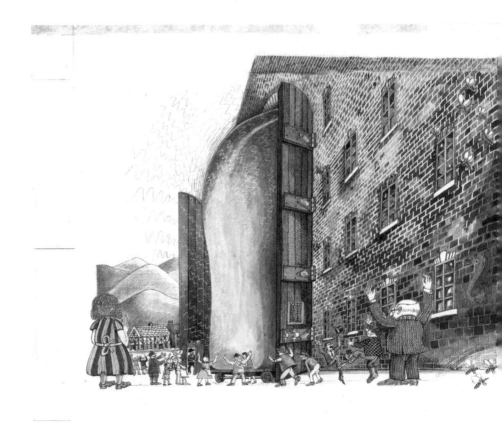

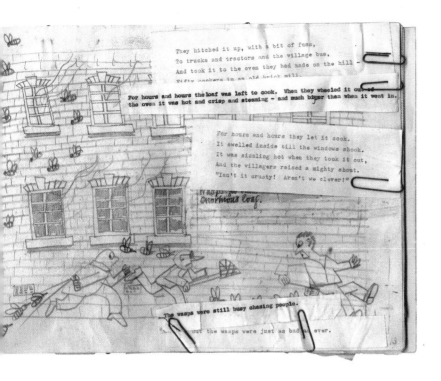

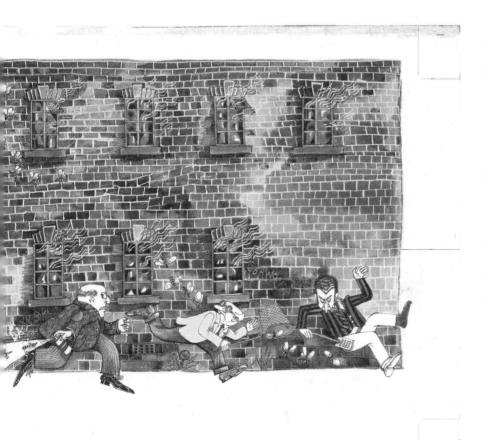

Double page spread from *The Giant Jam Sandwich*, Final artwork
Pen, ink and crayon

1971

I wrote the story and carried out the illustrations for this book. Janet Burroway turned the story into verse. It was published by Jonathan Cape in 1972 and is still in print today. It has been published in many languages.

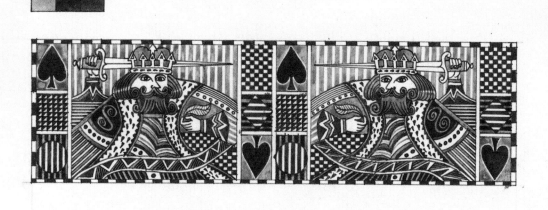

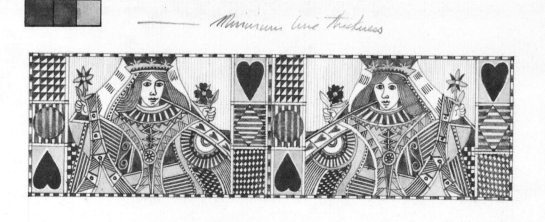

**Unadopted roughs
of mug designs
for Staffordshire
Potteries**
Pen and ink

1973

The expression
'unadopted' used to be a
professional and rather
charming euphemism for
'rejected'.

Can't Cantata Can't
Pen and ink

1972

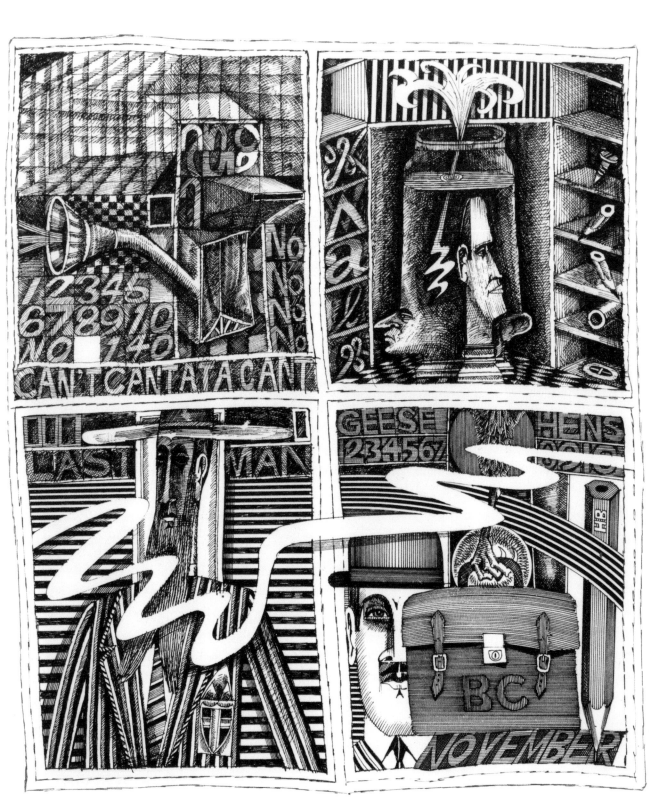

Box characters
Pen and ink

1973

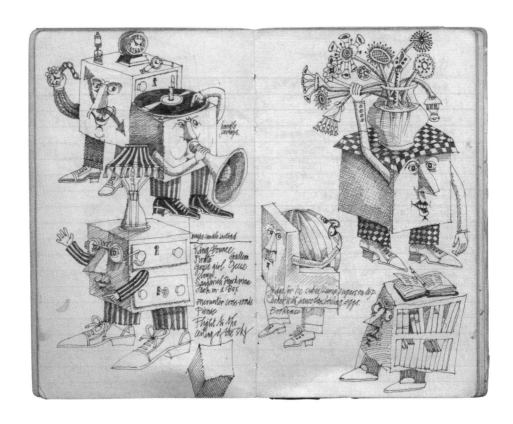

A left wing gorilla
Pen and ink

1979

In the collection of
Vivienne Shadbolt.

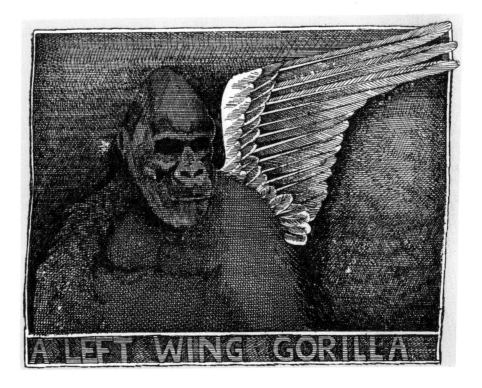

The old man without a dish struggled
with a fish in the empty dark street,
little knowing that his nephew was round
the corner with a water filled goldfish bowl.

The hallowed soul flew down from
the sky, revealing his mashed beak
and left foot which resembled
a bird's claw. He said nothing.

Swish and flutter.
The young man wept at the
fleeing of the hallowed soul.
The misery of marmalade without peel.

The faceless majority and the dreary
voice of public opinion and human mediocrity
monotonously interfered with the individual's
liberty and told him to return from
whence he came.

**The Old man without
a dish struggled
with a fish**
Pen and ink

1978

Practice drawings in
preparation for the 330
illustrations for *The
Nonsense Verse of Edward
Lear*, published in 1982
and republished in 2012, by
Jonathan Cape.

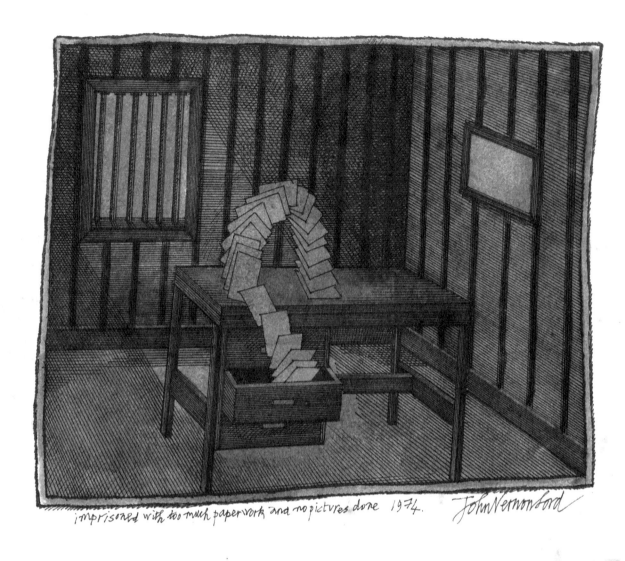

imprisoned with too much paperwork and no pictures done 1974. *John Vernon Lord*

Imprisoned with too much paperwork and no pictures done
Pen and ink

1974

This represents the time I had become Head of the Visual Communication Department at Brighton, when there was so much paperwork and meetings to attend. Hence the prison bars and the blank picture on the wall.

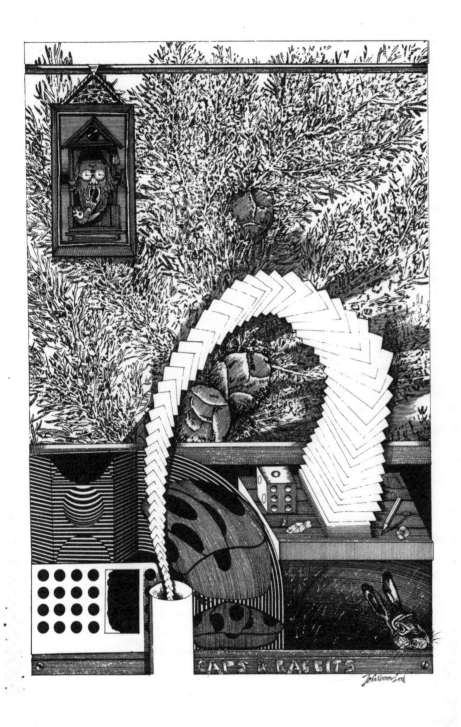

Caps and Rabbits
Pen and ink
1976

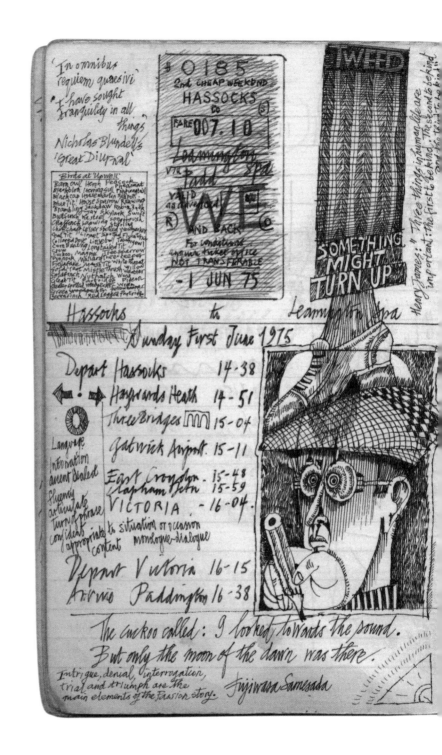

"In omnibus
requiem quaesivi"

"I have sought
tranquility in all
things"

Nicholas Blundell's
'Great Diurnal'

"Birds at Upwell"
Barn Owl Heron Pheasant
Blackbird Herring Gull Redwing Gull
Blackcap House Martin Redpoll
Blue Tit House Sparrow Reed Bunting
Brambling Jackdaw Robin Rook
Bullfinch Jay Skylark Swift
Chaffinch Kestrel Song Thrush
Chiff-chaff Lesser Spotted Woodpecker
Coal Tit Linnet Spotted Flycatcher
Collared Dove Little Owl Tawny Owl
Corn Bunting Long-tailed Tit
Cuckoo Magpie Tree Sparrow
Dunnock Mallard Tree Creeper
Fieldfare Marsh Tit White Throat
Goldfinch Mistle Thrush Willow Warbler
Goldcrest Nuthatch Wren
Great Tit Partridge Pigeon
Lesser Spotted Woodpecker Wheatear
Green Woodpecker Yellowhammer
Greenfinch Red Legged Partridge

$0185
2nd CHEAP WEEKEND
HASSOCKS
to
FARE 007.10
Leamington Spa
VIA Padd
VALID
AS INDICATED
R
AND BACK
For conditions
enquire ticket office
NOT TRANSFERABLE
-1 JUN 75

TWEED

SOMETHING
MIGHT
TURN UP

Henry James: "Three things in human life are
important; the first is to be kind;
the second is to be kind;
and the third is to be kind."

Hassocks to Leamington Spa

Sunday First June 1975

Depart Hassocks 14·38
Haywards Heath 14·51
Three Bridges [M] 15·04
Gatwick Airport 15·11
East Croydon 15·48
Clapham Jctn 15·59
VICTORIA -16·04

Language
Intonation
accent dialect
Fluency
articulate
turn of phrase
confident
appropriate to situation or occasion
content monologue-dialogue

Depart Victoria 16·15
Arrive Paddington 16·38

The cuckoo called: I looked towards the sound.
But only the moon of the dawn was there.

Intrigue, denial, interrogation,
trial and triumph are the
main elements of the Passion story. Fujiwara Samesada

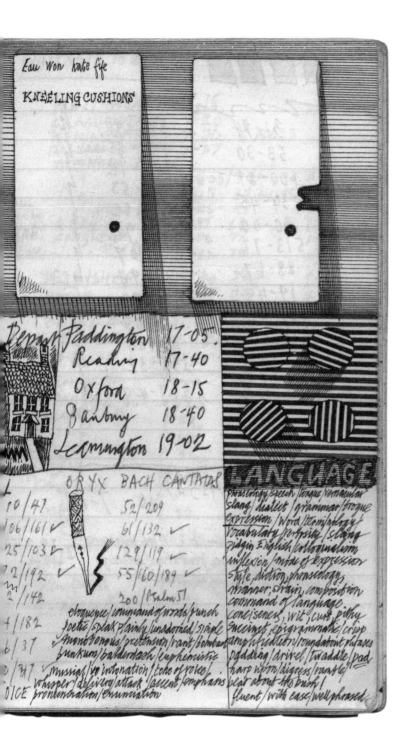

'In omnibus requiem quaesivi'
Pen and ink

1 June 1975

This includes a drawing of a rail ticket, which I used to do habitually at the beginning of most long train journeys in case I lost it. I would then have the evidence of having once owned such a ticket if I did lose it. One day I did indeed lose my ticket somehow and I showed the guard the drawing of the ticket as evidence. He was neither impressed nor amused, with the result that I had to buy a second ticket. Needless to say I don't draw tickets anymore!

The complete Latin sentence by Thomas à Kempis is: *"In omnibus requiem quaesivi, et nusquam inveni nisi in angulo cum libro"*, meaning: "Everywhere I have sought peace and not found it, except in a corner with a book. " Another translation is: "I have sought tranquillity in everything but found it nowhere except in a corner with a book."

**Hares, rabbits and
whisks**
Pen and ink
1975

King Henry VII

Pen, ink and pencil

1975

A trial drawing for a
prospective book about the
kings and queens of Britain.

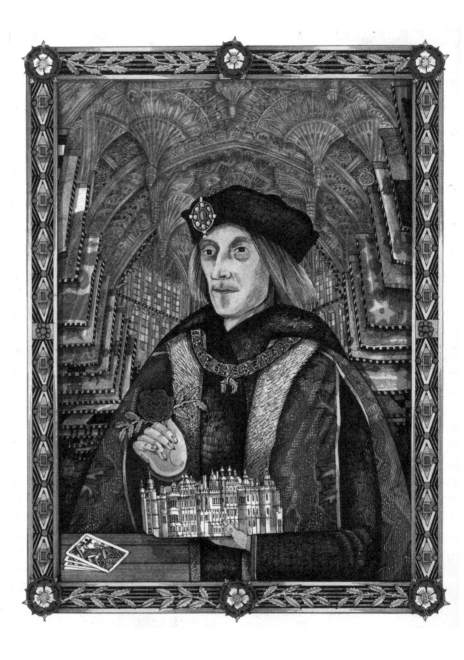

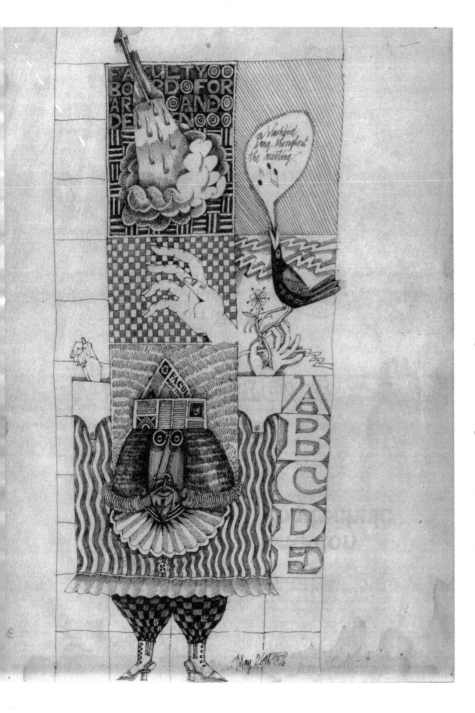

A blackbird sang throughout the meeting
Pen and ink

26 May 1976

A doodle carried out during a Faculty Board meeting at Brighton Polytechnic, during which a blackbird sang outside in the garden. I often tended to doodle during the frequent and endless committee meetings that I used to attend at Art College, Polytechnic and University. Many times I would think of the American Comedian Fred Allen's quote, that "a committee is a group of the unprepared, appointed by the unwilling to do the unnecessary". Another American comedian, Milton Berle, declared, "a committee is a group that keeps minutes and loses hours".

This doodle is in the collection of Ken Garland.

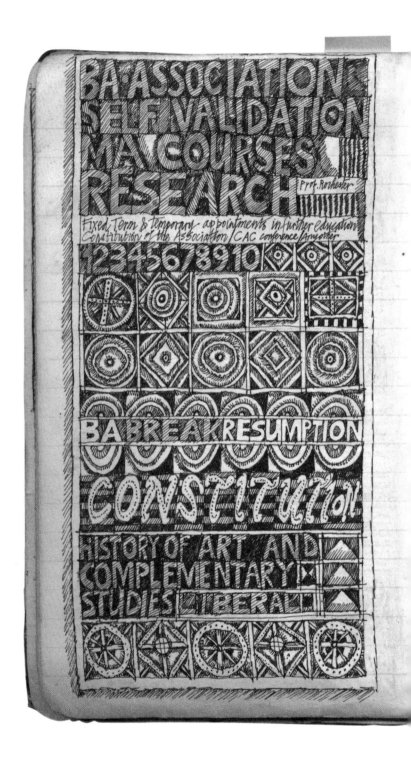

BA ASSOCIATION
SELF VALIDATION
MA COURSES &
RESEARCH

Prof. Rochester

Fixed Term & temporary appointments in further education
Constitution of the Association / CAC conference / Any other

1 2 3 4 5 6 7 8 9 10

BA BREAK RESUMPTION

CONSTITUTION

HISTORY OF ART AND
COMPLEMENTARY
STUDIES LIBERAL

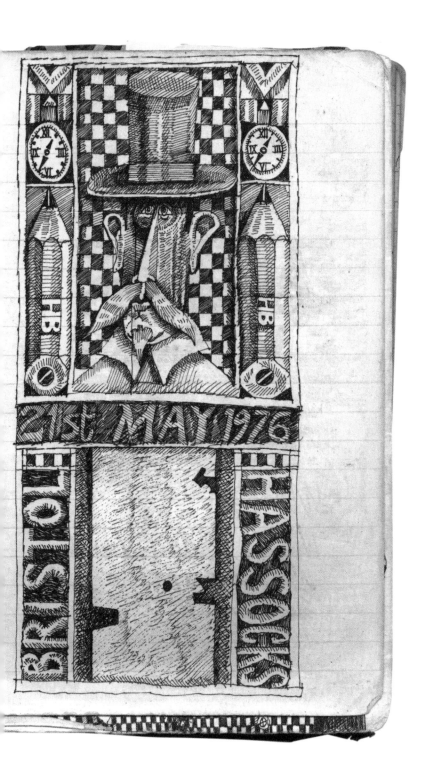

**BA Association/
Bristol/Hassocks**
Pen and ink
21 May 1976

133

Two Boxes in a Box

Pen and ink

1971

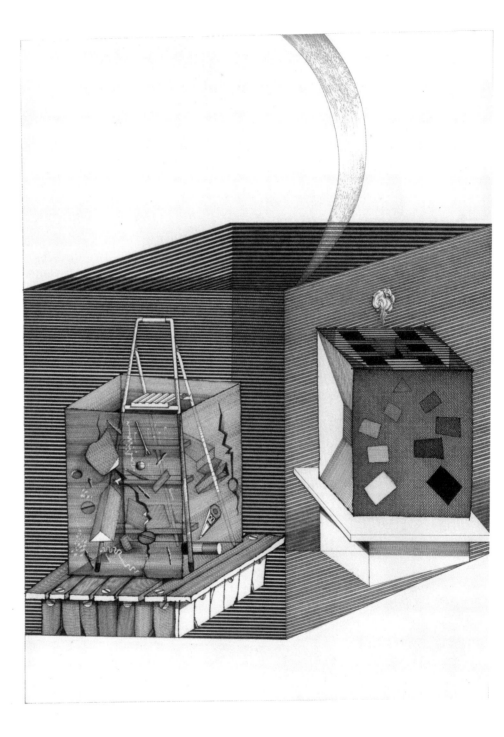

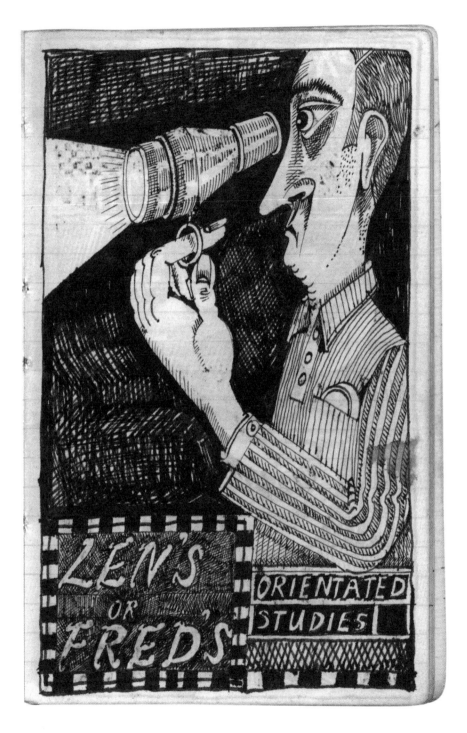

Len's or Fred's Orientated Studies
Pen and ink

1978

'Lens Orientated Studies' became a buzzword jargon for photography and filmmaking in the art schools of the 1970s.

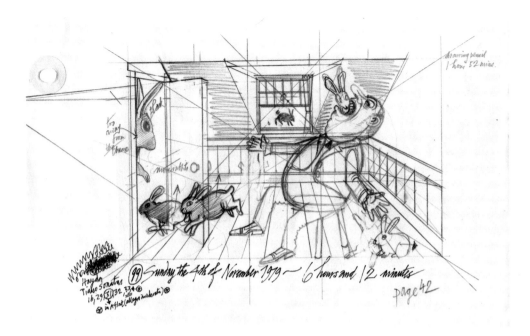

Rough drawing for the 'Old Person whose habits'
Pencil

4 November 1979

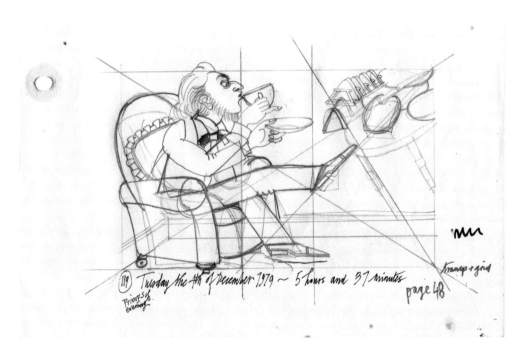

Rough drawing for the 'Old Man of the Dee'
Pencil

4 December 1979

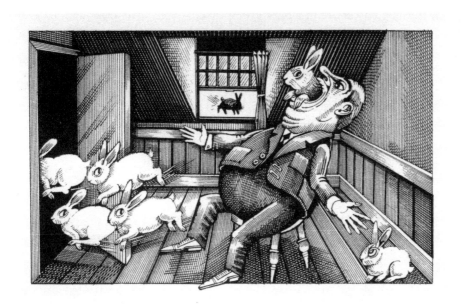

This illustration appears on page 42 in *The Nonsense Verse of Edward Lear*, published by Jonathan Cape in 1982 and republished in 2012. It took six hours and 12 minutes to draw.

Final drawing for the 'Old Person whose habits'
Pen and Ink

4 November 1979

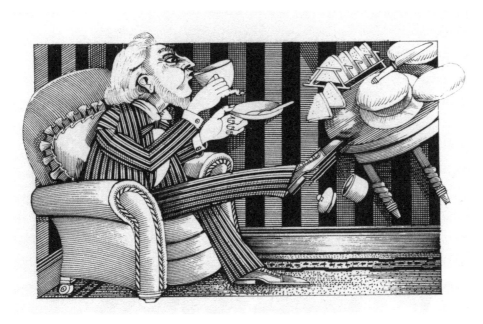

Another illustration from *The Nonsense Verse of Edward Lear* (on page 48) published by Jonathan Cape in 1982 and republished in 2012. It took five hours and 37 minutes to draw.

Final drawing for the 'Old Man of the Dee'
Pencil

4 December 1979

SAB	Drawing days	Drawing (SABBATICAL PERIOD)	DATE	TOTAL HOURS DAY	AGGREGATE ANNUAL HOURS TO DATE	PREP ⅘(166·07) 166·07	DRAW ⅘ (138·20)	SAB/M	
1	29	PREP + DRAW LEAR	SUN JULY 8 1979	PREP: 2:37 DRAW:	5:13	176:12	PREP TOWNS DRAW DUNLUCE		
2	30	DRAW LEAR (DUNLUCE)	MON JULY 9 1979	3:46	3:46	179:58	166·07	142·06	
3	31	DRAW LEAR (MESSINA) (ICKLEY)	TUE JULY 10 1979	3:34 8:52	7:26	187:24	166·07	149:32	
4	32	DRAW LEAR (BOULAK)	WED JULY 11 1979	2:56	2:56	190:20	166·07	152:28	
5	33	DRAW LEAR {BOULAK RYDE} 29	THUR JULY 12 1979	3:34 6:17	9:31	199:51	166·07	161:59	
6	34	DRAW LEAR (KAMSCHATKA)	FRI JULY 13 1979	5:59	5:59	205:50	166·07	167:58	
7	35	DRAW LEAR (LEGHORN)	MON JULY 16 1979	6:58	6:58	212:48	166·07	174:56	
8	36	DRAW LEAR (ANCONA)	TUE JULY 17 1979	7:15	7:15	220:03	166·07	182:11	8
9	37	DRAW LEAR {TREE 1 DUMFRIES}	THUR JULY 19 1979	7:01 3:14	10:15	230:18	166·07	192:26	9
10	38	DRAW LEAR {DUNDEE AOSTA}	MON JULY 23 1979	4:56 3:01	7:57	238:15	166·07	200:23	10
11	39	DRAW LEAR (AOSTA)	TUE JULY 24 1979	8:02 3:22	11:24	249:39	166·07	211:47	36 11
12	40	DRAW LEAR (BASING)	WED JULY 25 1979	7:52	6:12	255:51	166·07	217:59	
13	41	DRAW LEAR {BASING BEARD 2 BEARD 1}	THUR JULY 26 1979	6:12 1:12 1:50 1:47	8:49	264:40	166·07	226:48	14
14	42	DRAW LEAR (BEARD 1)	FRI JULY 27 1979	5:25	5:25	270:05	166·07	232:13	1
15	43	DRAW LEAR (TREE 2) (W.DUMPET)	SAT JULY 28 1979	4:27	4:27	274:32	166·07	236:40	
16	44	DRAW LEAR {TREE 2 CASSEL (4)}	SUN JULY 29 1979	3:04 1:13	7:17	281:49	166·07	243:57	16
17	45	DRAW LEAR (W.DUMPET)	MON JULY 30 1979	7:33 1:34	9:07	290:56	166·07	253:04	
18	46	DRAW LEAR (BATHE)	TUE JULY 31 1979	7:16	7:16	298:12	166·07	260:20	19
19	47	DRAW LEAR {DONG BONNET}	WED AUGUST 1 1979	7:10 1:22	8:32	306:44	166·07	268:52	20
20	48	DRAW LEAR {BONNET PRE-SIDE}	THUR AUGUST 2 1979	4:01 4:41	8:42	315:26	166·07	277:34	46 21
21	49	DRAW LEAR (HARE STITION)	MON AUGUST 6 1979	4:08	4:08	319:34	166·07	281:42	2
22	50	DRAW LEAR {LAU PEW}	TUE AUGUST 7 1979	2:16 5:26	7:42	327:16	166·07	289:24	2
23	51	DRAW LEAR (WEST) DUNWICH	WED AUGUST 8 1979	5:42	6:15	333:31	166·07	295:39	2
24	52	DRAW LEAR (BLACKHEATH)	THUR AUGUST 9 1979	3:23 3:33	8:53	337:24	166·07	299:34	2
25	53	DRAW LEAR (BUDE)	FRI AUGUST 10 1979	6:26	6:26	344:50	166·07	306:00	2
26	54	PREP LEAR	SAT AUGUST 11 1979	2:59	2:59	347:49	169:06	306:00	2
27	55	PREP LEAR	SUN AUGUST 12 1979	PREP 3:04	3:04	350:53	172:10	306:00	
28	56	PREP LEAR	MON AUGUST 13 1979	PREP 7:13	7:13	358:06	179:23	306:00	
29	57	PREP LEAR	16 AUG - 21 AUG (HOLIDAY)	PREP 9:01	HOL WEEK	367:07	188:24	306:00	
30	58	DRAW LEAR (SHEEN)	FRI AUGUST 24 1979	6:28	6:28	373:35	188:24	312:28	2
31	59	DRAW LEAR (TROY 2)	SAT AUGUST 25 1979	6:54	6:54	380:29	188:24	319:22	3
32	60	DRAW LEAR (TROY 1)	SUN AUGUST 26 1979	7:09	7:09	387:38	188:24	326:31	3
33	61	DRAW LEAR (COLUMBIA)	MON AUGUST 27 1979	6:04	6:04	393:42	188:24	332:35	3
34	62	DRAW LEAR (OWL)	THUR AUGUST 30 1979	3:57	3:57	397:39	188:24	336:34	
35	63	DRAW LEAR {OWL RHODES}	FRI AUGUST 31 1979	2:36 6:04	8:40	406:19	188:24	345:12	3
36	64	DRAW LEAR (TWICKENHAM)	SATURDAY SEPTEMBER 1 1979	4:43	4:43	411:02	188:24	349:55	3
37	65	DRAW LEAR (SMYRNA)	SUN SEPTEMBER 2 1979	6:41	6:41	417:43	188:24	356:36	3
38	66	DRAW LEAR (STATION)	MON SEPTEMBER 3 1979	6:34	6:34	424:17	188:24	363:10	3
39	67	DRAW LEAR WOKING SWEDEN	TUE SEPTEMBER 4 1979	2:54 4:19	7:13	431:30	188:24	370:23	38
40	68	DRAW LEAR SWEDEN JUNCTION	WED SEPTEMBER 5 1979	1:41 9:12	10:53	442:23	188:24	381:16	40
41	69	PREP LEAR	THUR SEPTEMBER 6 1979		5:36	447:59	194:00	381:16	
42	70	DRAW LEAR BLACK LAKE	FRI SEPTEMBER 7 1979	4:04 3:34	7:52	455:51	194:00	389:08	42
43	71	DRAW LEAR SAID HULL(68) PREP LEAR	SAT SEPTEMBER 8 1979	3:34 3:18 2:18	9:10	465:01	196:18	396:00	44
44	72	DRAW LEAR BUTE FLUTE	SUN SEPTEMBER 9 1979	4:41 3:50	8:31	473:32	196:18	404:31	4
45	73	DRAW LEAR CHIN WEILING (72) PREP LEAR	MON SEPTEMBER 10 1979	4:39 1:42 1:07	10:28	484:00	197:25	413:52	4
46	74	DRAW LEAR RYE	WED SEPTEMB 12 1979	3:58	3:58	487:58	197:25	417:50	49
47	75	DRAW LEAR WARE	THUR SEPTEMBER 13 1979	4:02	4:02	492:00	197:25	421:52	5
48	76	DRAW KNOTS	FRI SEPTEMBER 14 79		10:35	502:35	" " "	" " "	"
49	77	DRAW LEAR DESPAIR EALING	SUN SEPTEMBER 16 79	2:37 4:08	6:45	509:20	197:25	428:37	52
50	78	PREP LEAR	MON SEPTEMBER 17 79	5:39	5:39	514:59	203:04	428:37	52
51	79	DRAW LEAR (LETTER T)	WED SEPTEMBER 19 79	5:20	5:20	520:19	203:04	433:57	52
52	80	DRAW LEAR (LETTER O +)	THUR SEPTEMBER 20 79	9:21	9:21	529:40	203:04	443:18	52
53	81	DRAW LEAR (NEWRY)	TUE OCTOBER 2 79	5:13	5:13	534:53	203:04	448:31	52
54	82	DRAW LEAR {HENRY BANGOR}	WED OCTOBER 3 79	① 4:52 ② 4:31	6:23	541:16	203:04	454:54	53
55	83	DRAW LEAR (BANGOR)	SUN OCTOBER 7 79	1:32	1:32	542:48	203:04	456:26	54
56	84	DRAW LEAR STROUD SARK	MON OCTOBER 8 79	5:16 4:20	9:36	552:24	203:04	466:02	56
57	85	DRAW LEAR {CHORLEY WEST}	TUE OCTOBER 9 79	5:18 5:24	10:42	563:06	203:04	476:44	58
58	86	DRAW LEAR BRECON	WED OCTOBER 10 79	5:12 4:22	9:34	572:40	203:04	486:18	60
59	87	DRAW LEAR ELYTHE DISS PREP LEAR	THUR OCTOBER 11 79	3:44 2:23 PREP 2:09	8:25	581:05	205:12	492:35	62
60	88	DRAW LEAR WHERTLETLE BAB	FRI OCTOBER 12 79	3:36 3:34	6:10	587:15	205:12	498:45	64
61	89	DRAW LEAR CARLISLE RILEY	SUN OCTOBER 14 79	3:40 4:37	8:17	595:32	205:12	507:02	66
62	90	DRAW LEAR FRANCE ISCHIA	MON OCTOBER 15 79	4:36 3:16	7:52	603:24	205:12	514:54	68
63	91	PREP LEAR	WED OCTOBER 17 79	PREP 9:06	9:06	612:30	214:18	514:54	68
64	92	PREP LEAR	THUR OCTOBER 18 79	PREP 10:08	10:08	622:38	224:26	514:54 14:41	68

	Drawing	Date		Time	TOTAL HOURS DAY	AGGREGATE ANNUAL HOURS	PREP LEAR TODATE	DRAW LEAR TODATE	NO OF ILLUST	DURING SAB	OTHER
93	PREP LEAR	FRI 19 OCT	P.	5:26	5:26	628:04	229:52	514:54	92+2	68+2	
94	PREP LEAR	SAT 20 OCT	P.	8:16	8:16	636:20	238:08	514:54	92+2	68+2	
95	PREP LEAR / DRAW LEAR (SLOUGH)	SUN 21 OCT	P. / D	4:37 / 5:24	10:01	646:21	242:45	520:18	93+2	69+2	
96	PREP. LEAR	MON 22 OCT	P.	11:09	11:09	657:30	253:54	520:18	93+2	69+2	
97	DRAW LEAR (WHITEHALL)	TUE 23 OCT	D	6:37 / 5:40	12:17	669:47	259:34	526:55	93+2	70+2	
98	PREP LEAR	WED 24 OCT		9:23	9:23	679:10	268:57	526:55	93+2	70+2	
99	PREP LEAR	SAT 27 OCT	P	5:32	5:32	684:42	274:29	526:55	93+2	70+2	
100	PREP LEAR	SUN 28 OCT	P.	10:48	10:48	695:30	285:17	526:55	94+2	70+2	
101	DRAW LEAR (SKYE BORDER)	MON 29 OCT	D.	8:22	8:22	703:52	285:17	535:17	95+2	71+2	
102	DRAW LEAR (BORDER) / PREP LEAR	TUE 30 OCT	D / P	5:58 / 3:16	9:14	713:06	288:33	541:15	96+2	72+2	
103	DRAW LEAR (SOUTH)	WED 31 OCT		6:13	6:13	719:19	288:33	547:28	97+2	73+2	
104	PREP LEAR	THUR 1 NOV		4:25	4:25	723:44	292:58	547:28	97+2	73+2	
105	PREP LEAR	FRI 2 NOV		9:43	9:43	733:27	302:41	547:28	97+2	73+2	
106	DRAW LEAR (PUDDING)	SAT 3 NOV		6:38	6:38	740:05	302:41	554:06	98+2	74+2	
107	DRAW LEAR (HABITS)	SUN 4 NOV		6:12	6:12	746:17	302:41	560:18	99+2	75+2	
108	PREP LEAR	MON 5 NOV		3:35	3:35	749:52	306:16	"	"	"	
109	DRAW LEAR	WED 7 NOV		7:33	7:33	757:25	"	567:51	100+2	76+2	
110	DRAW LEAR (CALCUTTA) / PREP LEAR	THUR 8 NOV		7:45 / 3:52	11:37	769:02	310:08	575:36	101+2	77+2	
111	DRAW LEAR (NEPAUL)	FRI 9 NOV		7:59	7:59	777:01	"	583:35	102+2	78+2	
112	DRAW LEAR (MADRAS)	SAT 10 NOV		6:38	6:38	783:39	"	590:13	103+2	79+2	
113	DRAW LEAR (GONG)	SUN 11 NOV		7:33	7:33	791:12	"	597:46	104+2	80+2	
114	DRAW LEAR (KEW)	MON 12 NOV		6:42	6:42	797:57	"	604:28	105+2	81+2	
115	DRAW LEAR (GINGENTI) / PREP LEAR	TUE 13 NOV	D	7:15 / 3:10	10:25	809:22	313:18	611:43	106+2	82+2	
116	DRAW LEAR (CHILI)	WED 14 NOV	D	6:17	6:17	814:39	"	618:00	107+2	83+2	
117	DRAW LEAR (LEEDS) / PREP LEAR	FRI 16 NOV	D	5:01 / 2:20	7:21	822:00	315:38	623:01	108+2	84+2	
118	PREP LEAR / DRAW ELEPHANTELOPE	SAT 18 NOV	P / D	0:42 / 3:16	4:00	830:00	316:20	"	"	"	
119	DRAW ELEPHANTELOPE	MON 19 NOV		7:24	7:24	837:24	"	"	"	"	
120	DRAW LEAR (EMS)	TUE 20 NOV	P	6:34	6:34	843:58	316:20	629:35	109+2	85+2	+1
121	DRAW LEAR (NORTH)	WED 21 NOV	P	3:57	3:57	847:55	"	633:32	"	"	
122	DRAW LEAR (NORTH)	THUR 22 NOV	P	3:17	7:05	855:00	320:08	636:49	110+2	86+2	+1
123	DRAW LEAR (TURKEY) / DRAW LEAR (NICE)	FRI 23 NOV	P	4:00 / 4:37	8:37	863:37	320:08	645:26	112+2	88+2	+1
124	PREP LEAR	SAT 24 NOV		9:11	9:11	872:48	329:19	"	"	"	
125	DRAW LEAR (MARSH)	SUN 25 NOV		7:50	7:50	880:38	329:19	653:16	113+2	89+2	+1
126	DRAW LEAR (BRADLEY) / PREP LEAR	MON 26 NOV		6:00 / 3:12	9:12	889:50	332:31	659:16	114+2	90+2	+1
127	PREP LEAR	TUE 27 NOV		5:56	5:56	895:46	338:27	"	"	"	
128	DRAW LEAR (TYRE)	WED 28 NOV	D	7:50	7:50	903:36	"	667:06	115+2	91+2	+1
129	PREP LEAR	THUR 29 NOV		2:21	2:21	905:57	340:48	"	"	"	
130	DRAW LEAR (CHEAM)	FRI 30 NOV	D	6:04	6:04	912:01	340:48	673:07	116+2	92+2	+1
131	PREP LEAR / DRAW LEAR (ORLEANS)	SAT 1 DEC		4:35 / 6:01	10:36	922:37	345:23	679:08	117+2	93+2	+1
132	DRAW LEAR (VIENNA)	SUN 2 DEC	D	6:13	6:13	928:50	345:23	685:21	118+2	94+2	+1
133	DRAW LEAR (DEE 2)	TUE 4 DEC	D	5:37	5:37	934:27	345:23	690:58	119+2	95+2	+1
134	DRAW LEAR (HURST)	THUR 6 DEC	D	2:26	2:26	936:53	345:23	693:24	"		
135	DRAW LEAR (HURST)	FRI 7 DEC	D	1:33	1:33	938:26	345:23	694:57	"		
136	DRAW LEAR (HURST)	SAT 8 DEC	D	2:04	2:04	940:30	345:23	697:01	120+2	96+2	+1
137	DRAW LEAR (POOLE)	SUN 9 DEC	D	6:09	6:09	946:39	345:23	703:10	121+2	97+2	+1
138	DRAW LEAR (PINK)	FRI 14 DEC	D.	3:50	3:50	950:29	345:23	707:00	122+2	98+2	+1

Drawing

Timetable of drawing activity during a Sabbatical Period

Pen and ink

1979

Brighton Polytechnic granted me a six-month sabbatical period in 1979. The list of timings here shows that over the 178 total days of the six months I spent 110 days of them drawing and completing 101 illustrations in the total time of 707 hours. Including the time it took to carry out research for *The Nonsense Verse of Edward Lear*. The total time taken to work on the book during this period was 774 hours and 23 minutes!

The whole book involved writing an introduction, editing and indexing, as well as providing 330 illustrations. It took four years altogether to complete the work, taking 1,978 hours to draw, using 294 actual days to execute them. (For the record, it took me three minutes and 19 seconds to type out this caption using my two index fingers!)

1980s

In 1981 I relinquished the post of Head of Department of Visual Communication at Brighton Polytechnic but continued as a teacher of Illustration. However, I was often asked to continue taking on various Heads' jobs during my time in Brighton. I was appointed Chair of the CNAA Graphic Design Board in 1981 and I also served as a Member of the CNAA Committee for Art and Design until 1984. This activity involved me in over seventy validation events at art colleges, polytechnics and universities in the UK, Ireland and Hong Kong. In 1985 I spent a six month industrial secondment with London publishers, Mitchell Beazley. The task involved the interviewing of illustrators and artists' agents with their portfolios and building up a file of more than 500 illustrators' work. In 1986 I was appointed as a Member of the Secondary Examinations Council's Grade Criteria Working Party for the GCSE Examinations in Art and Design until 1987. In the same year I was appointed Professor of Illustration at Brighton Polytechnic. During the 1980s I worked on four books, creating a total of 691 black and white illustrations for them. Two of these books (which I also edited and introduced) were for Jonathan Cape: *The Nonsense Verse of Edward Lear* in 1984, and *Aesop's Fables*, retold in verse by James Michie in 1989 and winner of the WH Smith/V&A Illustration Award the following year. A book of my doodles and diaries was published by the Camberwell Press in 1986. I also illustrated a book of poetry for children, chosen by Ruth Craft, entitled *The Song that Sings the Bird*, which was published by Collins in 1989. In the middle of all this work, my studio in Ditchling was destroyed by a falling tree during the October 1987 hurricane. Thus, I had to work in a makeshift studio for quite some time.

I am an avid diarist and I have been keeping diaries and notebooks since I was a teenage art student at Salford in 1956. These early student diaries disappeared in mysterious circumstances (I strongly suspect that my stepmother destroyed them). Those that remain, scattered about my studio, contain not only drawings, sketches and doodles, but more than seven million words. The written diary entries are jottings which tend to

describe humdrum daily events. It should be noted, though, that the pages of diaries and notebooks included in this book have been selected for the images rather than the written entries. In many cases, when I read past entries, I am embarrassed by the triviality of what I have written but this does not stop me writing them. Keeping a diary has become such a habit that it seems impossible to cease writing in one.

Most of the diary and notebook drawings selected for inclusion in this book were drawn in Alwych Notebooks, with single pages measuring 102 × 162 mm (4 × 6.4 inches). Others are in Filofax Organisers, with punched holes and single pages measuring 95 × 172 mm (3.74 × 6.77 inches). I have been using these Alwych Notebooks and Filofaxes for more than 50 years.

My diary entries diminished during the 1970s but I resumed keeping a regular diary, on a day-to-day basis from the 7th of July 1979 up until the present day. Throughout the 1980s the diaries were handwritten with occasional drawings, such as the ones included in this chapter. I then abandoned the handwritten diary in 1992 in favour of typing the daily entries. The notebooks which start to appear in the 1990s chapter and later come over in this book as being similar to the diaries – they are like miniature sketchbooks. These have been kept up fairly consistently over the years and often include written material; notes and drawings are sometimes done on trains and as a passenger during car journeys, hence the wobbly writing in them. Some of the drawings are observations of family kitchens and gardens. They are mainly drawings done for their own sake, rather like exercising – to keep the fingers and brain nimble and to explore new technical ways of making images, a little, I suppose, like playing scales in different keys on a piano. Looking for fresh nuances in visual expression is always a preoccupation. So, in a way, many of these drawings represent ways of exploring. It is these 'off the cuff' drawings that the illustrator in me envies. Not because they are more freely drawn than my illustrations but because I am less worried about whether they work or not.

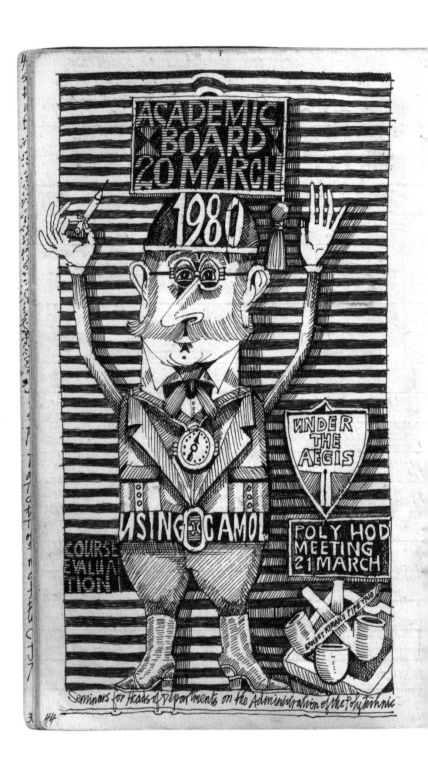

MISTY FORESTS, HEAVY OAKEN DOORS, MONOTONE DIALOGUE, KEYS+CHAINS, WILD COASTS & CLIFFS, BLACK CLOTHES, STONE STAIRCASES, COB WEBS, IRON BARS, CANDLE LIGHTS AND THE SMELL OF TALLOW, GRAVEYARDS, CASTLES, PICTURES, TAPESTRIES, PORTRAITS, BUSTS, CROSS-SWORDS, VAST LOG FIRES, HEAVY CURTAINS, 4 POSTER BEDS, LIBRARIES OF ANCIENT VOLUMES, VAST DINING TABLES WITH VAST GOBLETS AND SILVERWARE, VAULTS, STONE SLAB WALLS, DRIPPING DAMP WALLS, MARBLE SLABS, MALIGNANT ATMOSPHERE OF INFERNAL AIR AND MIASMA OF BARBARITY, STATUES, FAST MOVING CLOUDS ACROSS A MOONLIT SKY, FEARFUL TENSION, FLICKERING FLAMES, BALACLAVA-LIKE HOODS, BALUSTRADES, APPREHENSION, RINGS, SILVER DECANTERS, ENDLESS BROODINGS, DREAD, FORBODING, ARMOUR, CLOAKS, EXOTIC FRUIT BOWLS, ORIENTAL RUGS, OLD PISTOLS, TASSELS, THIS GROUNDLESS DREAD MUST BE PUT TO REST, RATS+SPIDERS, OWLS+BATS, LIGHTNING+THUNDER SHADOWS, CANDLE SNUFF, CREAKING DOORS+GRAVELLY FOOTSTEPS, ECHOING WITH HOLLOW SOUND, WROUGHT IRON, GRANDFATHER CLOCKS TICKING.

45

Academic Board

Pen and ink

20 March 1980

This diary drawing
was carried out during an
Academic Board meeting
at Brighton Polytechnic.

143

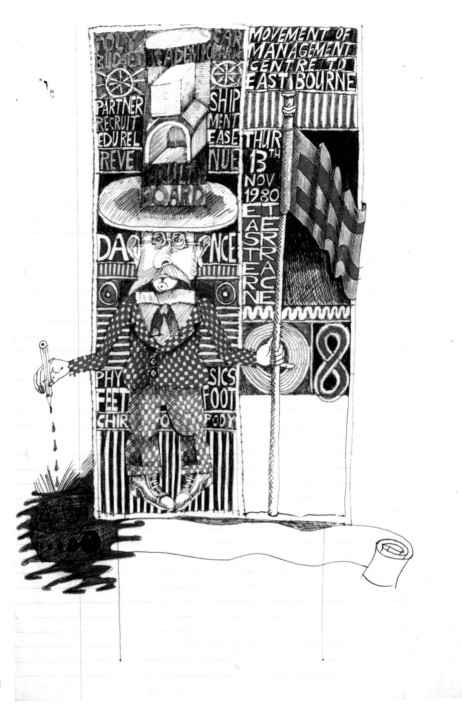

**Movement of
Management Centre
to Eastbourne**
Coloured biros

13 November 1980

A doodle carried out during
an Academic Board meeting
at Brighton Polytechnic.

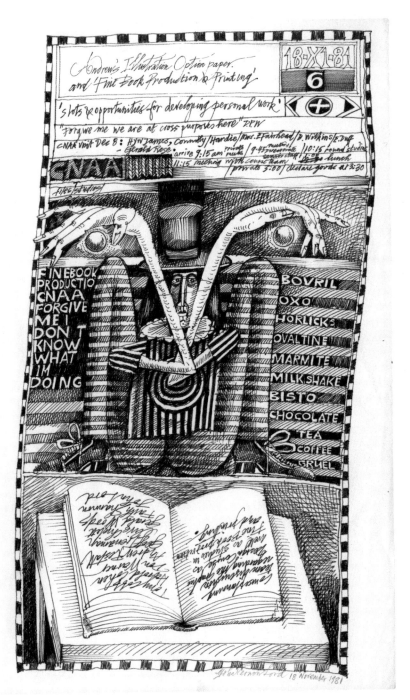

Andrew's Illustration Option paper

Pen and ink

18 November 1981

A doodle carried out during a Graphic Design course planning team meeting at Brighton Polytechnic.

'Selected Writings of the Ingenious Mrs. Aphra Behn'
Grove Press - New York - Selections from Aesop's Fables ↓

Aesop's Fables, with His Life
in English, French, and
Latin, by Francis Barlow.
London, 1687. "The
ingenious Mrs. A. Behn,"
says an introductory note,
"has been so obliging as to
perform the English poetry,
which in short comprehends
the sense of the fable and moral."

1. A maid whom a lion was adored
Consents to love, but first she him implored
To quit his nails and teeth;
the monarch yields,
Which done, with ease she her
fond lover kills.
Moral.
Almighty love assails with
powerful charms,
And both our prudence and
our strength disarms.

2. The satyr sees the clown whom cold assails
To heat his hands by breathing on his nails
Finding him blow his broth, the cause demands,
Cried he, That cools my broth, that warms my hands.

→ Moral.
The sycophant with the
same breath can praise
Each faction, and what's
uppermost obeys.

3. The hare and tortoise being to run a race
The hare first slept, depending on his pace.
The tortoise still crept on, with motion slow,
And won the victory from her swift-heeled foe.

Mean parts by industry have
luckier hits,
Than all the fancied power
of lazier wits.

4. The fox who lost her tail persuades the rest,
To bob their trains, as most commode, and best;
When one replied — we, more discreet, disdain
To buy convenience with public shame.

He that grave counsel for
your good pretends,
Fifty to one, promotes his
private ends.

5. Cupid and Death by dire mistake changed darts,
Death shot young flames into the aged hearts;
From Cupid's bow Death's fatal arrow flies
And when the youth should only languish, dies.

'Tis death to youth by age
to be embraced,
And winter's snow would June's
gay roses blast.

6. The lion, past his hunting youth, pretends
He's sick, and begs the visits of his friends
All but the fox obey, who thus bespake:
Footsteps to's den I find, but none turned back.

Of specious overtures
let all beware,
'Twas fair pretences
raised the Western War.

7. The ape implored the fox her bum would veil
With a proportion of his useless tail
But he replied — though me no good it do,
I will not spare an inch to favor you.

Thus the ill-natured rich
reserve their store,
And please themselves to see
their neighbours poor.

8. The mice consult how to preserve their fate
By timely notice of th' approaching cat.
We'll hang a bell about her neck, cried one;
A third replied — but who shall put it on?

Good counsel's easy given,
but the effect
Oft renders it uneasy
to transact.

• Fables of Aesop And other Eminent Mythologists with
Morals and Reflexions By Sir Roger L'Estrange, Kt.
LONDON, Printed for R. Sare, T. Sawbridge, B. Took, M. Gillyflower,
A. & J. Churchill, and J. Hindmarsh, 1692.

• Fables of Aesop And Others Newly done into English (by S. Croxall)
with an Application to each Fable. Illustrated with Cutts.
garrit aniles Ex re Fabellas ——— Hor.
LONDON: Printed for J. Tonson at Shakespear's Head
in the Strand, and J. Watts at the Printing-Office in
Wild Court, near Lincolns-Inn-Fields - MDCCXXII. (1722)

• Three Hundred Aesop's Fables Literally translated from the Greek
by the Rev. Geo. Fyler Townsend, M.A. Fully illustrated by
Harrison Weir. LONDON George Routledge and Sons, Limited
New York : E. P. Dutton & Co.

110

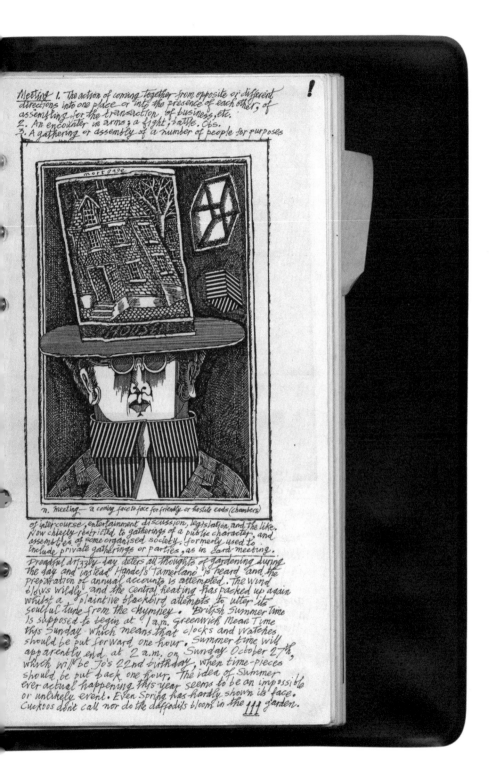

Meeting 1. The action of coming together from opposite or different directions into one place or into the presence of each other, of assembling for the transaction of business, etc.
2. An encounter in arms; a fight; battle. Obs.
3. A gathering or assembly of a number of people for purposes

n. meeting — a coming face to face for friendly or hostile ends (Chambers)

of intercourse, entertainment, discussion, legislation, and the like. Now chiefly restricted to gatherings of a public character, and assemblies of some organised society. Formerly used to include private gatherings or parties, as in card-meeting.

Dreadful drizzly day deters all thoughts of gardening during the day and instead Handel's 'Tamerlano' is heard and the preparation of annual accounts is attempted. The wind blows wildly and the central heating has packed up again whilst a plaintive blackbird attempts to utter its soulful tune from the chimney. British Summer Time is supposed to begin at 1 a.m. Greenwich Mean Time this Sunday which means that clocks and watches should be put forward one hour. Summer time will apparently end at 2 a.m. on Sunday, October 27th, which will be Jo's 22nd birthday, when time-pieces should be put back one hour. The idea of Summer ever actual happening this year seems to be an impossible or unlikely event. Even Spring has hardly shown its face. Cuckoos don't call nor do the daffodils bloom in the **111** garden.

Man with house inside his hat (mortgage worries)
Pen and ink
30 March 1985

147

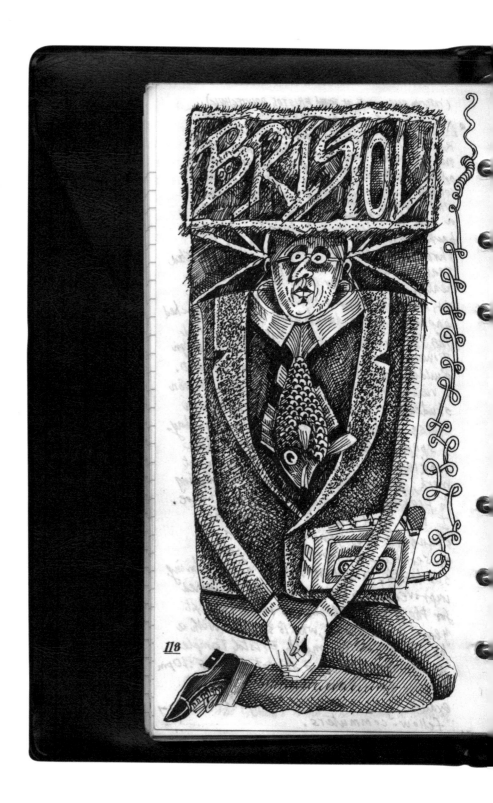

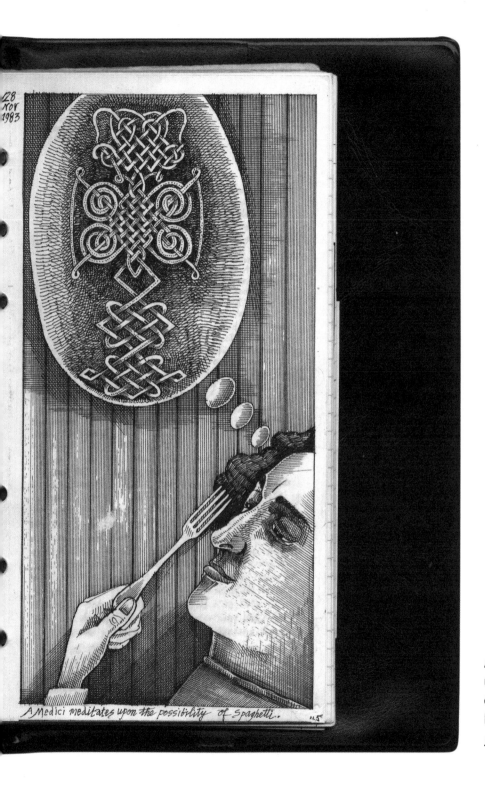

**A Medici meditates
upon the possibility
of spaghetti**
Pen and ink
28 November 1983

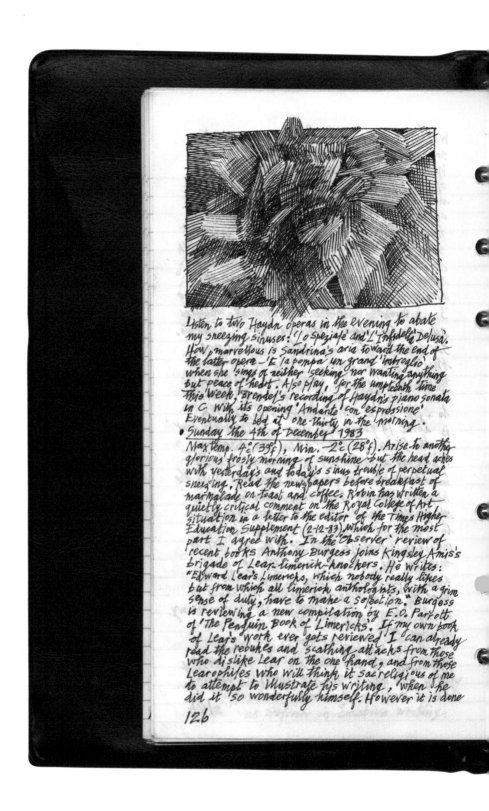

Listen to two Haydn operas in the evening to abate
my sneezing sinuses: 'Lo Speziale' and 'L'Infidelta Delusa'.
How marvellous is Sandrina's aria toward the end of
the latter opera —'E la pompa un grand'imbroglio'
when she sings of neither seeking nor wanting anything
but peace of heart. Also play, for the umpteenth time
this week, Brendel's recording of Haydn's piano sonata
in C with its opening 'Andante con espressione'.
Eventually to bed at one-thirty in the morning.

• Sunday the 4th of December 1983

Max temp. 4°c (39°f), Min. −2°c (28°f). Arise to another
glorious frosty morning of sunshine —but the head aches
with yesterday's and today's sinus trouble of perpetual
sneezing. Read the newspapers before breakfast of
marmalade on toast and coffee. Robin has written a
quietly critical comment on the Royal College of Art
situation in a letter to the editor of the Times Higher
Education Supplement (2-12-83) which for the most
part I agree with. In the 'Observer' review of
recent books Anthony Burgess joins Kingsley Amis's
brigade of Lear-limerick-knockers. He writes:
"Edward Lear's Limericks, which nobody really likes
but from which all limerick anthologists, with a grim
sense of duty, have to make a selection." Burgess
is reviewing a new compilation by E.O. Parrott
of 'The Penguin Book of Limericks'. If my own book
of Lear's work ever gets reviewed I can already
read the rebukes and scathing attacks from those
who dislike Lear on the one hand, and from those
Learophiles who will think it sacreligious of me
to attempt to illustrate his writing, when he
did it so wonderfully himself. However it is done

126

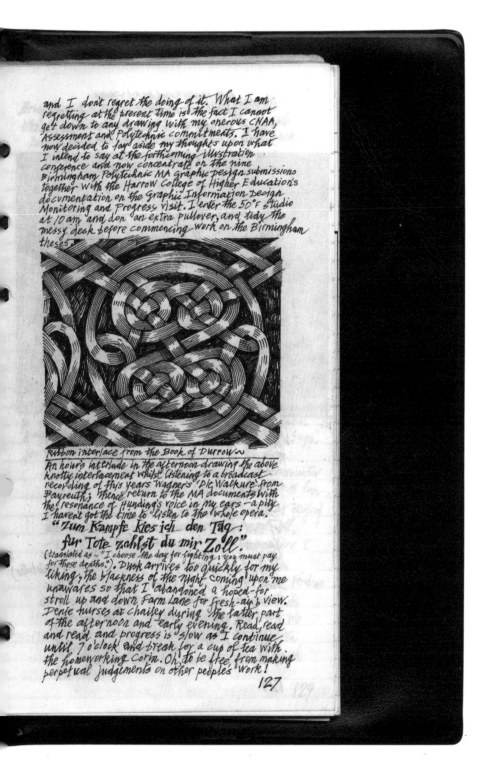

and I don't regret the doing of it. What I am regretting at the present time is the fact I cannot get down to any drawing with my onerous CNAA, Assessment and Polytechnic commitments. I have now decided to lay aside my thoughts upon what I intend to say at the forthcoming illustration conference and now concentrate on the nine Birmingham Polytechnic MA Graphic Design submissions together with the Harrow College of Higher Education's documentation on the Graphic Information Design Monitoring and Progress visit. I enter the 50°F studio at 10 am and don an extra pullover, and tidy the messy desk before commencing work on the Birmingham theses.

Ribbon interlace from the Book of Durrow~

An hour's interlude in the afternoon drawing the above knotty interlacement whilst listening to a broadcast recording of this year's Wagner's 'Die Walküre' from Bayreuth; thence return to the MA documents with the resonance of Hunding's voice in my ears – a pity I haven't got the time to listen to the whole opera.

"Zum Kampfe kies ich den Tag:
 für Tote zahlst du mir Zoll."

(translated as – "I choose the day for fighting: you must pay for those deaths."). Dusk arrives too quickly for my liking, the blackness of the night coming upon me unawares so that I abandoned a hoped-for stroll up and down Farm Lane for fresh-air & view. Denise nurses at Chailey during the latter part of the afternoon and early evening. Read, read and read and progress is slow as I continue until 7 o'clock and break for a cup of tea with the homeworking Corin. Oh, to be free from making perpetual judgements on other people's work!

127

Ribbon interlacement drawing from the Book of Durrow
Pen and ink

4 December 1983

stiff sunrise and silhoutted pine-trees of zero degrees.
Belling belches out heat and the radio intones 'music'.
Regiments of pencils and divers writing instruments
stand to attention polychromatically in various containers.
Metallic glint of Mundial scissors and Swann and Morton
number 4 surgical scalpel knife. Upon the blue plastic
covering of the nineteenth century mahogany desk rest
multifarious objects: the Tasco illuminated microscope
made in Hong Kong, an 'Engine Divided' six-inch ruler,
Scotch 'pressure-sensitive' tape, a Stabilo fluorescent
boss for highlighting passages of text, a Berol colourpen
and 'O·5mm Pentel propelling pencil, the Little Oxford
Dictionary, heaps of letters and envellopes, Erika
portable typewriter; The angle-poise lamp shines upon
CNAA agenda papers for the next Committee for Art &
Design meeting. Surrounded by shelves and drawers.
Upon the topmost bookshelf, upon the western side, reside
a collection of kitsch canines – Briggsian gifts over the
years. Dangling cups, torches, fir cones, children's
papier-mâché masks, rope, fly-swat, wrist-bands
and New York carrier-bags. Hanging black and yellow
blazer of thirty years the wearing. The northern shelves
of cassettes rise above the telephone desk which supports
honesty-seed stems, garden secateurs, Liz Kneen drawing,
garden gloves, parrafin or paraffin (rather) lamp.

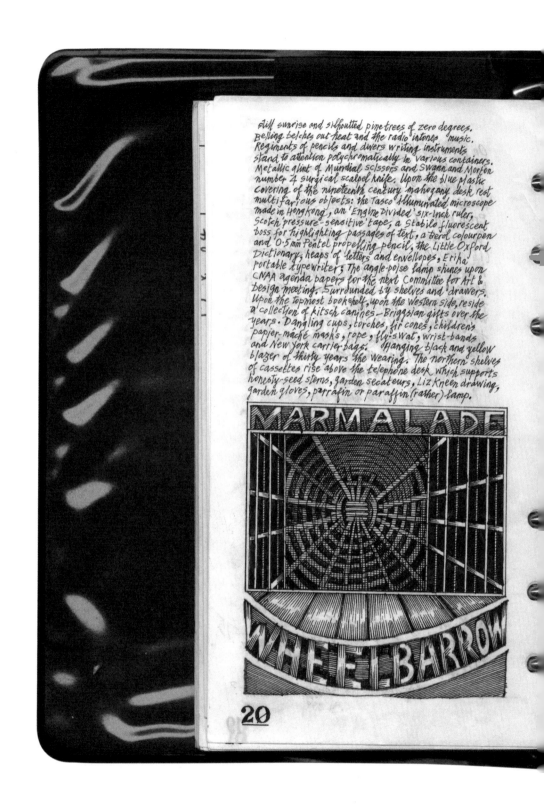

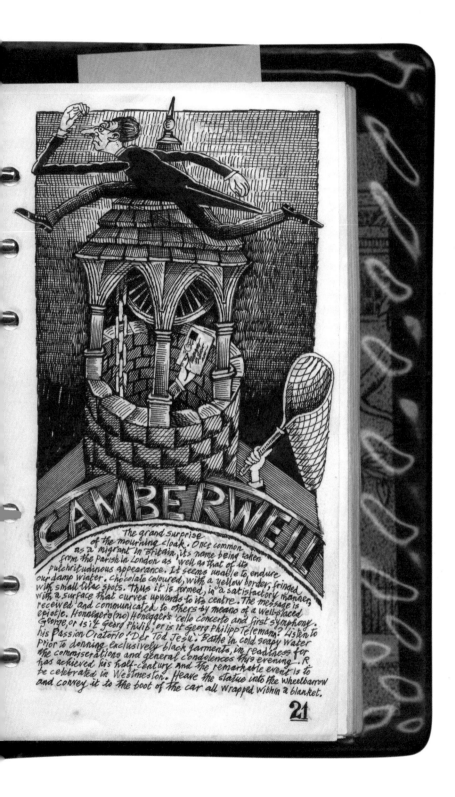

**Marmalade,
wheelbarrow,
Camberwell**
Pen and ink

21 January 1984

Another session of Bach cantatas, starting with the Wedding Cantata No 196 'Der Herr denket an uns' which is an early Mulhausen one and is a relatively indifferent composition as far as my ears are concerned. And so to the 75th with the magnificent trumpet-singing chorale in the Sinfonia beginning part two, and that warm, nostalgic-feeling chorale sung by the choir with strings & oboes at the end of part one. Trumpets resound at the beginning of Cantata number 1 - a great chorus. A splendid day-of-judgement rattling recitative from the bass comes in 9, whilst the trumpet intones the Advent chorale tune. This is followed by a gently consoling melody by way of contrast, only to be interrupted by another wild outburst. Horns begin the introduction to No 70 - a cantata which Whittaker thought was perfect in every way — and so it is. Splendid 'hellish serpent' aria by the bass and the strangely thrilling tenor aria with horns and oboes. Siegmund Nimsgern and Adalbert Kraus are on top form with these arias in the recording. Next the 'De Profundis' first Mulhausen cantata 'Aus der Tiefe' No. 131, which I have a soft spot for. Cantata 149 includes the beautiful soprano aria 'Gottes Engel'.

Looking through Moxon's illustrated volume of Tennyson's poems I discover that not only does the staircase in Sendak's 'Higglety Pigglety Pop' have a striking resemblance to Millais' illustration to St. Agnes Eve, but also Edward Gorey's work is not unlike the Millais' illustration to 'The sisters'. In the Moxon 'The Death of the Old Year' by Millais and Rossetti's 'St. Cecilia' do not seem to relate to the text.

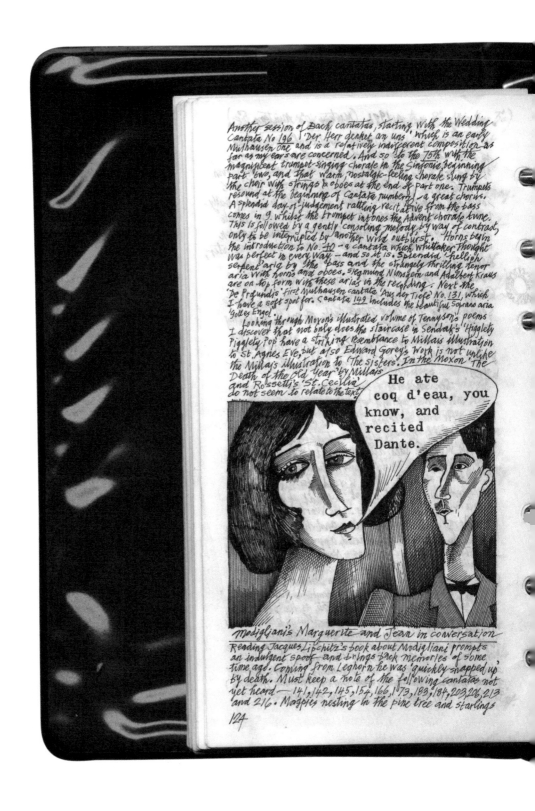

Modigliani's Marguerite and Jean in conversation

Reading Jacques Lipchitz's book about Modigliani prompts an indulgent spoof and brings back memories of some time ago. Coming from Leghorn he was 'quickly snapped up' by death. Must keep a note of the following cantatas not yet heard — 141, 142, 145, 154, 166, 173, 183, 184, 203, 206, 213 and 216. Magpies nesting in the pine tree and starlings

124

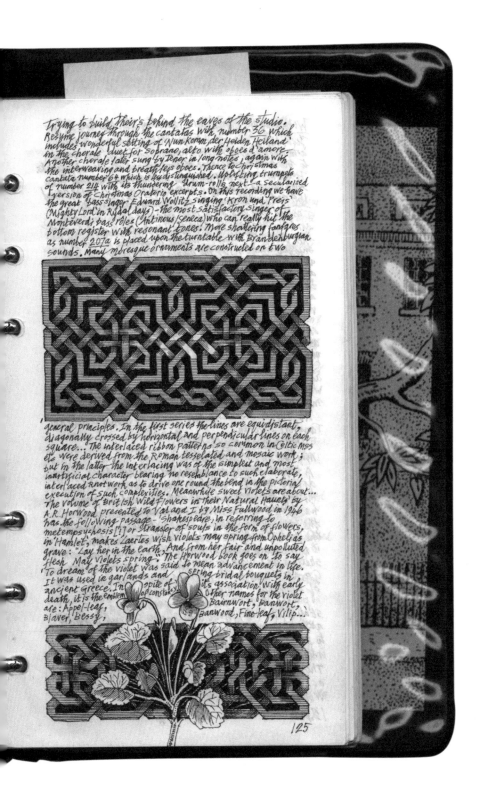

Trying to build their's behind the eaves of the studio.
Resume journey through the cantatas with number 36 which
includes wonderful setting of 'Nun Komm der Heiden Heiland'
in the chorale. Duet for soprano, alto with oboes d'amore.
Another chorale later sung by tenor in long notes, again with
the interweaving and breathless oboes. Thence to christmas
cantata number 64 which is distinguished. Uplifting trumpets
of number 214 with its thundering drum-rolls next - a secularised
version of Christmas Oratorio excerpts. On this recording we have
the great bass-singer Edward Wollitz singing 'Kron und Preis'
(Mighty Lord in Rigdal days) - the most satisfactory singer of
Monteverdi bass rôles (Antinous/Seneca) who can really hit the
bottom register with resonant tones. More shattering fanfares
as number 207a is placed upon the turntable with Brandenburgian
sounds. Many moresque ornaments are constructed on two

general principles. In the first series the lines are equidistant,
diagonally crossed by horizontal and perpendicular lines on each
square... The interlaced ribbon patterns 'so common in Celtic MSS
etc were derived from the Roman tesselated and mosaic work;
but in the latter the interlacing was of the simplest and most
inartificial character bearing no resemblance to such elaborate
interlaced knotwork as to drive one round the bend in the pictorial
execution of such complexities. Meanwhile sweet violets are about...
The volume of British Wild Flowers in their Natural Haunts' by
A.R. Horwood presented to Val and I by Miss Fullwood in 1946
has the following passage - 'Shakespeare, in referring to
metempsychosis [?] or transfer of souls in the form of flowers,
in 'Hamlet', makes Laertes wish violets may spring from Ophelia's
grave: "Lay her in the earth, And from her fair and unpolluted
flesh May Violets spring." The Horwood book goes on to say
'To dream of the violet was said to mean advancement in life.
It was used in garlands and spring bridal bouquets in
ancient Greece. In spite of its association with early
death, it is the emblem of constancy. Other names for the violet
are: Appel-leaf, Bairnwort, Banwort,
Blaver, Bessy, Banwood, Fine-leaf, Vilip...

125

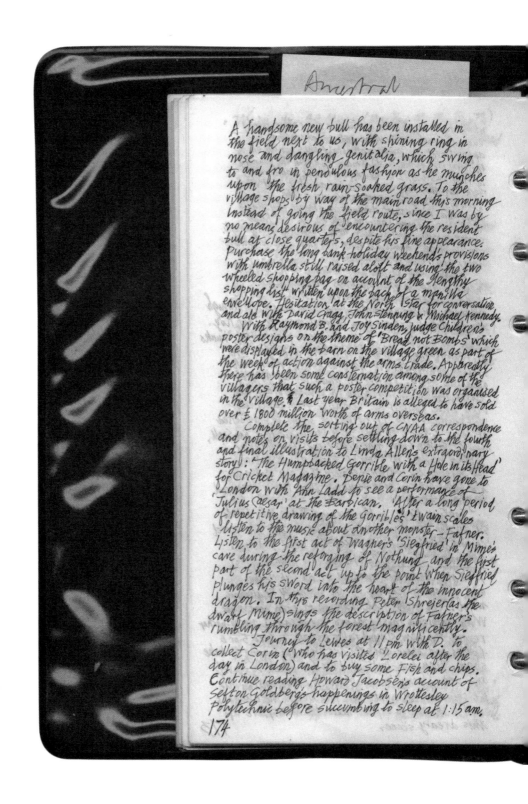

A handsome new bull has been installed in the field next to us, with shining ring in nose and dangling genitalia, which swing to and fro in pendulous fashion as he munches upon the fresh rain-soaked grass. To the village shops by way of the main road this morning instead of going the field route, since I was by no means desirous of encountering the resident bull at close quarters, despite his fine appearance. Purchase the long bank holiday weekend's provisions with umbrella still raised aloft and using the two wheeled shopping bag on account of the lengthy shopping list written upon the back of a manilla envelope. Hesitation at the North Star for conversation and ale with David Cragg, John Stenning & Michael Kennedy.

With Raymond B. and Joy Sinden, judge children's poster designs on the theme of 'Bread not Bombs' which were displayed in the barn on the village green as part of the week of action against the arms trade. Apparently there has been some consternation among some of the villagers that such a poster competition was organised in the village. Last year Britain is alleged to have sold over £1800 million worth of arms overseas.

Complete the sorting out of CNAA correspondence and notes on visits before settling down to the fourth and final illustration to Linda Allen's extraordinary story: 'The Humpbacked Gorrible with a Hole in its Head' for Cricket Magazine. Denise and Corin have gone to London with Ann Ladd to see a performance of 'Julius Caesar' at the Barbican. After a long period of repetitive drawing of the Gorribles' twain scales listen to the music about another monster – Fafner. Listen to the first act of Wagner's 'Siegfried' in Mime's cave during the reforging of Nothung and the first part of the second act up to the point when Siegfried plunges his sword into the heart of the innocent dragon. In this recording Peter Shreier (as the dwarf Mime) sings the description of Fafner's rumbling through the forest magnificently.

Journey to Lewes at 11pm with D. to collect Corin (who has visited Lorelei after the day in London) and to buy some fish and chips. Continue reading Howard Jacobson's account of Sefton Goldberg's happenings in Wrottesley Polytechnic before succumbing to sleep at 1:15am.

174

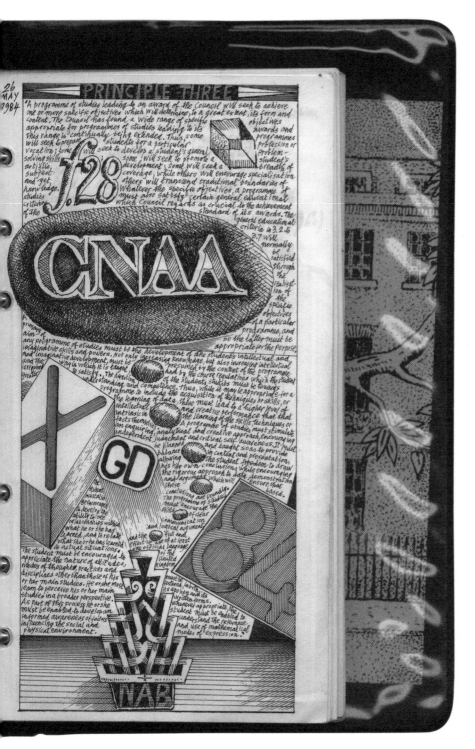

CNAA Principle Three
Pen and ink

26 May 1984

The Council for National Academic Award's Committee for Art and Design spent some considerable time giving attention to the implementation of its Principle 3, which was concerned with the overall balance and aims of programmes of study in undergraduate courses. I was on a Working Party of the Committee that looked into the relevance of this principle to courses in Art and Design. Hence, I wrote out the principle here in full as a way of getting it into my brain, believing that writing such things out often aids memory. It was an educational principle that was keen to make sure that students perceived their studies within a broad perspective and to appreciate disciplines other than their own, as well as avoiding narrow specialism.

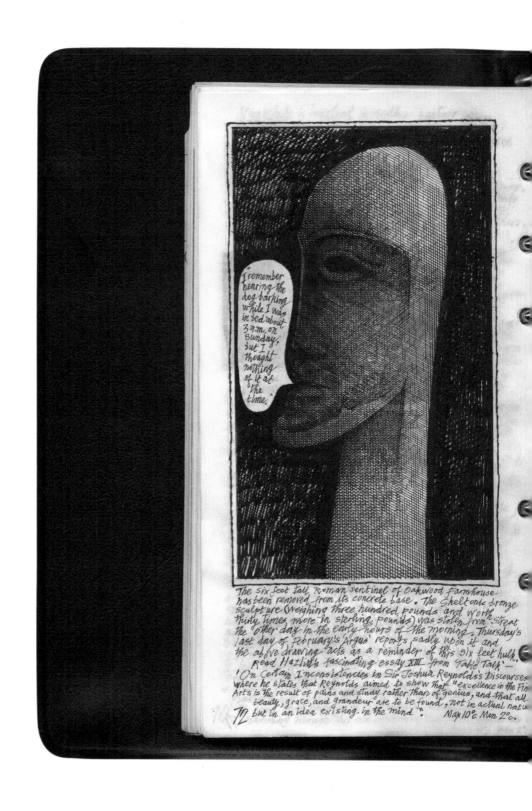

The six feet tall, Roman sentinel of Oakwood Farmhouse
has been removed, from its concrete base. The Skeltonic bronze
sculpture (weighing three hundred pounds and worth
thirty times more in sterling pounds) was stolen from street
the other day in the early hours of the morning. Thursday's
last day of February's 'Argus' reports sadly upon it and
the above drawing acts as a reminder of this six feet hulk.
 Read Hazlitt's fascinating essay XIII from 'Table Talk'—
'On Certain Inconsistencies in Sir Joshua Reynolds's Discourses'
where he states that Reynolds aimed to show that "excellence in the Fine
Arts is the result of pains and study rather than of genius, and that all
 beauty, grace, and grandeur are to be found, not in actual nature
 but in an idea existing in the mind". Max 10°c Min 2°c.

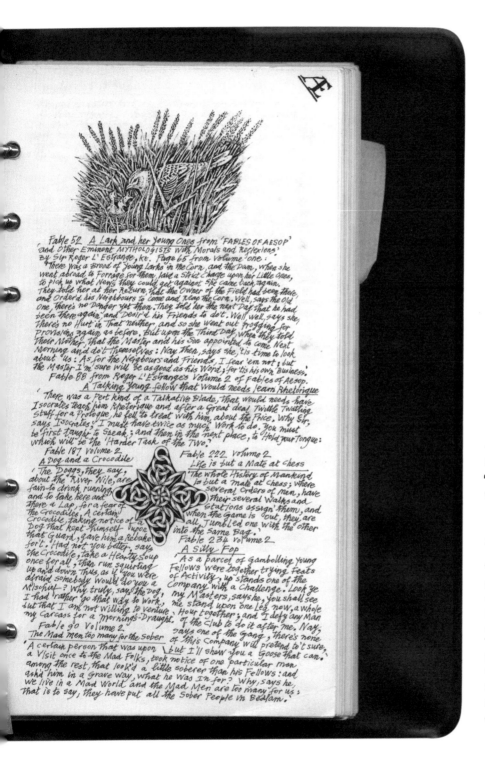

John Skelton's sculpture and 'The Lark and her Young Ones'

Pen and ink

28 February 1987

This is a drawing of a sculpture by John Skelton, which was stolen from his home in Streat in the early hours of the morning. The illustration of 'The Lark and her Young Ones' was photocopied from my illustration in *Aesop's Fables*, published by Jonathan Cape in 1989.

'Preferring to discuss the heap of sugar cubes'
Pen and ink

11 April 1983

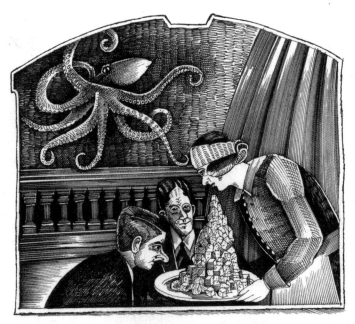

Preferring to discuss the heap of sugar cubes with the waitress, they chose to ignore the octopus which was dancing more than elegantly upon the bannisters. It is known that these particular molluscs are of solitary inclination when they reach adulthood; abandoning their herd-like instinct when young. It was therefore gratifying to think that this creature was prepared to forgo its solitary habit and it was distinctly pleasing for the two young men to talk sugar with the waitress.

Vessels
Pen and ink

ca. 1985

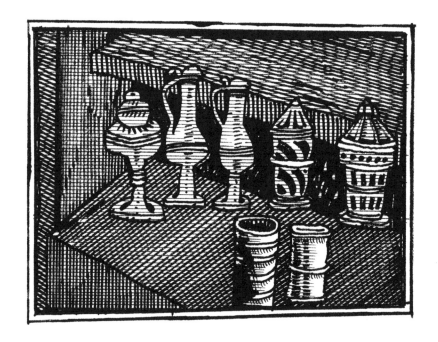

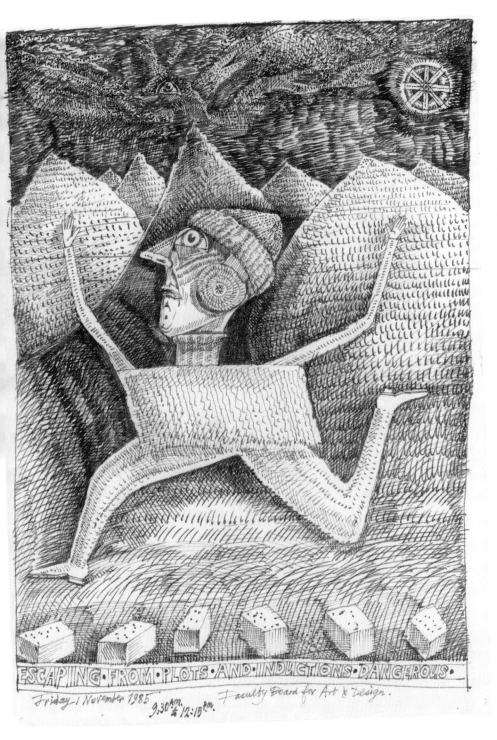

**Escaping
from
plots and
inductions
dangerous**
Pen and ink

1 November 1985

A doodle carried out at
a meeting of the Faculty
Board for Art, Design &
Humanities at Brighton
Polytechnic.

In the Aldrich collection at
the University of Brighton.

ESCAPING · FROM · PLOTS · AND · INDUCTIONS · DANGEROUS ·

Friday 1 November 1985 9.30ᵃᵐ to 12:15ᵖᵐ. Faculty Board for Art & Design.

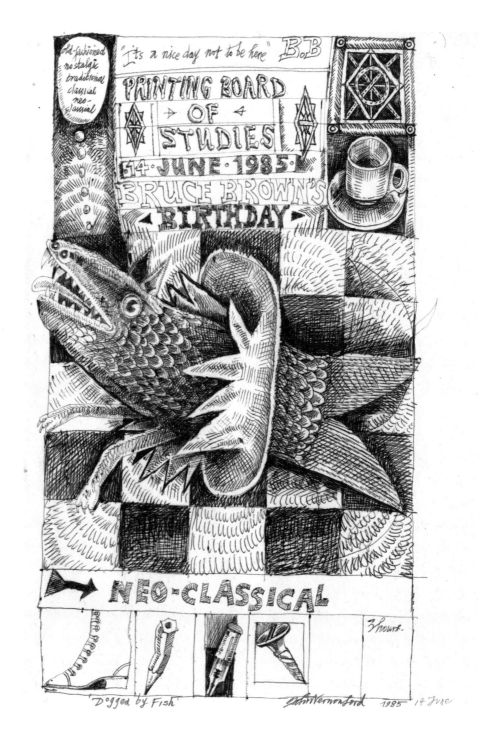

It's a nice day not to be here

Pen and ink

14 June 1985

This doodle was drawn during a Printing Board of Studies meeting at Brighton Polytechnic.

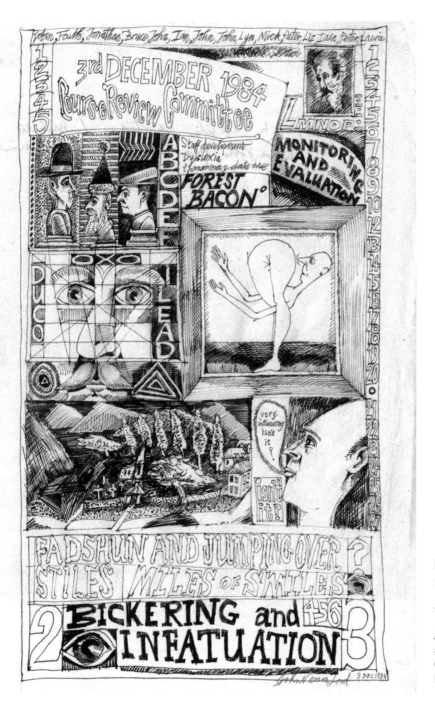

Man smelling himself
Pen and ink

3 December 1984

A doodle carried out during
a Faculty Course Review
Committee meeting at
Brighton Polytechnic.

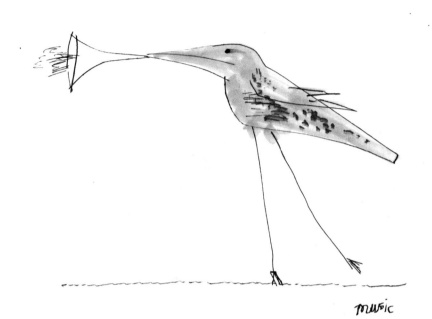

music

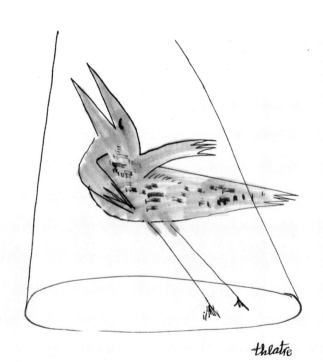

théâtre

164

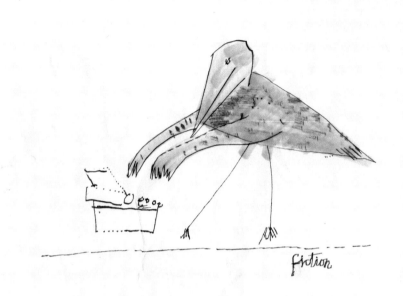

fiction

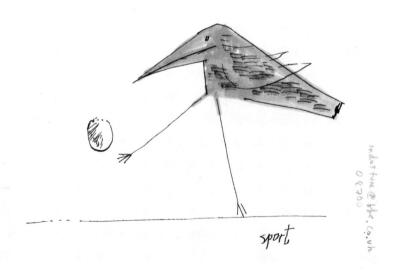

sport

**Four Green birds:
Fiction, Music,
Sport and Theatre**
Pen, ink and felt pen

ca. 1985

Fine Art
Examination Board
Pen and ink

20 June 1986

Another doodle
drawn during a Fine Art
Examination Board meeting
at Brighton Polytechnic.

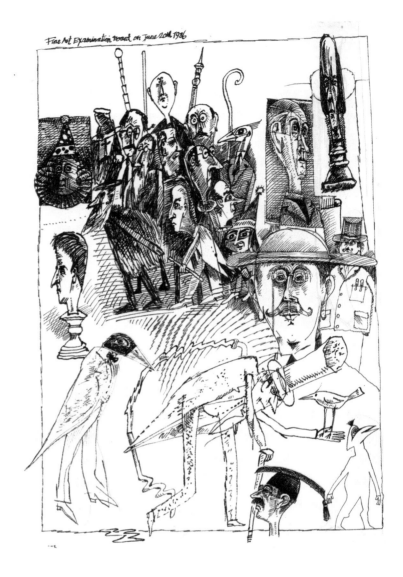

Man and snake
looking at a pyramid
Pen and ink

20 June 1986

A doodle carried out
during a Fine Art
Examination Board meeting
at Brighton Polytechnic.

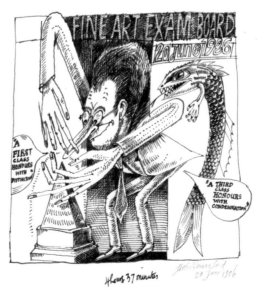

I have to leave the meeting at quarter to four to catch the 4.03 train at Brighton station to Victoria, thence to South Kensington and walk to the Royal College of Art at Kensington Gore, arriving there at 5.45. Quentin Blake greets me at the top of the lift, then we meet Martin West of Kestrel/Penguin Books and Ian Craig who is Design Director of Jonathan Cape. We talk about the imminent forum which is scheduled to start at 6.30. The forum was organised by The Children's Book Circle, which is an informal association of children's book editors and publishers and all those concerned with children's books — agents, librarians and booksellers. It was founded in 1962. The theme of the forum was the "hoary old chestnut" – "DOES TEACHING IN ART COLLEGES PROVIDE A SATISFACTORY OR SUFFICIENT BASIS FOR THE PUBLICATION OF CHILDREN'S ILLUSTRATED BOOKS? Quentin was chairman, Ian spoke on behalf of the publishers and I spoke on behalf of the teachers and illustrators. It went off far better than I expected though, as usual, I was somewhat intimidated by having to address over one hundred people (in the business) in the senior common room of the Royal College of Art. Plenty of splashings of cold Liebfraumilch benevolently supplied by Martin West gave me the confidence to cope with it all. As is always on this topic, one heard the same old comments coming forth from the floor and no truly fresh statement was made. It was good to see good old friends like Valerie Kettley, Enid Fairhead, Quentin, Ian, Martin, Faith Jacques, Fiona French, Susan Einzig, Fritz Wegner, Mike Forman, Gerald Rose et al. Fritz kindly gave me a lift in his car to Victoria Station in time to catch the 9:08 pm train to Brighton and as I arrived into Brighton I stepped on to a train bound for Hassocks on the adjacent platform just as it was departing. At Hassocks, straight into a Taxi to Upwell arriving there at precisely 10:20 – which is astonishing considering I journeyed via Brighton and the rail strikes were scheduled for 10 o'clock. A quick herb omelette when I arrive home followed by a chat with D & the girls by the log fire. A little fall of snow was on the ground in the garden. Listen to a recording of Musica Reservata, of Music from the time of Boccaccio and then go to blessed bed and read until 1:30 am a fascinating book "The People's England" by Alan Ereira — which traces the experience of specific groups of working people from the advent of the enclosures to the present day. ie it's about labourers, servants, shopkeepers, miners, factory workers, soldiers, sailors and immigrants etcetera —

41

• Thursday 18th February and Friday 19th February were busy days of teaching, Friday ending up with a finely articulated lecture by Justin Todd who talks about the development of his own magnificently wrought work. Tony C, Raymond P. and I conclude the weekend by partaking of drink & sausage at the Bull.

• Saturday 20th February: Today I purchase a superb desk of solid mahogany, replete with three drawers and two cupboards. The desk used to be a clerk's desk in Victorian times and came recently from Hanover Terrace in Brighton, and previous to that it was lodged in a solicitor's office in London. It has the following dimensions: 8 feet long x 2 feet six inches deep and 2 feet 8 inches high. I bought it from John Bird for one hundred and sixty pounds and most of the day was spent making room for it in the studio. In the evening we entertain the Cobbs and Stricklands to a supper of avocado pear, chicken cooked in lemon, olive oil, onions & garlic, followed by trifle. Easy and relaxed people ~ concluding the evening at 2 in the morn.

• Sunday 21 February. Prolonged breakfast with the Stricklands (Joan, David & Jake, who stay overnight) followed by a walk in dazzling sunshine and frosty temperatures. Thence D & I go to Isfield to have lunch with the Brophys; a delightful afternoon with Michael being in great form. How lazy I've been this weekend.

• Monday 22nd February. Continue to sort out the studio now that the new desk is installed. The afternoon & evening are spent preparing our annual accounts for my accountants — Lawrence Drizen & Co. — A tedious exercise in the extreme, which takes me well into the mid of an extremely cold night.

• Tuesday 23rd February: An enjoyable day of tutorials. No 173 bus back to Ditchling from Brighton now costs ninety-five pence. A couple of pints of delicious Fullers ESB at the North Star. Pancakes.

20 Feb 1982 42

Studio desk
Pen and ink

20 February 1982

There is nothing quite like the studio desk upon which you work. I have been working at this desk for the past 30 years and have developed a great fondness for it. A diary entry for 20th of February 1982 reads:

> Today I purchased a superb desk of solid mahogany, replete with three drawers and two cupboards. The desk used to be a clerk's desk in Victorian times and came recently from Hanover Terrace in Brighton and previous to that it was lodged in a solicitor's office in London. It has the following dimensions: 8 feet long x 2 feet 6 inches deep and 2 feet 8 inches high. I bought it from John Bird for one hundred and sixty pounds and most of the day was spent making room for it in the studio.

**Rough drawing
ideas for a set
of four postage
stamps related
to the poems of
Edward Lear**
Pencil

23 July 1987

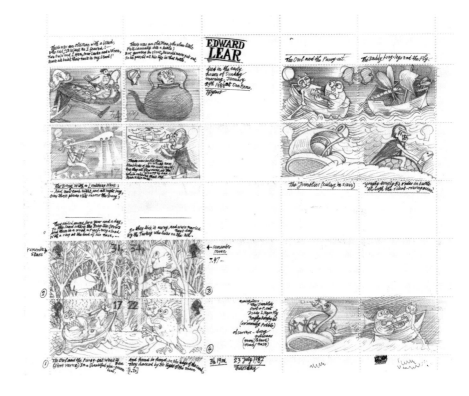

**Rough drawing,
establishing an
idea for a set of
4 postage stamps**
Pencil

24 July 1987

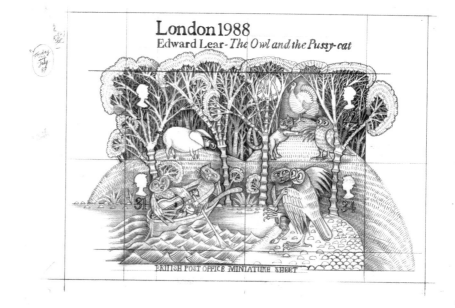

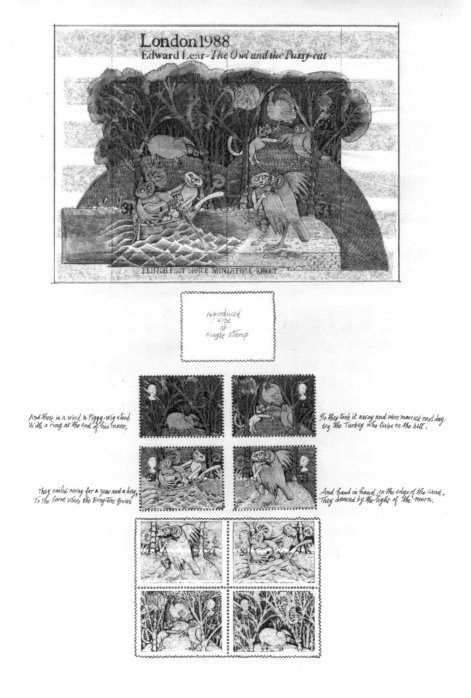

A rough colour version of the drawing on the previous page.
Pencil

24 July 1987

The brief was to create a miniature sheet of four stamps in which each individual stamp should work as a separate image on its own, but when all four stamps were placed together they would also work as a single image. This idea was eventually carried out in colour but was not adopted by the Royal Mail. The stamps that were finally accepted were designed by The Partners. They were issued to commemorate the centenary of Edward Lear's death in 1988.

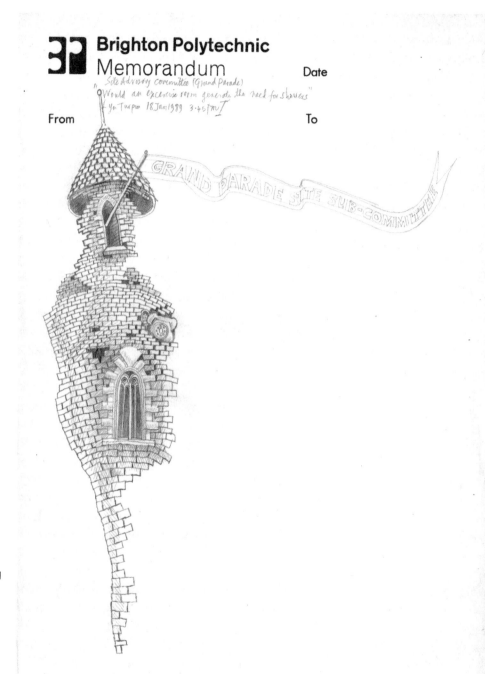

Brighton Polytechnic
Memorandum Date

Site Advisory committee (Grand Parade)
"Would an excercise room generate the need for showers"
Yn Turpin 18 Jan 1989 3.45pm

From To

**Grand Parade Site
Sub Committee**
Pen and ink

18 January 1989

Towers were a prevailing
theme among my doodles.
This one was drawn during
a meeting of the Grand
Parade Site Committee,
a group that discussed
accommodation issues
that affected the Faculty
of Art and Design at
Brighton. Perhaps there
is some symbolism here.

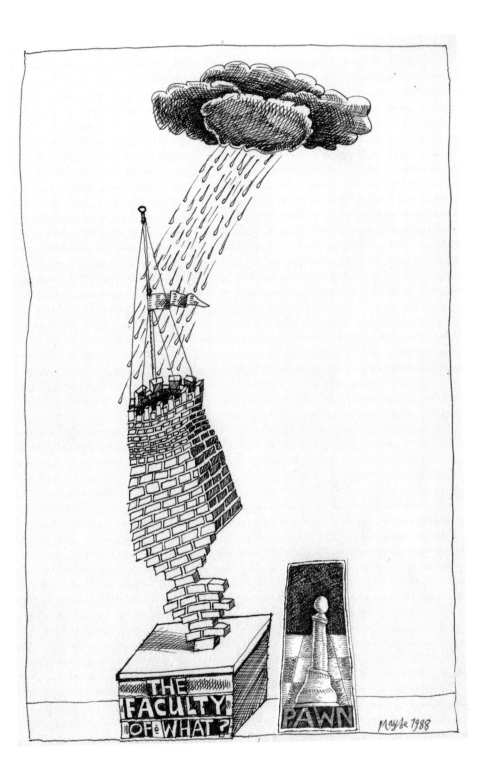

The Faculty of What?
Pen and ink

ca. 1988

This doodle was drawn during a meeting at Brighton Polytechnic discussing a proposal of a new title for the Faculty of Art and Design.

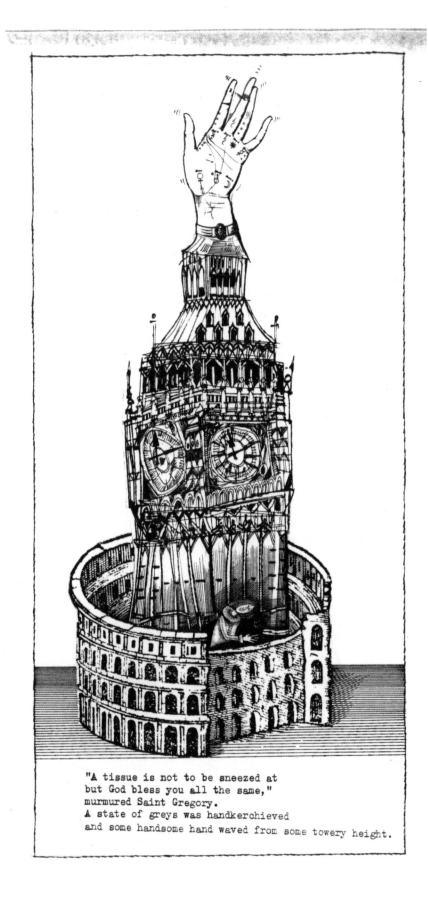

'A tissue is not to be sneezed at'

Pen, ink and collage

1987

An opening illustration for an unfinished pictorial novel.

"A tissue is not to be sneezed at
but God bless you all the same,"
murmured Saint Gregory.
A state of greys was handkerchieved
and some handsome hand waved from some towery height.

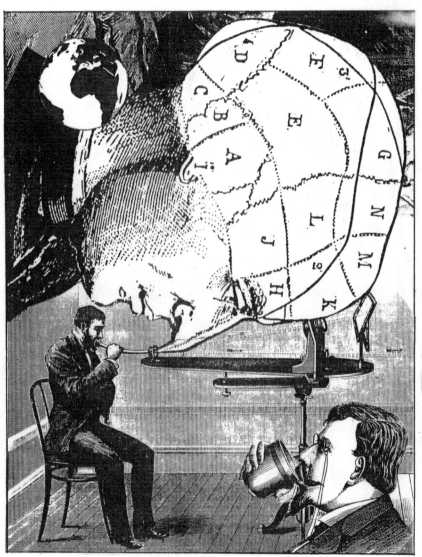

Ink and conkers. Blink and bonkers.
Blow forth a balloon to call an ancient tune.
Is this phoney or baloney?

**'Ink and conkers.
Blink and bonkers'**
Collage

1987

An illustration for an
unfinished pictorial novel.

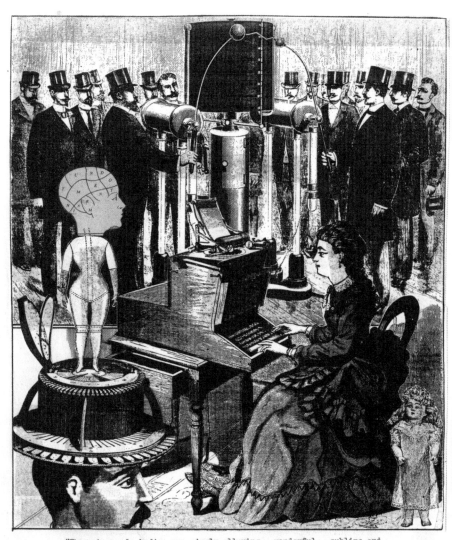

"Those heavenly bodies are simply alluring...wonderful...sublime and corporeal," he cogitated among the cog-construction within his newly prescribed hat. He continued to apply his mind to the understanding of the bewilderness before him. He wondered why women were treated so, and why many were committed to the typing of bumph all day and benumbing the tips of their fingers in the process. While the typewriter clicked endlessly, sundry gentlemen played automated ball games.

'Those heavenly bodies are simply alluring'
Collage

1987

An illustration for an unfinished pictorial novel.

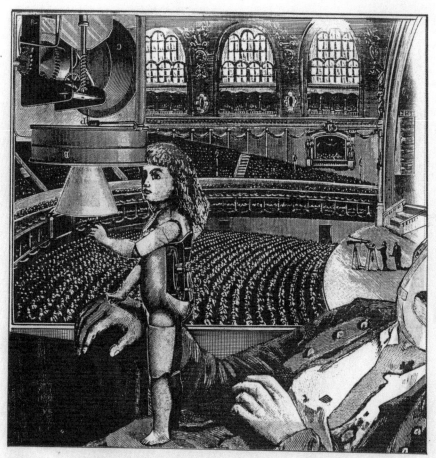

A breathless hush pervaded the concert hall while Signor Lungi Altobelli
was about to survey the swelling scene with his telescope. He was about to
embark upon the first performance of his eighteenth sonata for unaccompanied
telescope and obbligato waiter. The music itself turned out to be tremendously
dramatic and energetic but constructed out of a very limited amount of material.
It began in G minor, its opening phrase deriving from a G,B flat,B natural idea;
but then an A flat was introduced as a passing note. (This note,the flattened
supertonic,was much in evidence throughout this exacting work. Between the
movements the waiter served sundry soups and sardine sandwiches.

Meanwhile,up in one of the boxes, the doll stood on his knee and with her
left hand felt hot air blowing from the heat machine.

**'A breathless
hush pervaded
the concert hall'**
Collage

1987

Another illustration for an
unfinished pictorial novel.

A meeting of the BA Graphics Association at Brighton.
Pen and ink

24 October 1985

A doodle carried out at a meeting of the Faculty Board for Art, Design & Humanities at Brighton Polytechnic. In the Aldrich collection at the University of Brighton.

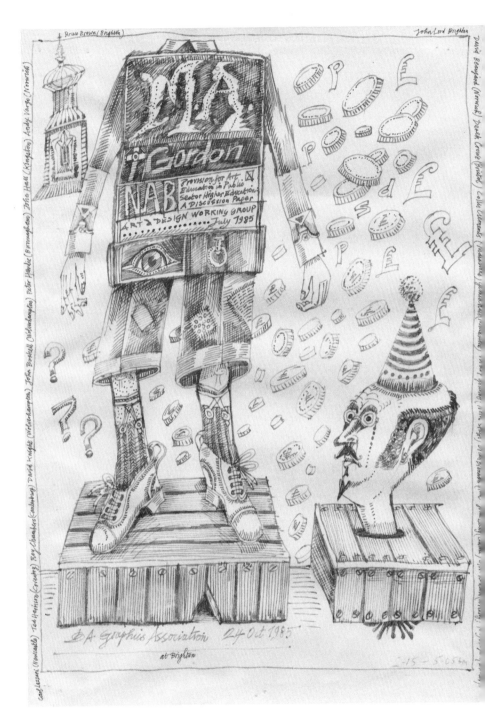

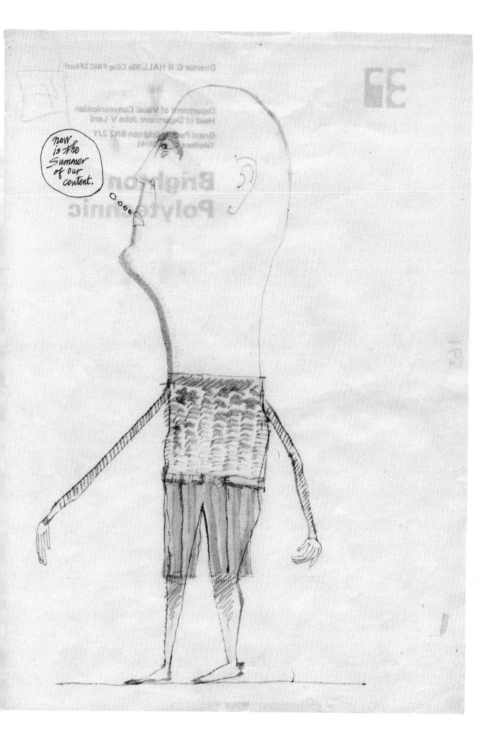

**Now is the summer
of our content**
Felt pen, pencil and
pen and ink

1985

This was drawn during
a BA (Hons) Graphic
Design staff/student
course evaluation meeting
at Brighton Polytechnic.
In the Aldrich collection at
the University of Brighton.

**A meeting of
the Graphic Design
External Moderation
Committee**
Pen and ink

18 June 1985

In the Aldrich collection at
the University of Brighton.

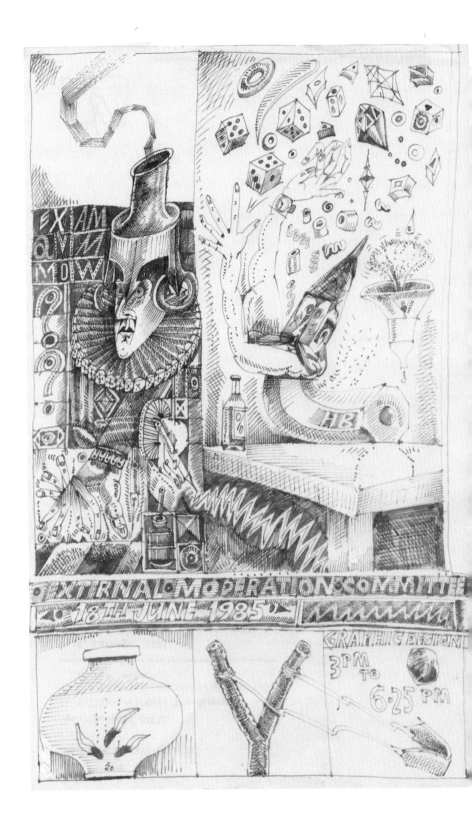

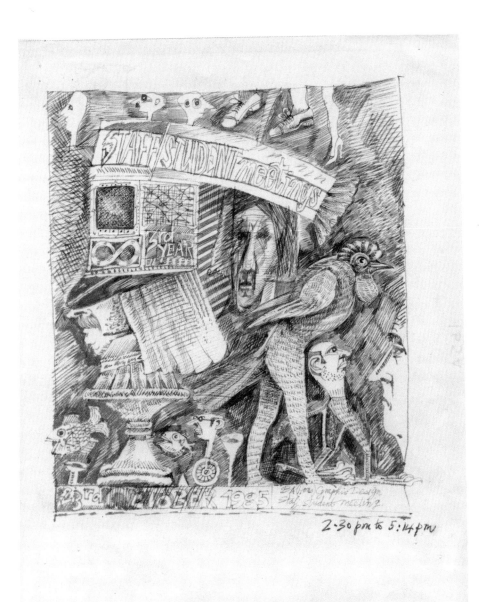

**Drawn during
a staff/student
meeting of the
BA (Hons) Graphic
Design course**
Pen and ink

23 October 1985

In the Aldrich collection at
the University of Brighton.

1990s

As far as commissioned illustration was concerned, the 1990s was a relatively lean period during which I had occasional papers and articles published. 1991 saw the publication of my inaugural lecture Illustrating Lear's Nonsense, (originally delivered in 1987). I also had an exhibition at the Brighton Polytechnic Gallery, which toured extensively during the next three years to Stoke, Cardiff, Glasgow, Northampton, Exeter, London (Barbican), Falmouth, Margate, Ramsgate, Tyneside, Salford and Edinburgh.

In 1994 I was invited to illustrate a poem by Wendy Cope, entitled *The Squirrel and the Crow*, one of the 'Prospero Poets' series for the Clarion Press. In 1995 I carried out illustrations for *King Arthur's Knights*, by Henry Gilbert, published by Macmillan. In 1998 I illustrated my first book for the Folio Society, *Myths and Legends of the British Isles*, edited by Richard Barber. This was commissioned by Joe Whitlock-Blundell, who I was to work with on a number of future projects. In the 1990s teaching and developing a new MA course at the University of Brighton preoccupied most of my time as did my responsibilities as Head of the Graphic Arts Department and later as Head of the School of Design at the University. I was attending many long meetings during this period and this probably accounts for the number of doodles that appear in the book in this chapter. I was privileged at this time to be working with such colleagues as Bruce Brown, George Hardie and Chris Mullen.

A Professor Emeritus was conferred upon me on my retirement from the University of Brighton on the last day of 1999 and, a year later, an Honorary Doctor of Letters. I taught there for 38 years and, although now retired, I am still giving lectures at Brighton, thus continuing a relationship with the institution of 53 years and counting.

**Your Course
Monitoring and
Evaluation papers**
Pencil

15 January 1990

This doodle was drawn
during a Course Review
Committee meeting of
the Faculty of Art, Design
& Humanities at Brighton
Polytechnic. As can be seen
in the drawing the reading
of 332 pages of agenda
papers for the meeting
took me 6 hours and
12 minutes to read.

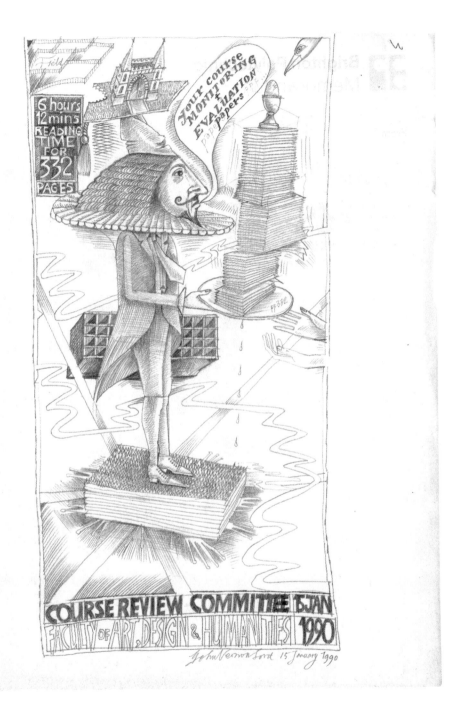

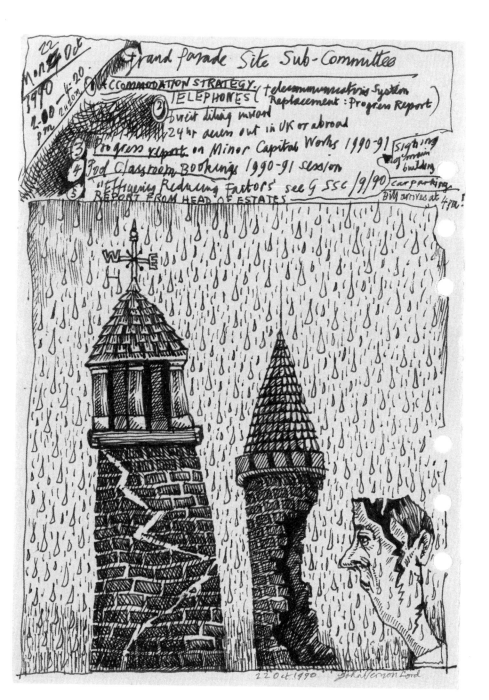

Accommodation Strategy

Pen and ink

22 October 1990

A doodle carried out during a Faculty Management Group meeting at Brighton Polytechnic.

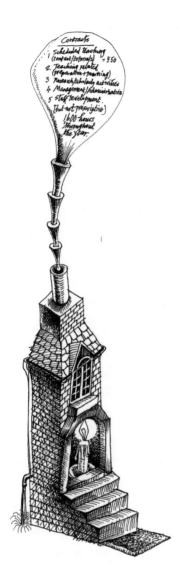

Contracts
Pen and ink

1990s

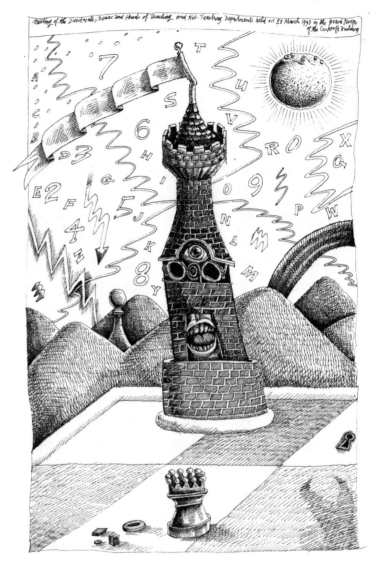

Meeting of the Directorate, Deans and Heads
Pen and ink

28 March 1990

A doodle drawn during a meeting
of the Directorate, Deans of Faculties
and Heads of Departments at
Brighton Polytechnic.

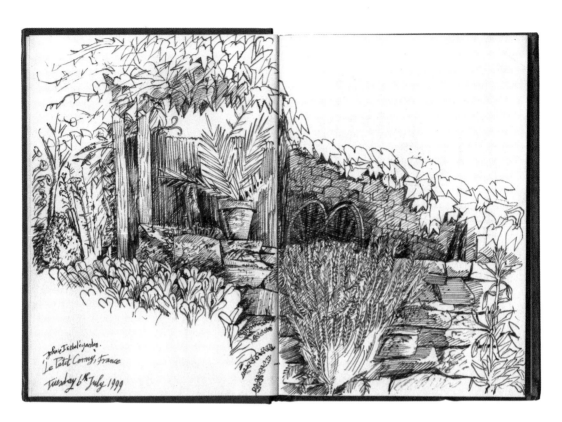

John Isabel's garden.
'Le Petit Cormy', France

Tuesday 6th July 1999

WMCP
Red Pen and ink

1992

**John & Isabel's Garden
at 'Le Petit Cormy', France**
Pen and ink

6 July 1999

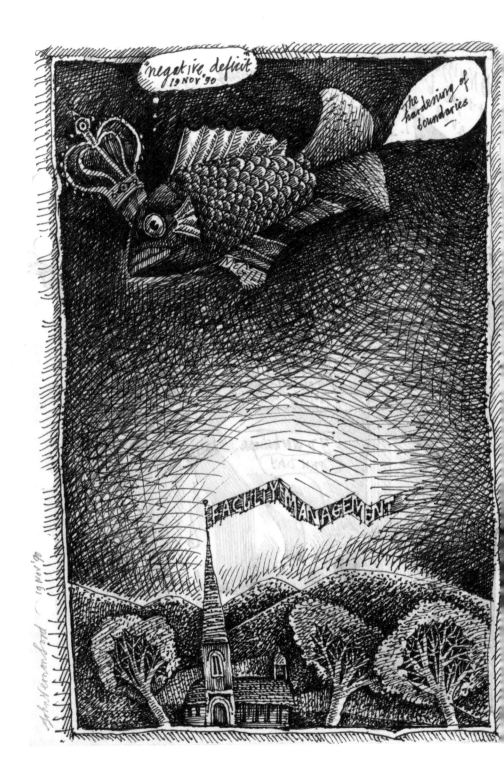

Negative deficit
Pen and ink

19 November 1990

A doodle carried out
during a Faculty
Management meeting
at Brighton Polytechnic.

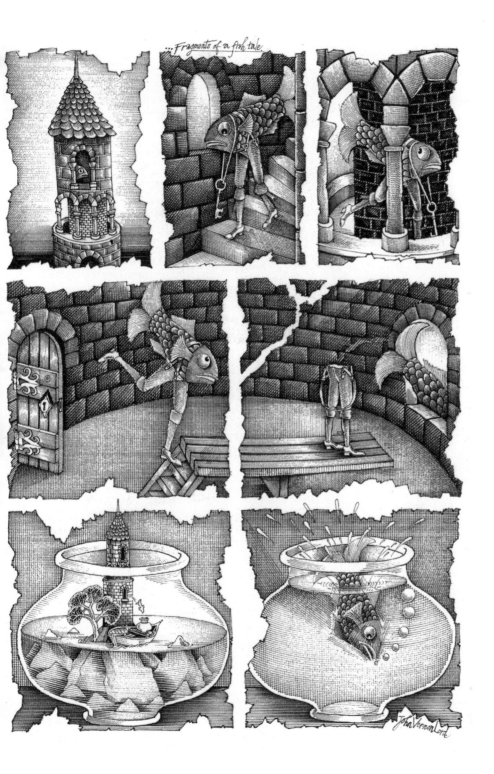

**Fragments of
a fish tale**
Pen and ink
1993

Hickory Dickory Dock

Pen and ink

December 1990

A doodle carried out
during a Faculty Academic
Board meeting at
Brighton Polytechnic.

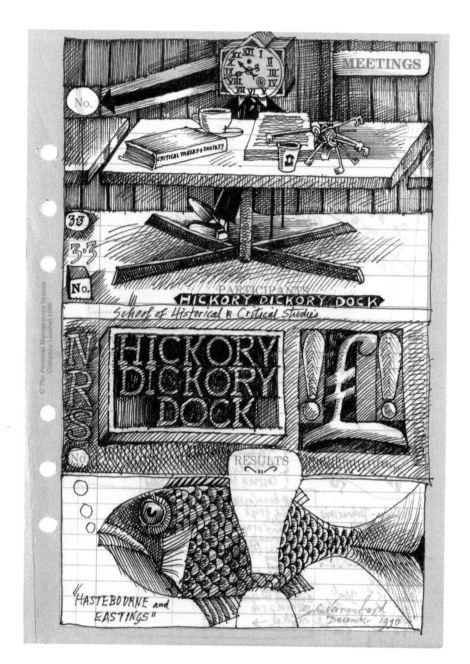

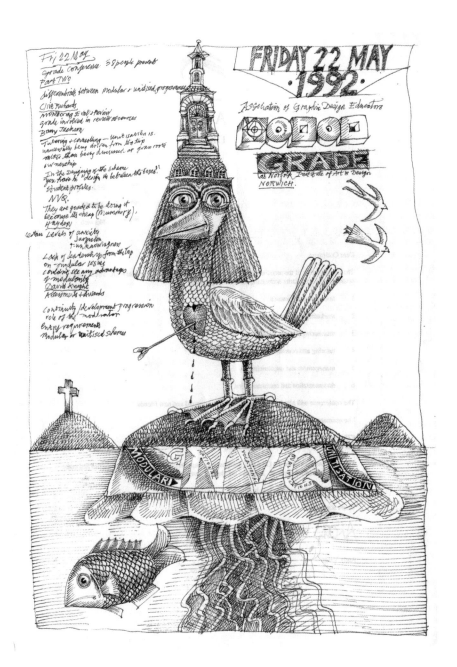

Grade Conference

Pen and ink

22 May 1992

A doodle drawn during
a meeting of GRADE
(the Association of
Graphic Design Educators).

The head of the
steam of volition
Pen and ink

6 November 1992

This doodle was drawn during
a meeting of the Faculty of
Art, Design & Humanities at
the University of Brighton.

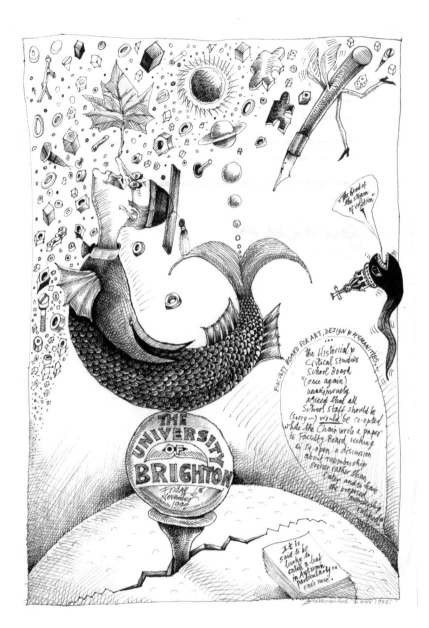

Fri 19 Jan 1996
Des & Comm BOS
Board Rm

Product Design
Fav of ES developing Product des course
within the capacity of existing staff, surely
Klimowski - emerging any moment now (late report)
Intercalation
change Business
Semesterisation (DCBS/9/96)
Draft Academic Health Report 1996
Limited to 10 pages (strict limitation of pages)
Construction of 4th Wing
Fraternity academic collaboration
Equal oppo
Research increasing (active staff)
Gallery
Revised Ac Health Report for Ac Prog in Des & Comm
Andrew Atofs course at Hastings.
External Examiner nomination 3D Crafts

'A Logical fallacy' Iain
Is that an oxymoron?
Discussion Document Nov 95
A SVS favourable Transport Policy for the U of Brighton
4th Wing - consider bicycles
support Newbury.

9·30 - 12·27

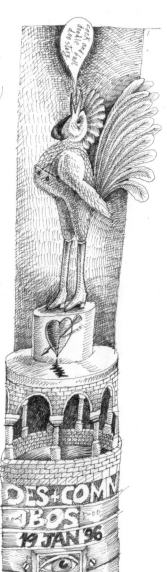

Des & Comm BOS
Pen and ink

19 January 1996

A doodle made during
a meeting of the Design
and Communication
Board of Studies at the
University of Brighton.

**Polytechnic
Strategic Plan
towards 2000**
Pen and ink

11 January 1991

This doodle was drawn
during a meeting of the
Faculty Board for Art,
Design & Humanities at
Brighton Polytechnic.

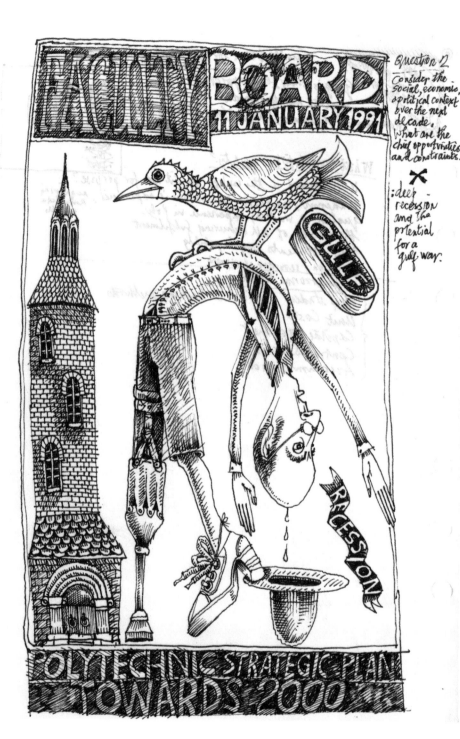

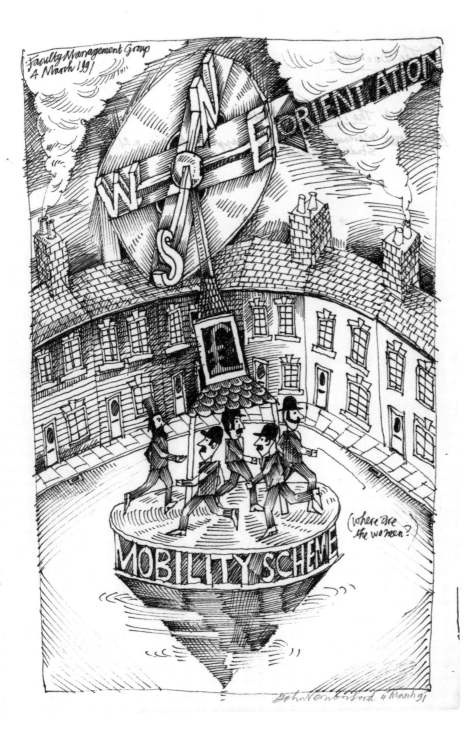

Orientation/ Mobility scheme

Pen and ink

4 March 1991

A doodle from a meeting of the Faculty Management Group at Brighton Polytechnic.

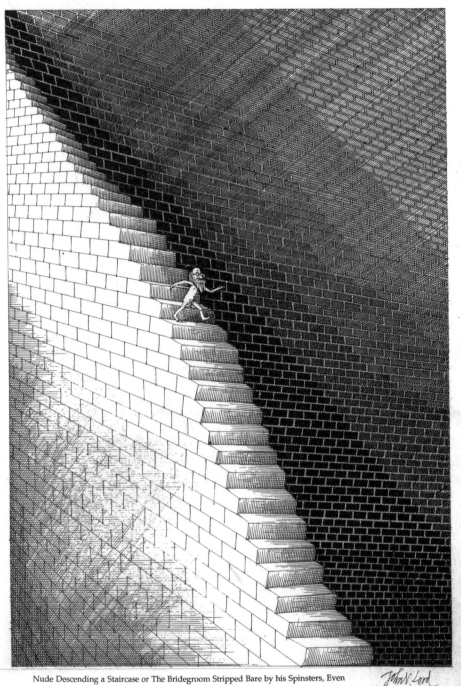

Nude Descending a Staircase or The Bridegroom Stripped Bare by his Spinsters, Even

**Nude Descending
a Staircase or
The Bridegroom
Stripped Bare by
His Spinsters, Even**
Pen and ink

1991

Academic health or illness of the faculty

Pen and ink

22 October 1990

A doodle carried out during a Faculty Management meeting at Brighton Polytechnic.

This is followed by a surprisingly lively solo violin accompaniment to the the tenor aria. The bass aria is stormy with a delicious accompaniment by the orchestra. The tenor continues to moan magnificently about 'sin sorely destroying us' in his chorale. Riches continue with the soprano and alto duet weaving their pleas for mercy in a beautiful chorale duet setting.

This is certainly one of the great cantatas. And so to Cantata 102: another one which seems to gather up the gloom, opening with a setting of Jeremiah in the chorus, which somehow seems to stab. All is woe to the soul in the mournful alto aria, with the oboe wailing in like sentiment to the voice. Unrelenting gloom. Cantata 103 is another great one — 'Ye shall weep and lament but the world will rejoice'. Bach's piccolo howls in the background and at times seems to mock in the opening chorus. The lively tenor aria allows us to recover ourselves with a confident trumpet and rhythm. The wandering of the soul in the wilderness is illustrated among the oboes in the tenor aria of Cantata 104. Bach's comforting mood is introduced in the bass aria; a pastoral scene of the good Shepherd. Another heavy gloom is made manifest in the chorus of Cantata 105. The slow throbbing rhythm exacerbates the anguish of the guilty soul — "Lord, weigh Thou and judge us not." A fascinating feature of the chorale setting is a delaying orchestral effect at the end of each line. The soprano aria is a gem — good words too: 'How tremble and totter the sinner's thoughts while they accuse one another and again dare to excuse themselves.' And then we come to the marvellous 'Gottes Zeit', or the 'Actus Tragicus' Cantata No 106, one of the earliest of Bach's cantatas. It evokes a tender spirituality helped along by the innocent, shrill sound of the recorders. The soul is certainly transported into paradise in this work. It is sublime with its most remarkable simple 'Amen' at the end echoed by the instruments, including those plaintive recorders. I am mad writing this.

George phoned to meet in Brighton with Sally about the catalogue next Tuesday. He is currently designing European stamps + lets hope for a success. Cooked ratatouille and pasta for supper after watering the vegetable plot and greenhouse. Watched 2½ minutes of "Heaven's Gate"-exhausting stuff.

Sunday 18 August

This solitary 'interlude' is strange and causes too much inner thinking. Temperatures: Max 24°c; Min. 8°c. No rain all last week. Breakfast of Ritz biscuit and hot water with lemon in the garden. A perfect sunny morning while I scan the main news in 'The Independent'. Headline plans to spread London to the east to choke Britain further. The government is considering abolishing minimum standards for school buildings — another cynical attitude to education. Abundant butterflies in the garden, mainly 'peacocks' & meadow browns with the occasional 'red admiral', comma and cabbage white. Trim the edges of the lawn in the quietness of the morn. The very clipping of the shears seems to be too loud. Supplement my breakfast with pickings from raspberry cane, gooseberry bush and tomato plant. And so into the studio to work — find that there is an electricity power cut and therefore cannot use the word-processor. Cannot even listen to music and am therefore obliged to 'write instead. I start by preparing the staff development reports and quite honestly I feel that the whole business is a futile waste of time. This takes until lunch which occupies me in the preparing and eating of brief cucumber sandwiches, a couple of pickled onions and mineral water. Afterwards I do a bit of gardening — clearing nettles mostly and taking cuttings of fuchsia & buddleia. I also sow fritillary seeds and perspire a lot in the sun.

Back to Bach Cantatas, starting with No.107, another one about the troubled soul. Unusual that only the bass has a recitative preceding his aria. It has a vigorous bass aria and a cheerful flute melody with the tenor aria but compared to others this cantata doesn't reach the heights. The Lord tells his disciples that it is for their good that he goes away in a bass aria (with interweaving oboe d'Amore) which opens Cantata 108. Another lovely melody for the tenor who sings long notes on the word 'glaube' as he responds to the Saviour. Cantata 109 is something special. A fine chorus opens it, singing 'I believe, Lord, help my unbelief.' This is followed by a marvellous recitative and aria for the tenor as he totters with his vacillating spirit. Faith conquers all in the melodious aria for alto and two oboes. An extended chorale magnificently concludes the work.

178

A pen brush
Pen and ink

17 August 1991

A trial drawing for an emblem for a letterhead for Rosemary Sandberg, an agent for artists and writers. Most of the text includes notes about listening to a number of JS Bach's cantatas.

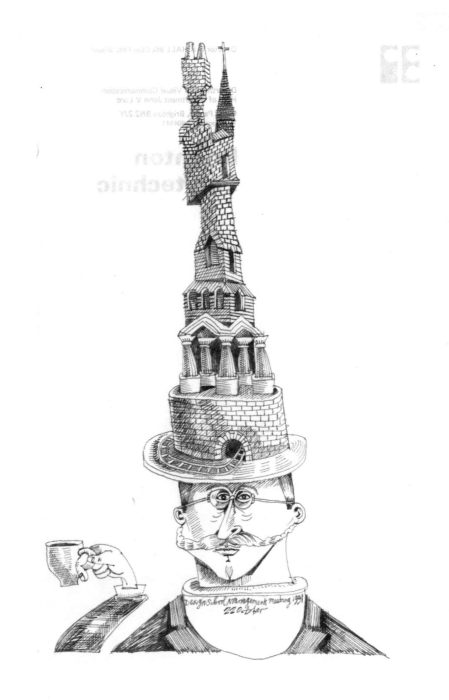

**Design School
Management
meeting**

Pen and ink

22 October 1991

This doodle was
drawn during a Faculty
Management Group
meeting at Brighton
Polytechnic.

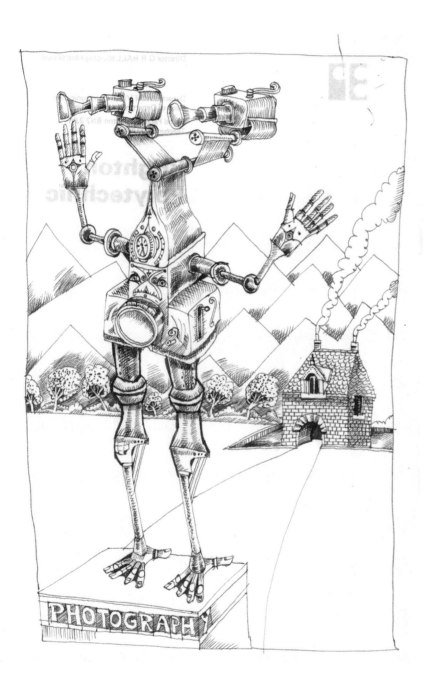

Photography
Pen and ink

10 December 1991

This image emerged during a successful validation meeting of the BA (Hons) Editorial Photography Course at Brighton Polytechnic.

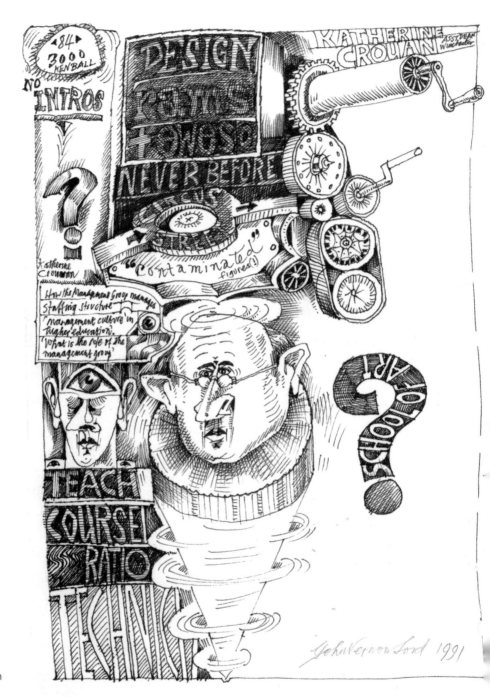

84 3000 Ken Ball

Pen and ink

1991

A doodle drawn during a
Faculty Management
Group meeting at Brighton
Polytechnic.

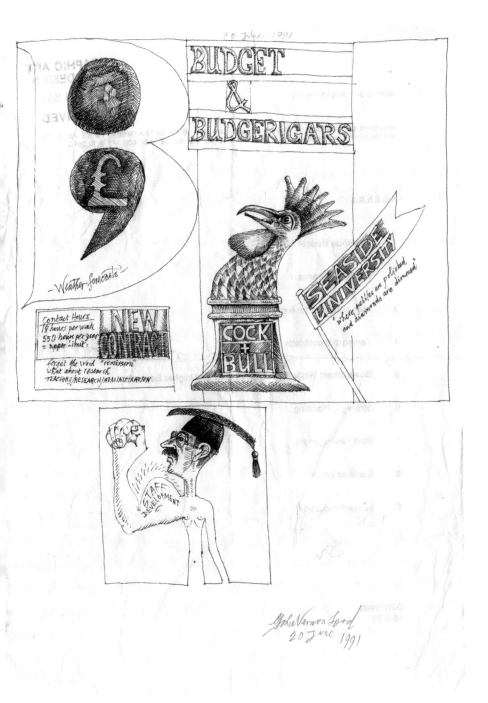

Budget and budgerigars
Pen and ink

26 June 1991

A doodle carried out during a meeting of the Directorate, Deans and Heads of Department at Brighton Polytechnic.

Graphic Design
Staff meeting
Pen and ink

12 July 1994

A doodle drawn on
the back of an envelope
during a Graphic Design
staff meeting at the
University of Brighton.

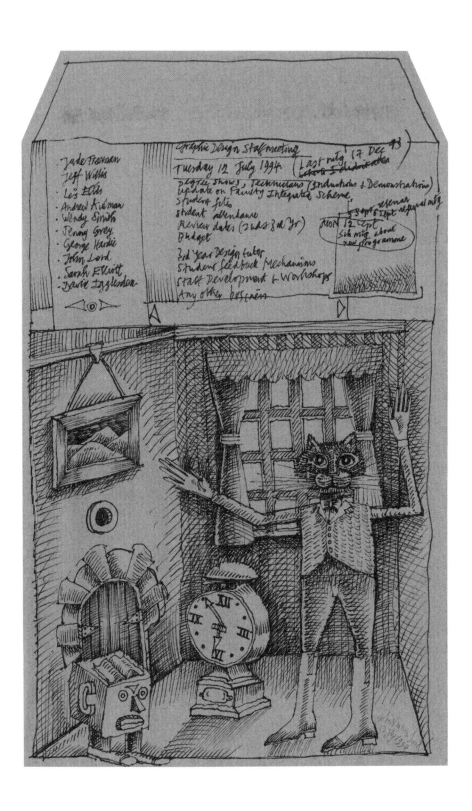

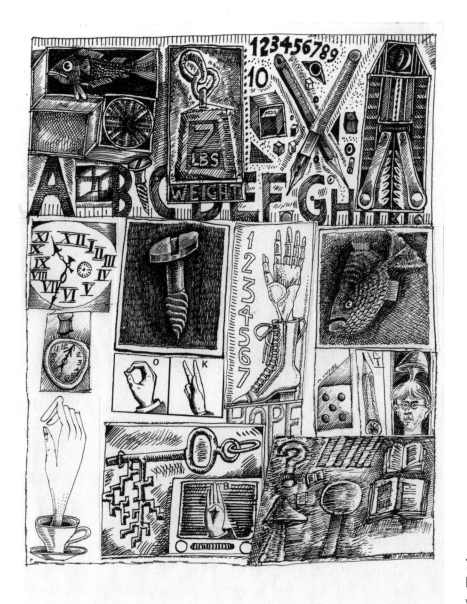

7lbs weight
Pen and ink collages of
various doodles

1990s

**Faculty
Management Group**

Pen and ink

12 May 1992

A doodle drawn during
a Faculty Management
Group meeting at Brighton
Polytechnic.

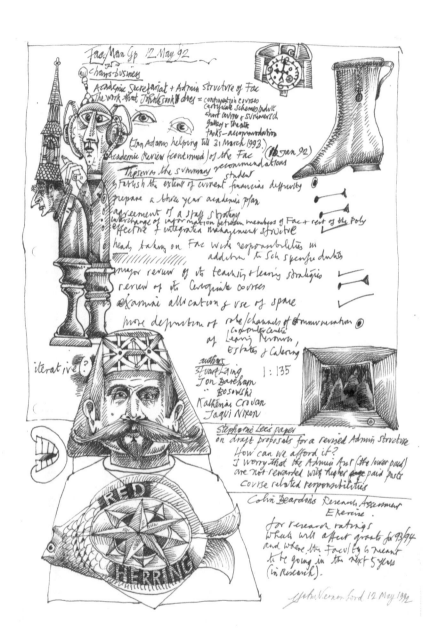

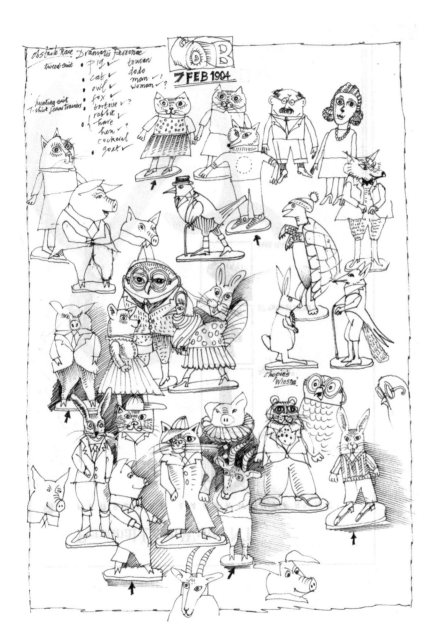

**Obstacle Race:
Dramatis Personae**
Pen and ink

7 February 1994

A sketch of toys for a children's story about an obstacle race, which didn't get any further than this.

Definition

Pen and ink

31 May 1995

A doodle drawn during a
validation meeting of the
Book Arts MA at
Camberwell College of Arts.

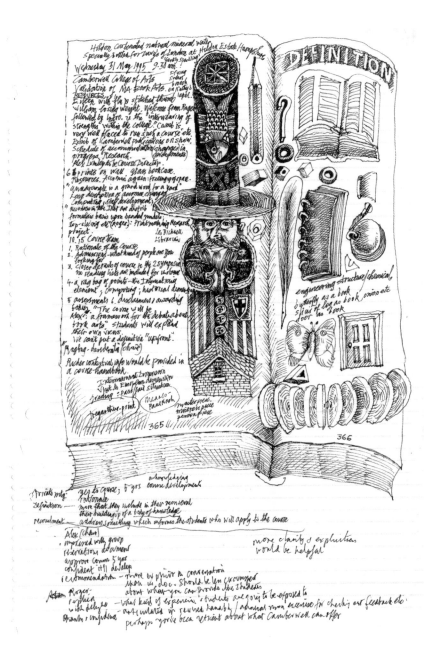

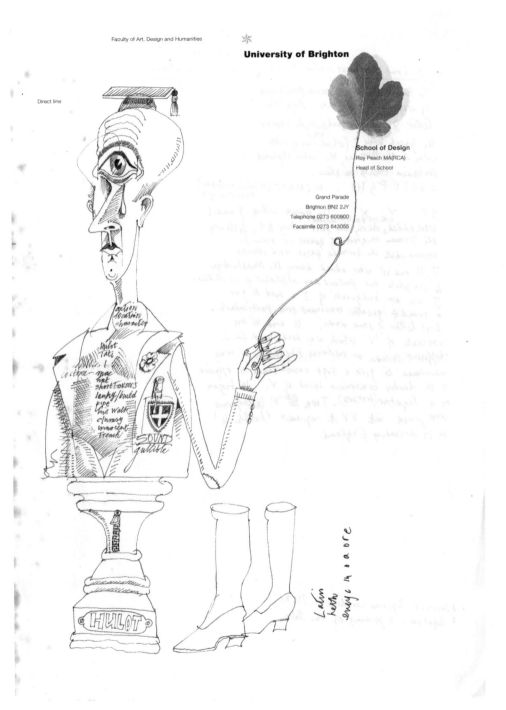

211

MPhil/PhD
Pen and ink

30 May 1996

This doodle was drawn
during a meeting of the
Faculty Board for Art,
Design & Humanities'
Research Committee
at the University of
Brighton. The meeting
was mainly about going
through applications for
registrations of MPhil/
PhD research students
and approving supervisors.
The drawings symbolised
the walls that had to be
climbed to achieve an
MPhil/PhD.

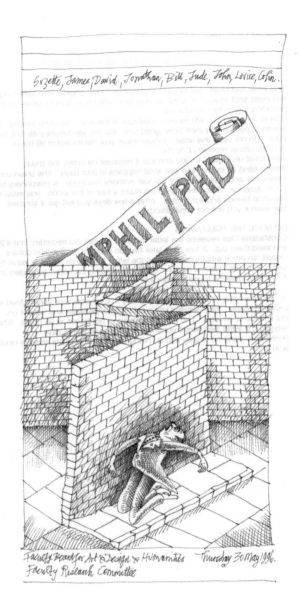

Ulysses
Pen, ink and collage

1996

A trial drawing for
the opening chapter
of the novel by James Joyce.

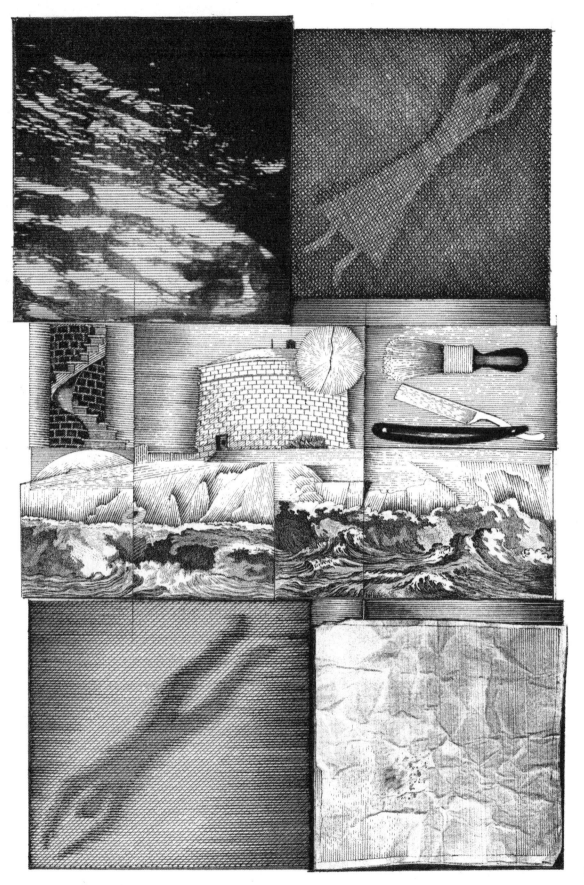

213

Faculty Research Committee

Pen and ink

26 February 1998

This doodle was drawn during a Faculty Research Committee at the University of Brighton.

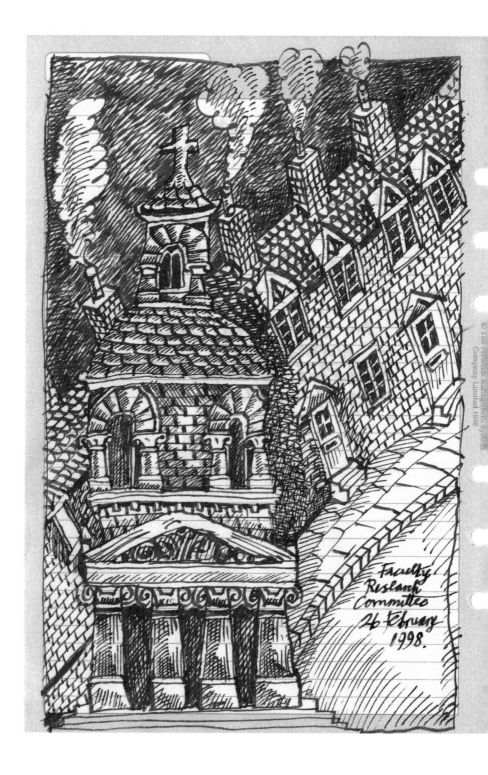

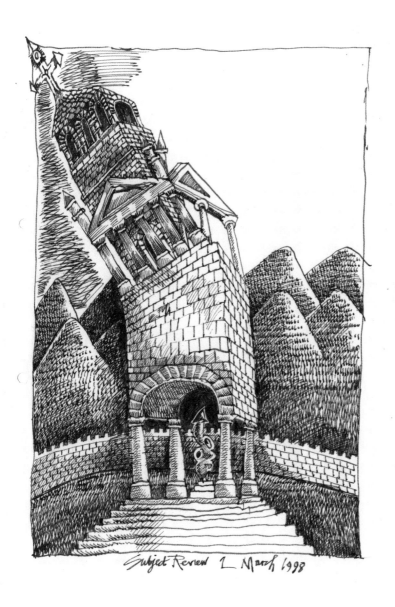

Subject Review 1 March 1998

Subject Review
Pen and ink

2 March 1998

Doodle from a meeting of
an Art and Design subject
review at the University
of Brighton.

Brick

Pen and ink

23 July 1998

This was drawn during
the presentations by
candidates during the
selection programme for
the appointment of Head
of the School of Historical
and Critical Studies at the
University of Brighton.

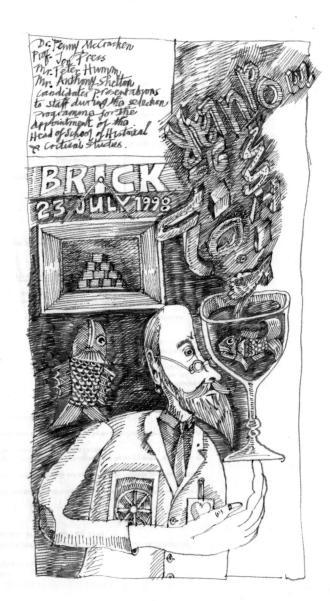

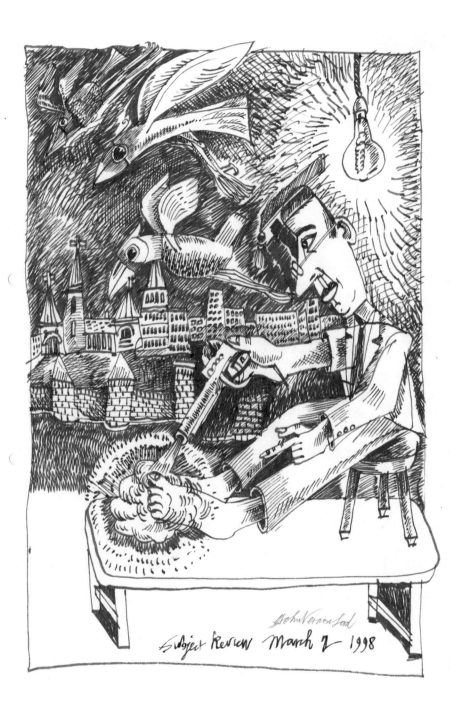

Man spraying his feet
Pen and ink

2 March 1998

A doodle produced during
a Faculty subject review
Committee meeting at the
University of Brighton.

Them, us

Pen and ink

2 March 1998

A doodle drawn during
a Faculty subject review
Committee meeting at the
University of Brighton.

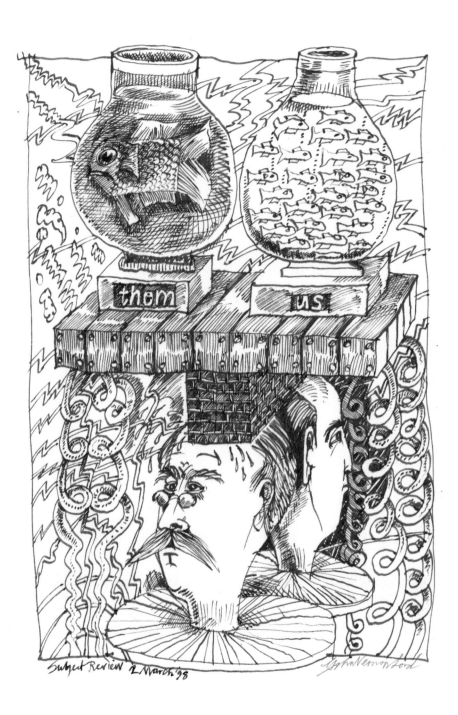

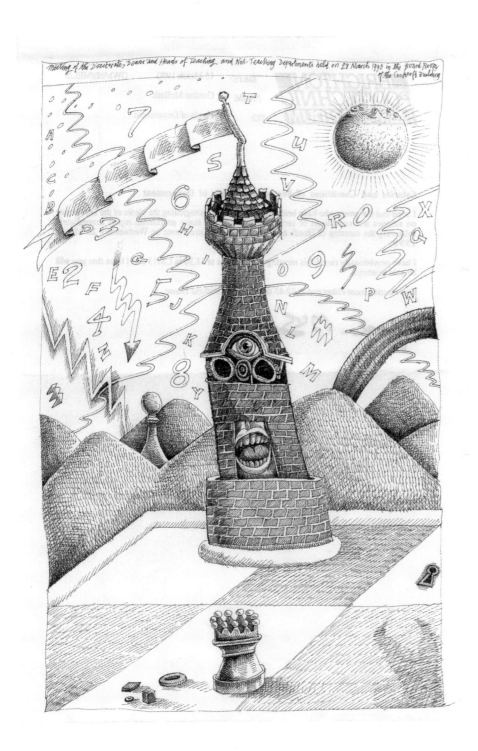

Meeting of the Directorate

Pen and ink

28 March 1990

A doodle drawn during a meeting of the Directorate, Deans of Faculties and Heads of Departments at Brighton Polytechnic. In the Aldrich collection at the University of Brighton.

219

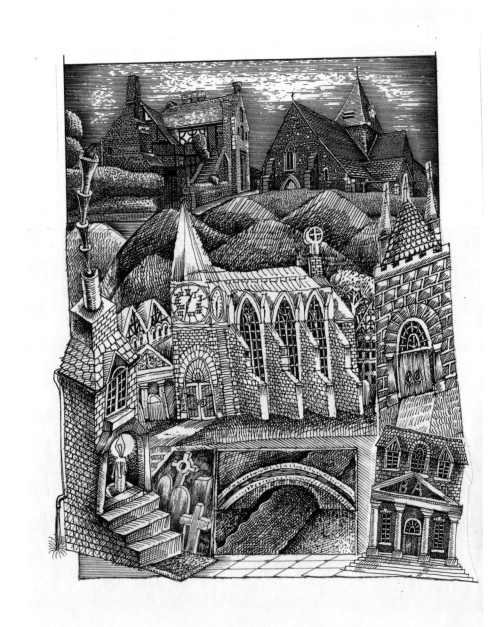

Buildings
Pen, ink and collage
1999

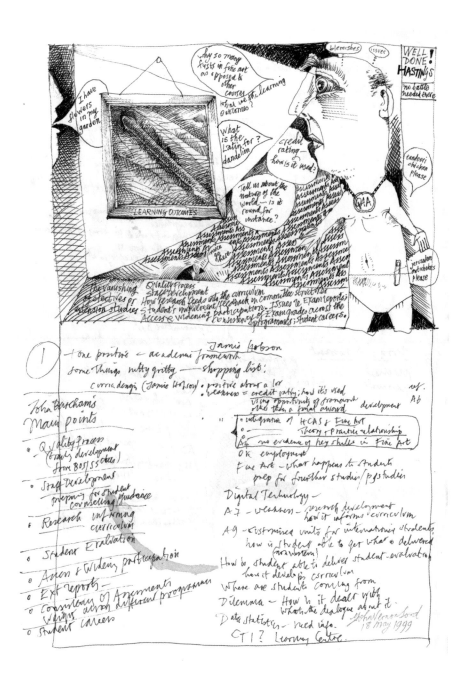

**I have flowers
in my garden**
Pen and ink

18 May 1999

A doodle drawn during
a Quality Assurance
Agency's review of the
teaching performance in
the Art and Design courses
at the University of Brighton.

**I don't know
what isn't going on**
Pen and ink

26 March 1990

A doodle carried out
during a Faculty Course
Review Committee meeting
at Brighton Polytechnic.
In the Aldrich collection at
the University of Brighton.

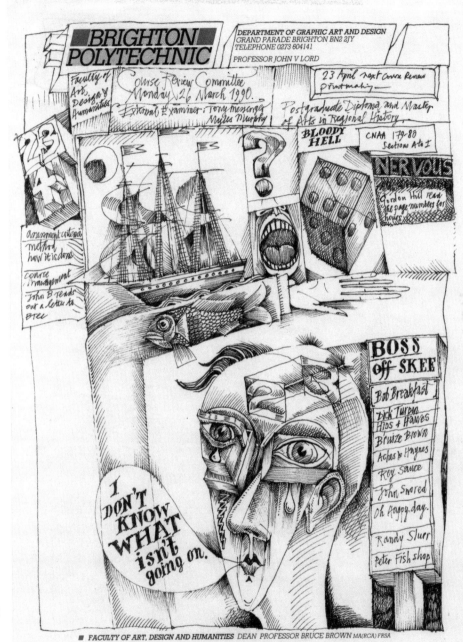

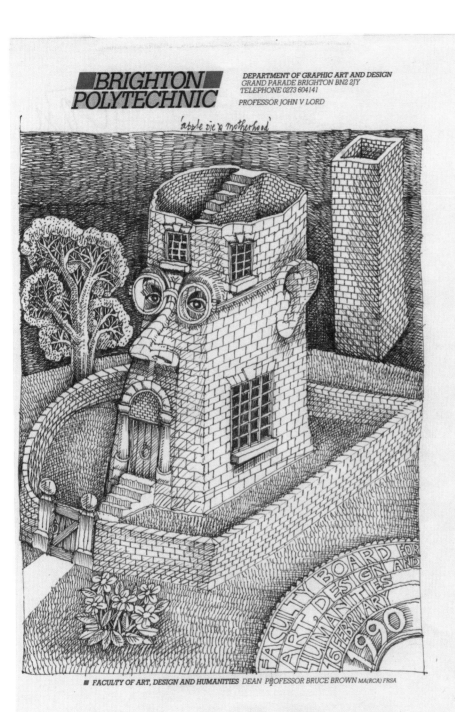

'apple pie is motherhood'

Apple pie and motherhood
Pen and ink

16 February 1990

A doodle drawn during
a meeting of Brighton
Polytechnic's Faculty
Board for Art, Design
and Humanities at
Brighton Polytechnic.
In the Aldrich collection at
the University of Brighton.

223

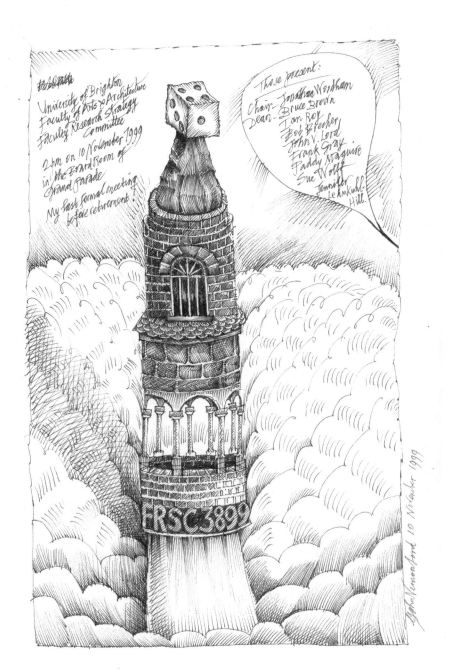

A tower rocket

Pen and ink

10 November 1999

A doodle drawn during a meeting of the Faculty of Arts and Architecture Faculty Research Strategy Committee meeting at the University of Brighton. My last formal meeting at Brighton before I retired from teaching.

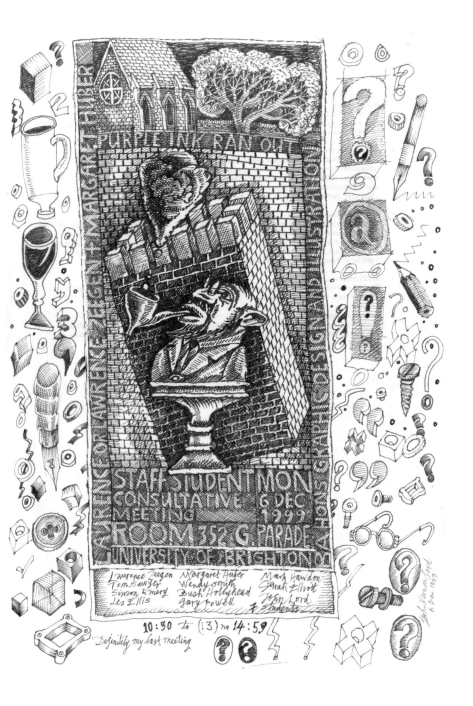

Purple ink ran out

Pen and ink

6 December 1999

I produced this doodle during a Graphic Design Staff/student committee meeting at the University of Brighton. This was the very last informal meeting I attended at Brighton before I retired from teaching on the last day of 1999.

2000s
and beyond...

Most of the drawings from this point on are taken from my notebooks, which, in a way, are a form of sketchbook too. They serve a number of purposes. Sometimes I use them to create trial drawings or I might practice for a particular illustration commission that I'm working on. Other notebook drawings are experimental; working out and overcoming compositional and technical issues and seeing what happens. I seem to incorporate text in a number of these images too, which is simply a result of my love of letterforms. When I have a break I love to put on some music but I also feel a need to draw at the same time. The resulting drawings are usually fairly abstract or whimsical. At other times, especially when I am away from home and staying with family, I will draw the area about me, whether I'm in a garden or indoors observing objects on a kitchen table.

Professionally, I have mostly worked on 'fine press' books since my retirement from teaching in 1999. I've worked on two sets of illustrations for the Folio Society: *Icelandic Sagas* (Volume 2), translated and edited by Magnus Magnusson, published in 2002, and *Epics of the Middle Ages*, edited by Richard Barber, published in 2005.

The publication of a small booklet, *The Pink House*, by Olive Cook, in 2002, marked my first collaboration with Dennis Hall of Inky Parrot Press and his limited edition Artists' Choice Editions imprints. *The Hunting*

of the Snark by Lewis Carroll, was the next book, published in 2006. *John's Journal Jottings* was published by the Inky Parrot Press in 2009 and *Alice's Adventures in Wonderland* by Artists' Choice Editions in the same year.

In 2007 I had a retrospective exhibition at Brighton, which was accompanied by a book entitled, *Drawing Upon Drawing: 50 Years of Illustrating by John Vernon Lord* published that year by the Centre of Contemporary Arts at the University of Brighton. It was introduced by Sir Quentin Blake and contained 396 illustrations and drawings.

Recently I have illustrated Lewis Carroll's *Through the Looking Glass* and *What Alice Found There*, which was introduced by Selwyn Goodacre and published by Artists' Choice Editions in 2011 and accompanying the special edition is *Lord's List, A Selection of Publications*.

At the time of writing, the Folio Society is due to publish *Finnegans Wake* by James Joyce in 2014 and, perhaps, this project has been the greatest challenge I have ever had, but something I have always wanted to illustrate since I was a student. It was something of a great privilege to work on it – especially since I tentatively suggested that I might illustrate this particular James Joyce classic to the Folio Society's commissioner, Joe Whitlock Blundell, at a party 18 years prior to actually receiving the commission.

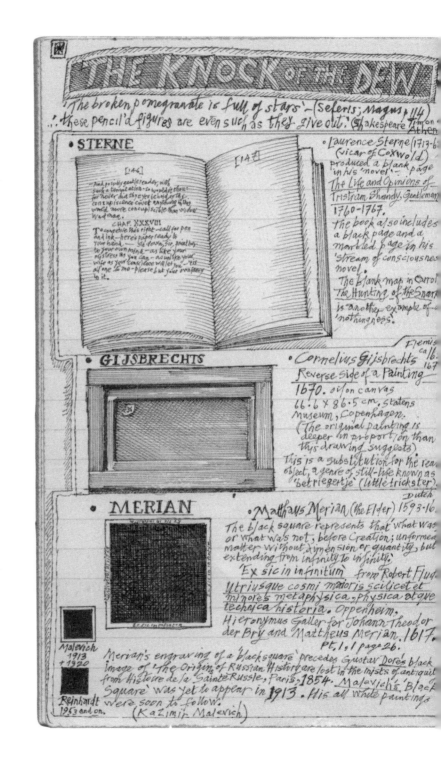

THE KNOCK OF THE DEW

'The broken pomegranate is full of stars'– (Seferis; Magus, 114)
'.'. these pencil'd figures are even such as they give out.' Shakespeare (Timon of Athens)

• STERNE

[146]

—And possibly gentle reader, with
such a temptation—so would'st thou—
for never did thy eyes behold, or thy
concupiscence covet anything in this
world more concupiscible than widow
Wadman.

CHAP. XXXVIII
To conceive this right—call for pen
and ink—here's paper ready to
your hand.—— Sit down, Sir, paint her
to your own mind—as like your
mistress as you can—as unlike your
wife as your conscience will let you—'tis
all one to me—please but your own fancy
in it.

[147]

• Laurence Sterne (1713-68)
(vicar of Coxwold)
produced a blank page
in his 'novel'—
The Life and Opinions of
Tristram Shandy, Gentleman.
1760-1767.
The book also includes
a black page and a
marbled page in his
'stream of consciousness'
novel.
The blank map in Carroll
The Hunting of the Snark
is another example of
'nothingness'.

• GIJSBRECHTS

Flemish
ca. 1630-1675

• Cornelius Gijsbrechts
Reverse Side of a Painting
1670. oil on canvas
66.6 X 86.5 cm. Statens
Museum, Copenhagen.
(The original painting is
deeper in proportion than
this drawing suggests)
This is a substitution for the real
object, a genre of still-life known as
'betriegertje' (little trickster).

• MERIAN

• Matthaus Merian (the Elder) 1593-16. Dutch
The black square represents that what was
or what was not, before Creation; unformed
matter without dimension or quantity, but
extending from infinity to infinity.
'Ex sic in infinitum' from Robert Fludd
Utriusque cosmi maioris scilicet et
minoris metaphysica, physica atque
technica historia. Oppenheim.
Hieronymus Galler for Johann Theodor
der Bry and Mattheus Merian. 1617.
Pt. 1, 1 page 26.

Malevich
1913
+ 1920

Reinhardt
1953 and on.

Merian's engraving of a 'black square' precedes Gustav Doré's black
image of 'the Origin of Russian History are lost in the mists of antiquit
from Histoire de la Sainte Russie, Paris, 1854. Malevich's 'Black
Square' was yet to appear in 1913. His all white paintings
were soon to follow. (Kazimir Malevich)

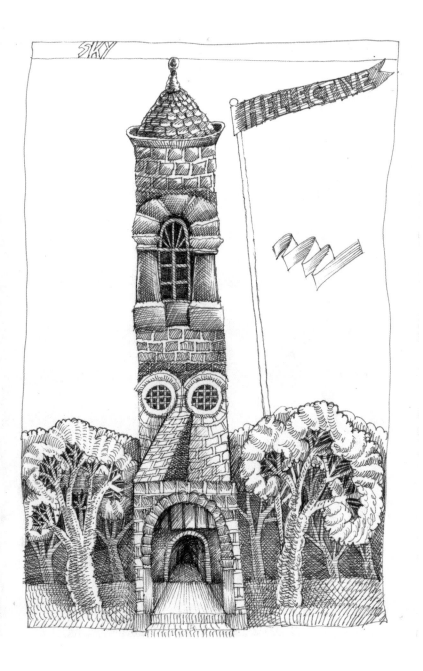

Hellective

Pen and ink

1990s

A doodle about elective studies, which were being inaugurated at the time.

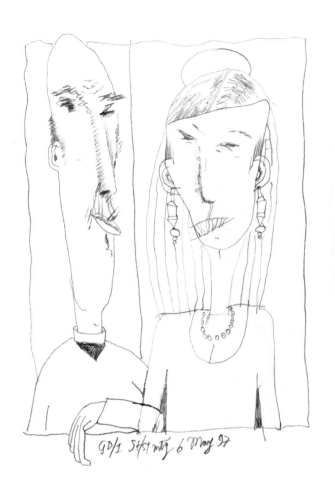

**A couple: Graphic
Design staff/student
meeting**
Pencil

6 May 1997

These were drawn with
my left hand.

Tattoo
Pencil

6 May 1997

This was drawn during
a staff/student meeting
of Graphic Design and
Illustration courses at the
University of Brighton.

Several heads
Pen, ink and pencil

1990s

board

© 1991 *FILOFAX* Ref. 102406

© 1991 *FILOFAX* Ref. 102406

MA weighting
Pen and ink
1990s

A storm in a teacup
Pen and ink
1990s

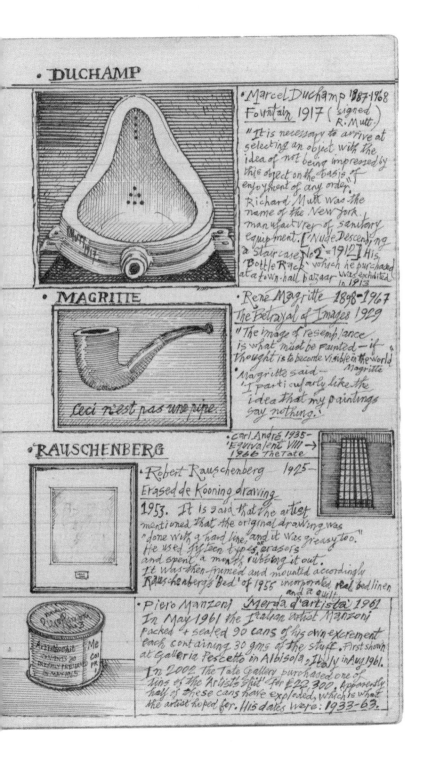

**The Knock
of the Dew**
Pen and ink

July 2000

These are notes and rough illustrations of what might be considered by some as being significant 'landmarks' in art. They were drawn in preparation for a projected series of drawings that I intend to expand on in the future. They range from Sterne's blank page from his novel *Tristram Shandy* (1760s), Gijsbrecht's reverse side of a canvas (1670), and a number of black images by Merian (1617), Doré (1854), Malevich (1913 & 1920) and Reinhardt (1953 and on) to Duchamp's urinal (1917), Magritte's *This is not a pipe* (1929), Rauschenberg's erased drawing by de Kooning (1953), Carl André's bricks (1966), and one of Manzoni's tin of his own excrement (1961).

1 4 7 2 3 5 6 8 9 0 =
A E F H I K L M N T V W X Y Z
B C D G J O P Q R S U =

The numbers 1, 4 and 7 are made up of straight lines and the rest have curvilinear characteristics. The letters A, E, F, H, I, K, L, M, N, T, V, W, X, Y, and Z are made up of straight lines whilst the rest have curved elements.

SH	PASSION RATION FASHION	PATIO RATIO 23·03·05	RATION NATION SHUN	mouse = mice house hice BROTHER foot = feet BRETHREN boot = beet MOTHER tooth = teeth METHREN booth = beeth HE, HIS, HIM SHE, SHIS, SHIM

Travis & Emery Bookshop (music) 17, Cecil Court, off Ch X Rd
http://www.travis-and-emery.com London WC2N 4EZ
email: abeenq@travis-and-emery.com
FAX (0207 497 0790/phone 0207 240 2129
Thematische-Systematisches Verzeichnis der Musikalischen Werke von Johann Sebastian Bach /: Bach-Werke-Verzeichnis

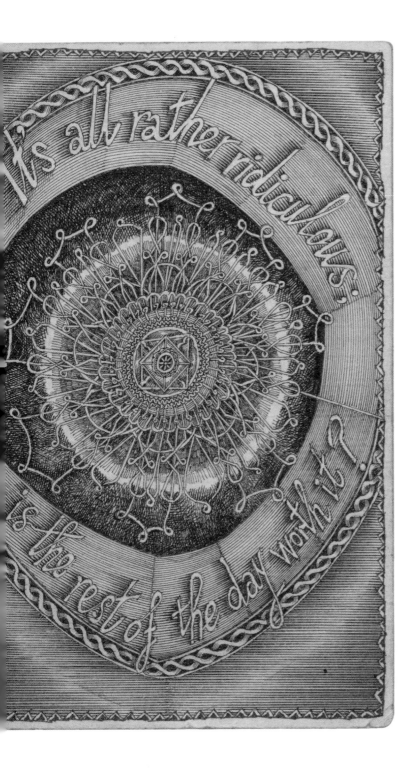

It's all rather ridiculous; is the rest of the day worth it?

It's all rather ridiculous; is the rest of the day worth it?
Pen and ink

24 October 2004

This drawing was a response after listening to Magdalena Kožená singing the aria 'J'ai versé le poison' from Massenet's opera *Cleopatre* one morning. It was so sublime a performance; I could see little point in doing much else for the rest of the day other than produce this drawing!

~~Fever Vibert~~ (applies HDD digiters + PL goldsmiths TF)

Yellow; lying in the approximate wavelength range 585-5: nanometries. Hammers and buntings may be yellow, as daffodils are. Those who are considered to be cowards are oft-called 'yellow bellied'. In soccer, (otherwise call football) a card of a yellow colour, that is displayed by a referee during a match, indicates that a player has been officially cautioned for some offence or other. Ah, the sound of 'a little bit of bread and no chees. resounds upon the Downs - the glorious utterance of the 'Emberiza citrinella', recalling the yellow colour of the citric fruit known as the Lemon. There was once even a 'yellow peril', a notion of an alleged power of Asiatic peoples, especially the Chinese, to threa the so-called supremacy of Western civilisation. There are of course the familiar 'yellow pages' those bulky tomes that list subscribers by the business or service provided - a classified telephone directory. Ah yes, there is the 'yellow jersey' worn b the cyclist with the fastest time in each stage of a cycle race, particularly the 'Tour de France'. A 'yellow line' or double yellow lines are those th are painted along the edge of a road indicating waiting restrictions or, in the case of double yello lines - no parking at all. Yelling has nothing t with the colour yellow as far as I know, meaning shouting & screaming, often uttered in a loud or piercing way, sometimes in pain, anger or perhaps; yelp is close to yell, often referred to the noise o a dog when he or she utters a sharp, high-pitched cry or bark, usually indicating some kind of pain And so must this particular stream of consciousness end whilst the sun shines...

... No, it must continue. I have that nagging need t write something down, an irrepressible urge to writ whatever it may be about. It must be that manic disorder that has been called 'hypergraphi. a condition that must apply to diary writers. Yellow was the favourite colour of my father. He picked every daffodil in the garden at Glossop when I was born and took them to my mother when he first set eyes upon me. Yellow must be an unusual favourite colour. The word daffodil relates to the word asphodel from the Latin affodil It is, as we all know, a widely cultivated Eurasian amaryllidaceous plant known as 'Narcissus pseudonarcissus' having spring-blour. yellow flowers. Sometimes it is a national emblem of Wa

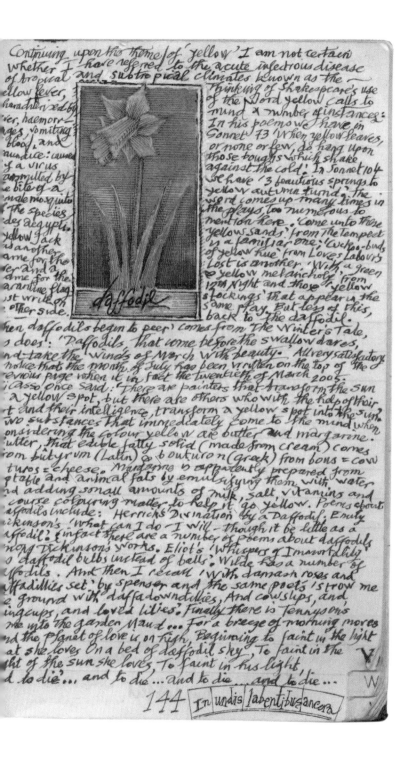

Continuing upon the theme of 'yellow' I am not certain
whether I have referred to the acute infectious disease
of tropical and subtropical climates known as the
yellow fever, characterised by fever, haemorr-
ages, vomiting blood, and jaundice: caused
by a virus and transmitted by the bite of a
female mosquito of the species Aedes aegypti.
Yellow Jack is another name for the fever and a
name for the quarantine flag, but we'll write on
the other side.

Thinking of Shakespeare's use
of the word yellow calls to
mind a number of instances:
In his poems we have in
Sonnet 73 'When yellow leaves,
or none or few, do hang upon
those boughs which shake
against the cold'. In Sonnet 104
we have '3 beauteous springs to
yellow autumn turn'd'. the
word comes up many times in
the plays, too numerous to
mention here. 'Come unto these
yellow sands' from The Tempest
is a familiar one; 'Cuckoo-buds
of yellow hue' from Loves Labours
Lost is another. With a green
& yellow melancholy' from
12th Night and those 'yellow
stockings' that appear in the
same play. But less of this,
back to the daffodil.

'When daffodils begin to peer' comes from The Winter's Tale,
as does: 'Daffodils, that come before the swallow dares,
and take the winds of March with beauty.' All very satisfactory
notice that the month of July has been written on the top of the
previous page when it is fact the twentieth of March 2005.
Picasso once said: 'There are painters that transform the sun
to a yellow spot, but there are others who with the help of their
art and their intelligence, transform a yellow spot into the sun.'
Two substances that immediately come to the mind when
considering the colour yellow are butter and margarine.
butter, that edible fatty solid (made from cream) comes
from butyrum (Latin) & bouturon (Greek) from bous = cow
turos = cheese. Margarine is apparently prepared from
vegetable and animal fats by emulsifying them with water
and adding small amounts of milk, salt, vitamins and
of course colouring matter to help it go yellow. Poems about
daffodils include: Herrick's Divination by a Daffodil, Emily
Dickinson's 'What can I do - I will - though it be little as a
daffodil? In fact there are a number of poems about daffodils
among Dickinson's works. Eliot's 'Whispers of Immortality'
is 'daffodil bulbs instead of balls'. Wilde has a number of
daffodils. And then I recall 'with damask roses and
daffadillies set' by spenser and the same poet's 'strow me
the ground with daffadowndillies, And cowslips, and
kingcups, and loved lilies'. Finally there is Tennyson's
'Come into the garden Maud ... For a breeze of morning moves
and the planet of love is on high, Beginning to faint in the light
that she loves On a bed of daffodil sky, To faint in the
light of the sun she loves To faint in his light,
and to die ... and to die ... and to die ... and to die ...

144 In undis labentibus ancora

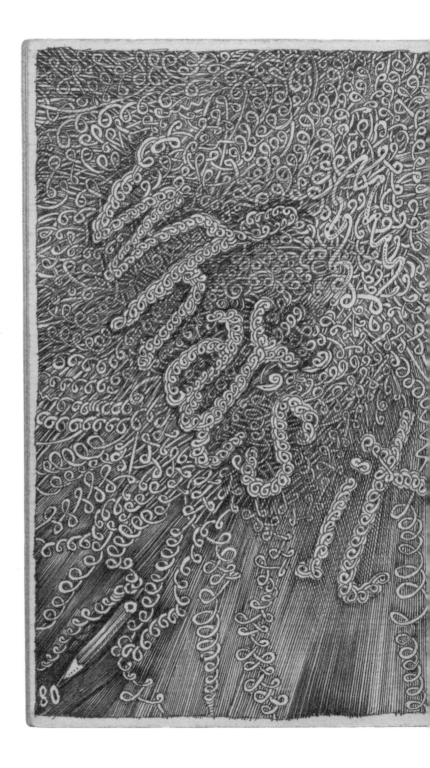

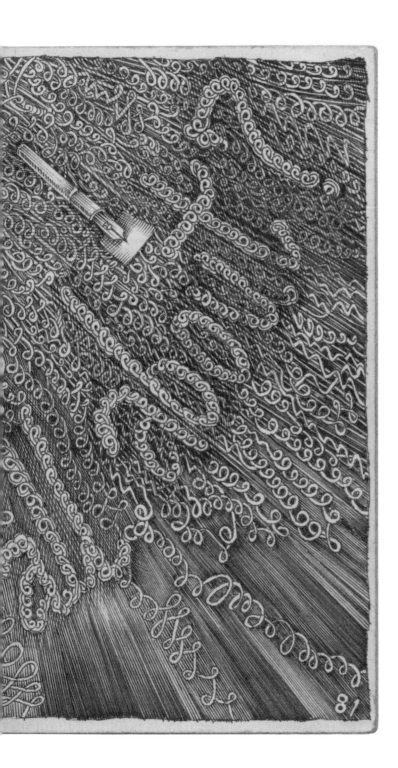

What's it all about?
Pen and ink

15 February 2006

A drawing carried out over a few days in my eldest daughter's kitchen in Somerset during after-meal conversations.

A drawing explosion
Pen and ink

January 2007

A Drawing explosion Jan.2007

Varoom;
the logo sits
on the loco
Pen and ink

27 July 2006

This is a reaction to the logo
and the title of the then new
magazine published by the
Association of Illustrators.

The logo sits on a loco. *John Vernon Lord 27 July 2006*

the journal of illustration and ..."made images!"

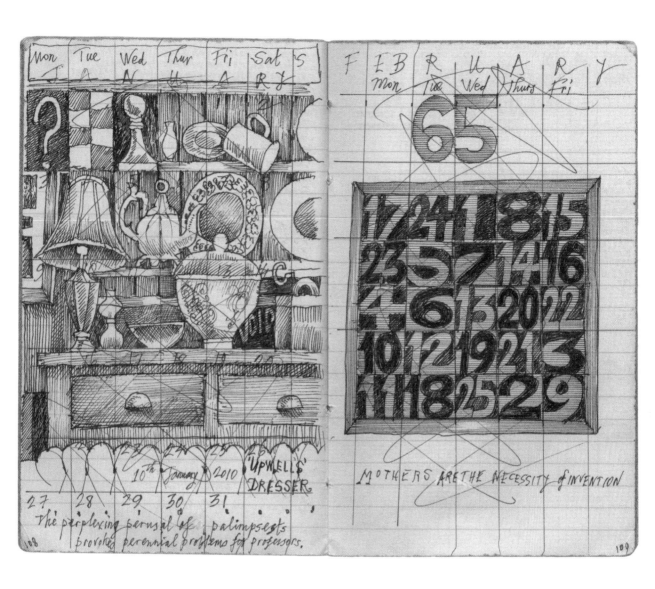

The following text appears within the sketchbook drawing:

Mon | Tue | Wed | Thur | Fri | Sat | S

JANUARY

10th January 2010 'UPWELL'S' DRESSER

27 28 29 30 31

The perplexing perusal of palimpsests provoked perennial problems for professors.

108

FEBRUARY

Mon | Tue | Wed | Thurs | Fri

65

17 24 1 8 15
23 5 7 14 16
4 6 13 20 22
10 12 19 21 3
11 18 25 29

MOTHERS ARE THE NECESSITY OF INVENTION

109

Upwell's dresser
Pen and ink
10 January 2010

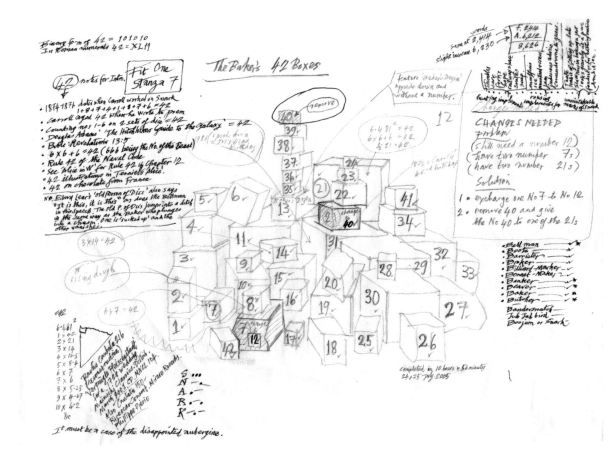

Rough drawing for the Baker's 42 boxes
Pencil

24 July 2005

This sheet shows notes and a preparatory drawing of the Baker's 42 boxes for one of the illustrations in Lewis Carroll's *The Hunting of the Snark*, published by Artists' Choice in 2006.

The number 42 occurs in Lewis Carroll's poem as the number of the Baker's items of luggage. Possessions can illustrate who we are, and journeys and quests are subjects often chosen by authors to be allegorical of life. Carroll was aged 42 when he first embarked upon writing the poem. If you add up the eight numbers in the two year dates when he worked on the book (1874–1876) you will soon realise that they add up to 42. Thus the reader will note that I have registered these dates on the grave of the pig that had been charged at Court, in the Barrister's dream, for deserting its sty. If the throw of two sets of six dice results in each set showing all the numbers from one to six face up, the sum of the twelve dice will add up to total of 42. The number forty-two became well known in Douglas Adams' *The Hitchhiker's Guide to the Galaxy*. It was a number that was put forwards as representing "the meaning of life, the universe, and everything". This was calculated by a computer called Deep Thought, which had been asked to calculate the 'Ultimate Answer'.

Enthusiasts of the number forty-two can be found declaring its significance in various websites, discovering scores of the most obscure connections with the number. It is a fanciful obsession for those with anorak tendencies. I have to curb the impulse myself! For instance Revelations (13:5) in the *Bible* tells us that 'The beast was given a mouth uttering proud boasts and blasphemies, and it was given authority to act for forty-two months'. The 'number of the beast' is said to be 666 and we find that $6 \times 6 + 6 = 42$.

The binary number of 42 is 101010, which fluctuates alternately between ones and zeros. The well-known phrase – to be 'at sixes and sevens' means to be in a state of confusion or disagreement over something. In the poem there is a wonderful remark made by the Bellman about the confusion of the vessel when 'the bowsprit got mixed up with the rudder sometimes' causing it to be 'snarked'. The Bellman's navigational orders to the crew would be bound to place them all at sixes and sevens but there was little they could do

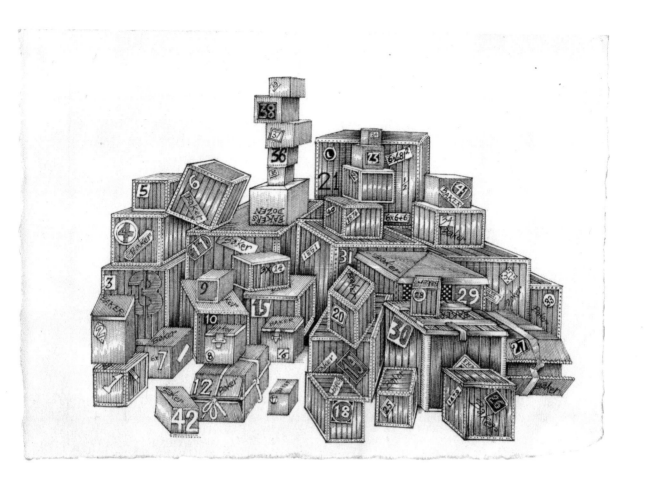

about it. Six times seven equals forty-two, of course. Carroll refers to this bewilderment and Rule 42 of the Bellman's Naval Code in the original preface of *The Hunting of the Snark*.

The number 42 also appears in Chapter 12 during Alice's evidence in the trial of 'who stole the tarts?' in Carroll's earlier book *Alice In Wonderland*. At one point the King of Hearts, 'called out, "Silence!" and read out from his book, "Rule Forty-two. All persons more than a mile high must leave the court."' There were, of course, forty-two illustrations by Tenniel in *Alice's Adventures in Wonderland*.

Before I leave the subject of 42, I cannot resist mentioning an episode on the evening of a recent birthday after I had spent a day going through Martin Gardner's engaging and absorbing book, *The Annotated Snark*. Two friends, who came to stay with us, brought with them a box of chocolates that they had bought from a shop in France and they brought it out for my birthday supper. I chose just two chocolates from the box. Astonishingly the first one I chose had the number '42' moulded onto it and the second one was in the shape of a bell. This seemed to be a remarkable coincidence in the way that of all my choices, among the other four people, these particular ones alluded to none other than *The Hunting of the Snark*. The number 42 connecting with the forty-two boxes, that the Baker had carefully packed for the Snark voyage and the bell relating to the Bellman's bell. This seemed to be extraordinary at the time, but it is often the case that so many things can connect with what you are currently obsessed with. There were no other numbers included in the rest of the selection of chocolates nor were there any others in the shape of the bell. Eventually we found out from the chocolate shop what the significance of the number 42 and the symbol of the bell was. The reply was that the number 42 signified nothing more prosaic than the postal district from which the chocolate was sourced and the bell signified Easter!

Final drawing of the Baker's 42 boxes
Pen and ink

25 July 2005

One of the illustrations in Lewis Carroll's *The Hunting of the Snark*, published by Artists' Choice in 2006.

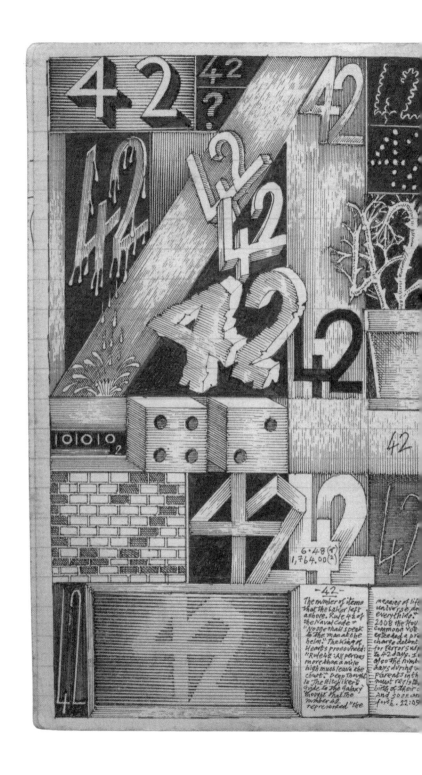

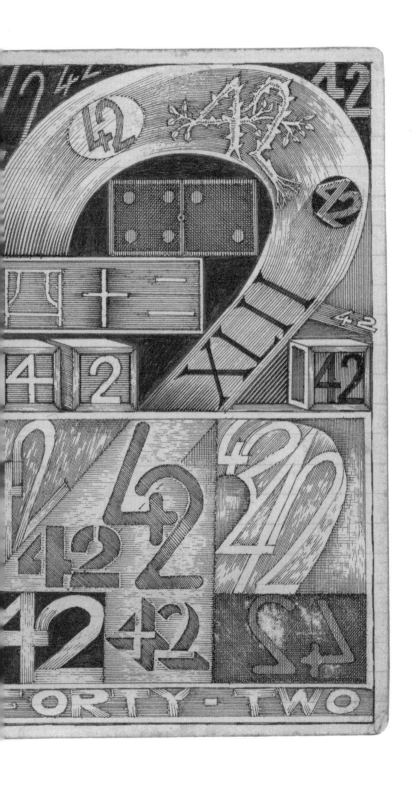

Forty-two

Pen and ink

22 September 2008

The number 42 is inscribed in this notebook drawing forty-two times.

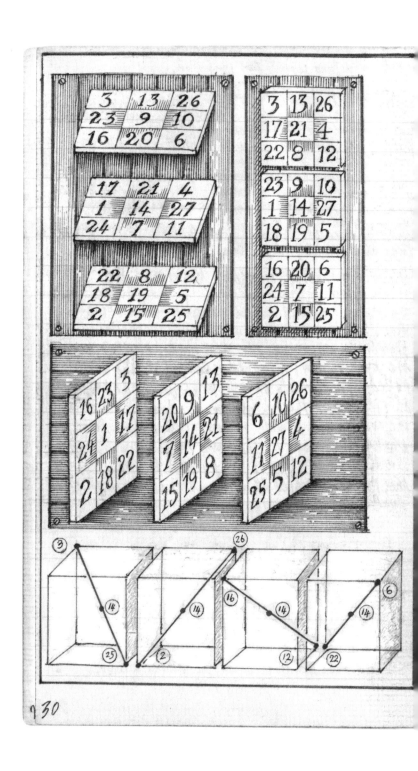

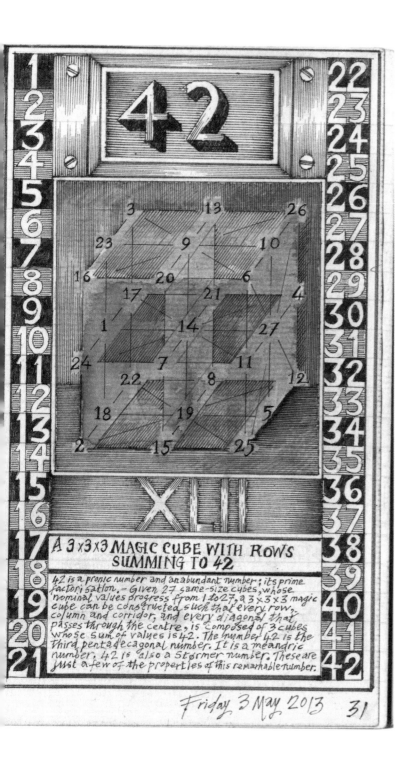

A 3×3×3 magic cube with all rows adding up to 42

Ink and watercolour

3 May 2013

Look and listen
Pen and ink

6 July 2006

I have always thought that 'looking and listening' should be fundamental as part of our education in schools. 'seeing and hearing' is not enough. Sharpening one's capacity to look and listen surely equips all people, whatever their occupation might be, to do their jobs properly. It gives them a greater degree of insight and awareness as well as providing a more enriched life. While I think about it, surely Art, Music and Physical Education should be seen as important as Maths and English in our schools.

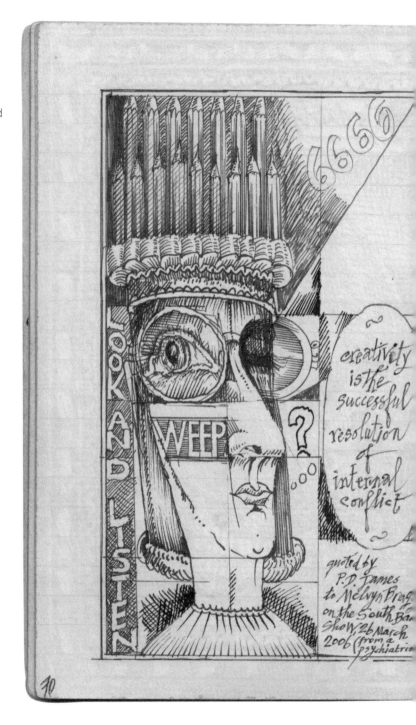

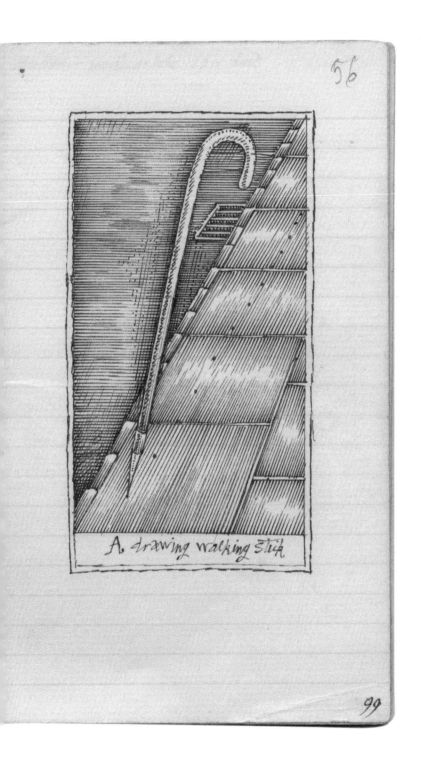

56

A drawing walking stick

99

**A drawing tree
and a drawing
walking-stick**
Pen and ink
June 2006

245

'INFINITE VARIETY'

Shakespeare, who had the deepest
penetration into nature, has sum'd up
all the charms of beauty in two Words,
INFINITE VARIETY.

Hogarth, _The Analysis of Beauty_, 1753

Age cannot wither her, nor custom
stale Her infinite Variety: other Women
cloy the appetites they feel.

Shakespeare Ant ∞ Cleo . ii 2 241

woman with child
who witnessed.
inket machine
not working

'A children's story which is enjoyed
only by children is a bad children's
story. The good ones last' said
CS Lewis in 1952 ('On Three Ways of
Writing for Children' — a lecture read to
the Library Association & published
in its Proceedings (1952) collected
in his Of other Worlds (1966).

46

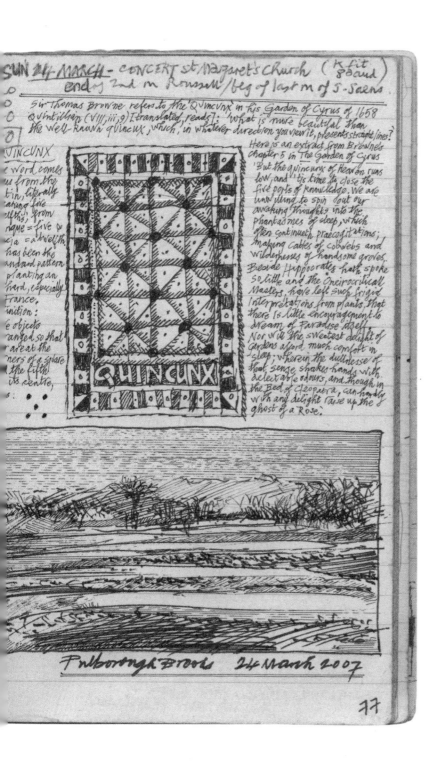

Infinite variety, Quincunx & Pulborough Brooks
Pen and ink
24 March 2007

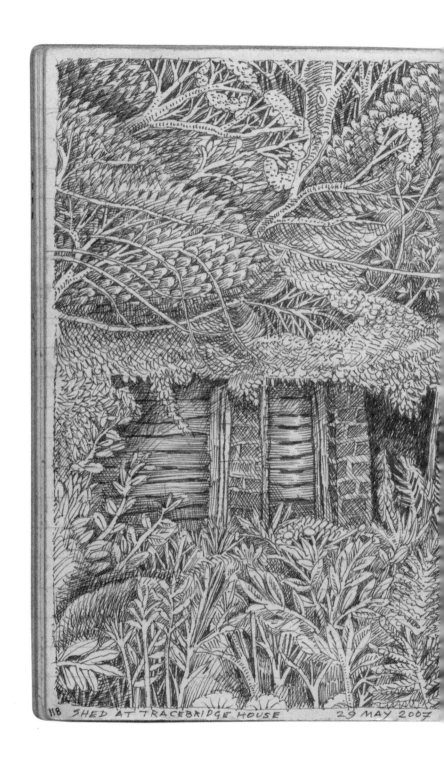

118 SHED AT TRACEBRIDGE HOUSE 29 MAY 2007

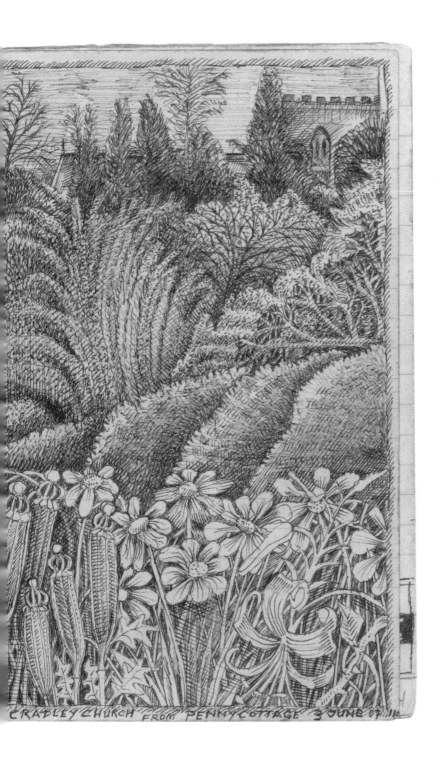

CRADLEY CHURCH FROM PENNY COTTAGE 3 JUNE 07

The shed at Tracebridge and Cradley Church from Penny Cottage
Pen and ink

29 May & 3 June 2007

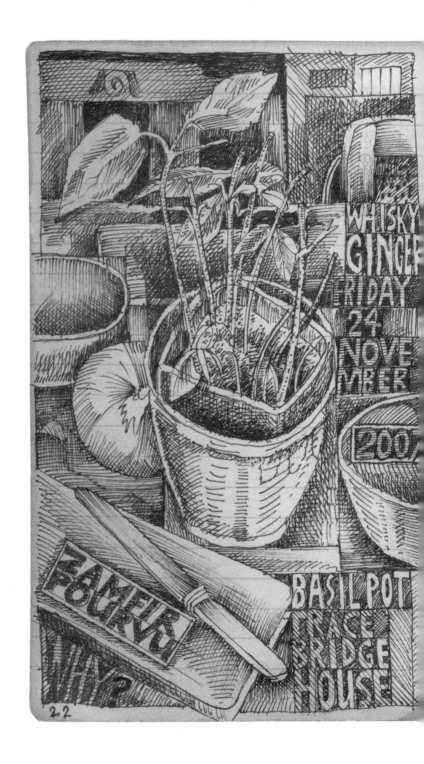

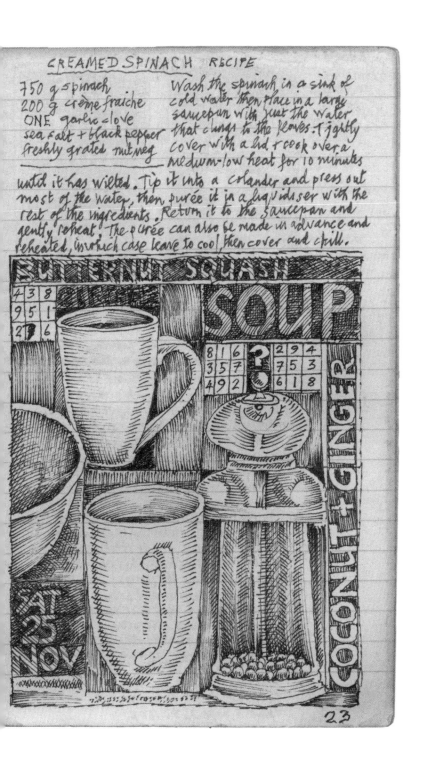

CREAMED SPINACH RECIPE

750 g spinach
200 g crème fraiche
ONE garlic clove
sea salt + black pepper
freshly grated nutmeg

Wash the spinach in a sink of cold water then place in a large saucepan with just the water that clings to the leaves. Tightly cover with a lid + cook over a medium-low heat for 10 minutes until it has wilted. Tip it into a colander and press out most of the water, then purée it in a liquidiser with the rest of the ingredients. Return it to the saucepan and gently reheat. The purée can also be made in advance and reheated, in which case leave to cool, then cover and chill.

BUTTERNUT SQUASH SOUP

COCONUT + GINGER

SAT 25 NOV

23

Creamed spinach – the kitchen table at Tracebridge
Pen and ink
25 November 2007

251

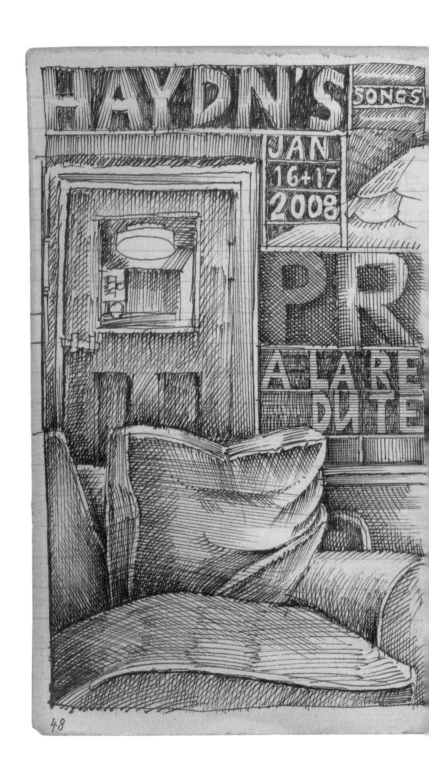

48

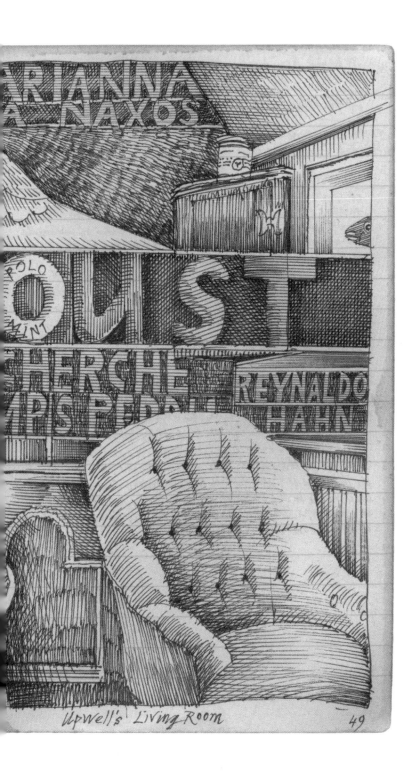

Upwell's Living Room

49

Upwell's living room
Pen and ink
16/17 January 2008

254

**Angel and Joan's
living room in Madrid**
Pen and ink

8 September 2008

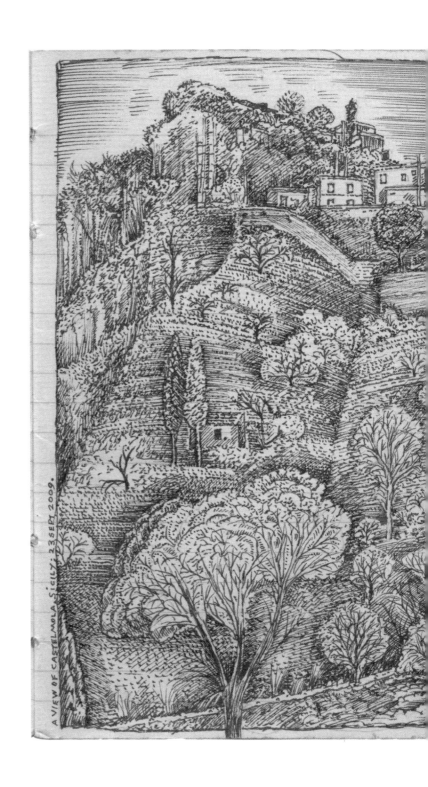

Castelmola, Sicily
Pen and ink

23 September 2009

Meanwhile I have been finding out lately that eating the tender lobes of elephants' ears is a culinary delicacy which is better avoided. I wouldn't bother eating Adam's apples from ostrich necks either. They're too full of gristle. I am going to take up smoking bananas. It's all a question of the yellowness of the fruit and

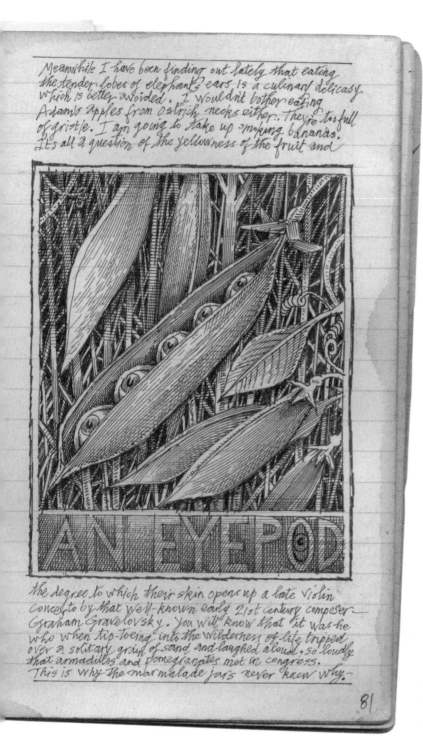

AN EYEPOD

the degree to which their skin opens up a late violin concerto by that well-known early 21st century composer Graham Gravelovsky. You will know that it was he who when tip-toeing into the wilderness of life tripped over a solitary grain of sand and laughed aloud, so loudly that armadillos and pomegranates met in congress. This is why the marmalade jars never knew why.

81

An eyepod
Pen and ink
April 2008

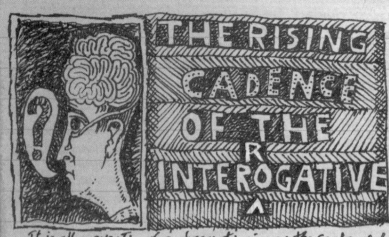

THE RISING CADENCE OF THE r INTEROGATIVE

It is all a question of a chromatic rise up the scale. Only then will the question be asked without being asked. The sentence, put in interrogative form, is but a question: 'Up-talk', rising inflection, weight of voice and so on. Because the voice may get higher at the end of a sentence does it necessarily suggest that a question is being asked. Apparently the name for 'uptalk' is HRT or 'High-rise terminals'. It is the way that some people speak — so that many of their sentences end up with an interrogative tone so that it sounds like a question even when it is only a statement. The term 'uptalk' was apparently coined by one James Gorman in 1993, a New Yorker. The rising intonation has been said to be used by way of signalling identity and group affiliation — a wanting to belong syndrome. It is used to get an audience involved or to seek concentration in others to what you are saying. It also suggests a lack of confidence in the perpetrator. Some have reckoned that the characteristic interrogative lift in a statement is one that is typically antipodean. It has also been taken up by the Estuary-speak trendie. It is often adopted by the speaker to gain some kind of approval or agreement or even the fear of taking up a stand about something. In any case the language changes & develops whatever we think about it. Whatever?

26

MONDEGREEN — mishearing of words.
Charles Altamont Doyle 1991 + 2002 illustrators
Five evening landscapes by Arthur Rackham 2002 "
Thelwell's 'Long Hot Summer of '76' w/colour crayon " "
E.H. Shepard 'Flying The Kite' 1991 LEE SCOTT
Prowling Cat' Rackham (1905) 1996 'TO SELECT
E.H Shepard 'The Only Child ——— 1993 Pam Foster
 'post fame'
Andy/Lee expected 5 pm 7 Dec William Pyke
Pam " " " 'A likely wimp'
Bill & Sue " Later am 9 Dec ~~Late am~~

EMOCRACY : "Democracy is the art and science of
 running the circus from the monkey cage."
 H.L Mencken quoted in the Huffington Post.
JOKE : Each joke is a small revolution.
 George Orwell on the Times

A POST FORM

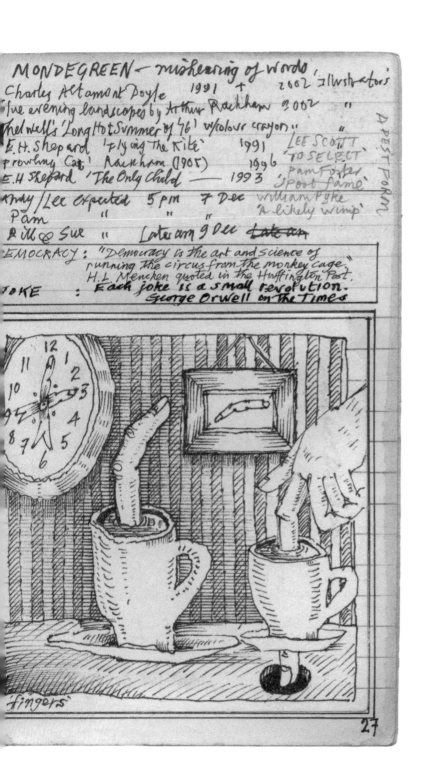

'fingers'

27

The rising cadence
of the interrogative
Pen and ink
November 2007

259

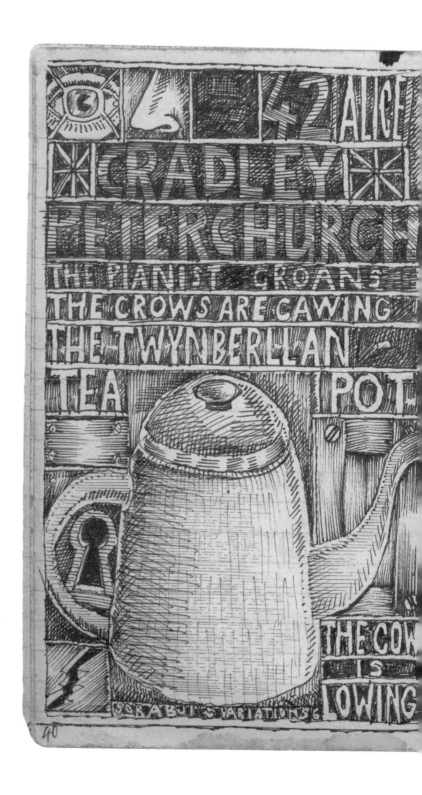

THE PIANIST CROANS
THE CROWS ARE CAWING
THE TWYN BERLLAN
TEA POT
THE COW IS LOWING

OSBABJINS VARIATIONS.

40

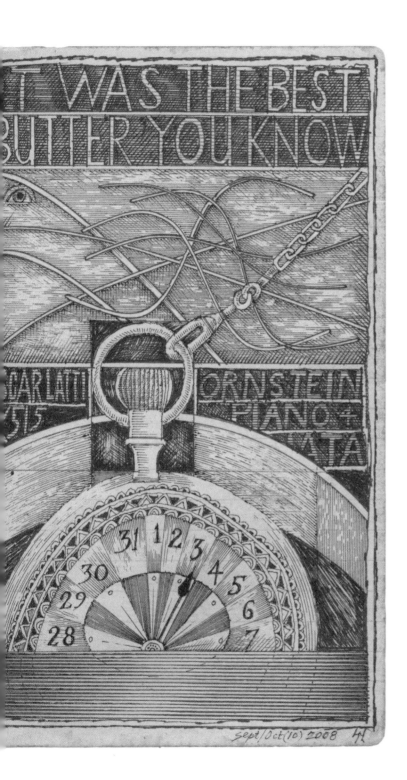

It was the best butter you know

SCARLATTI
5I5

ORNSTEIN
PIANO
TA

31 1 2 3 4 5 6 7
30
29
28

Sept/Oct(10) 2008

**The Twynberllan
teapot and
"it was the best
butter you know"**
Pen and ink

September / October 2008

The right hand page shows
a trial drawing for an episode
in Lewis Carroll's *Through
the Looking Glass*, which
I illustrated for an Artists'
Choice Edition, published
in 2009. 'It was the BEST
butter' is a remark, uttered
meekly, by the March Hare
in Lewis Carroll's *Alice's
Adventures in Wonderland*.
The March Hare had oiled
the works of the watch with
butter, a watch that told the
day of the month but not
the time.

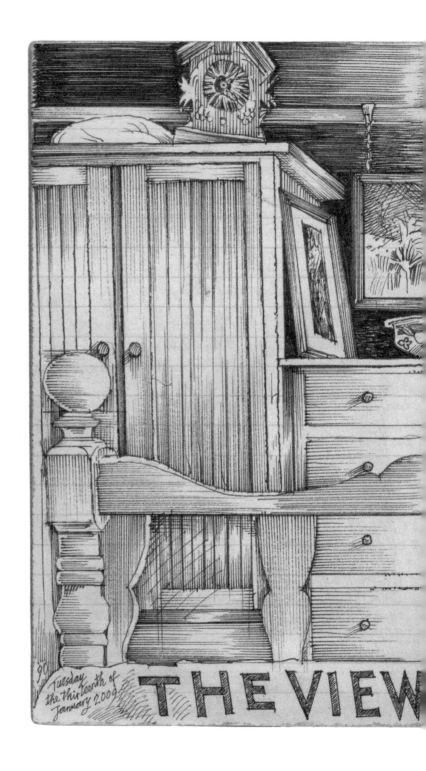

THE VIEW

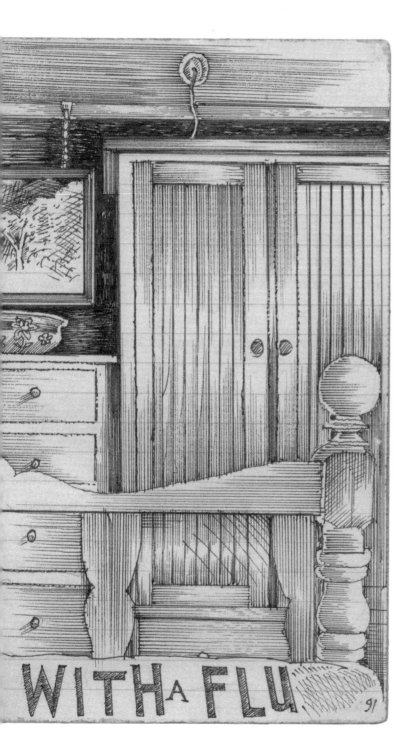

The view with a flu
Pen and ink

Notebook
13 January 2009

This was drawn in bed while
I was gradually recovering
from a bad bout of flu.

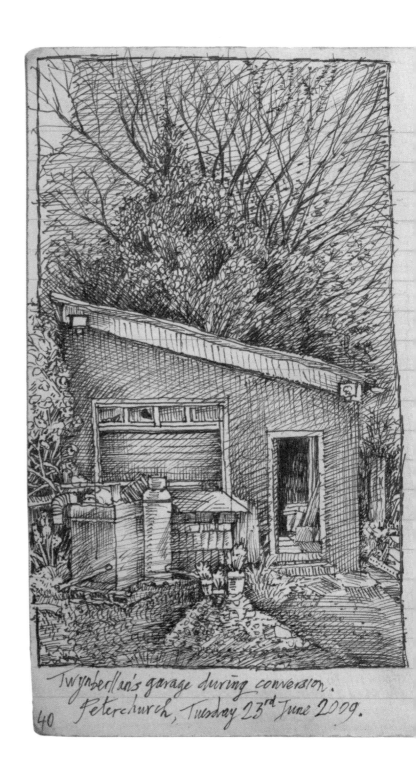

Twynberllan's garage during conversion.
Peterchurch, Tuesday 23rd June 2009.

40

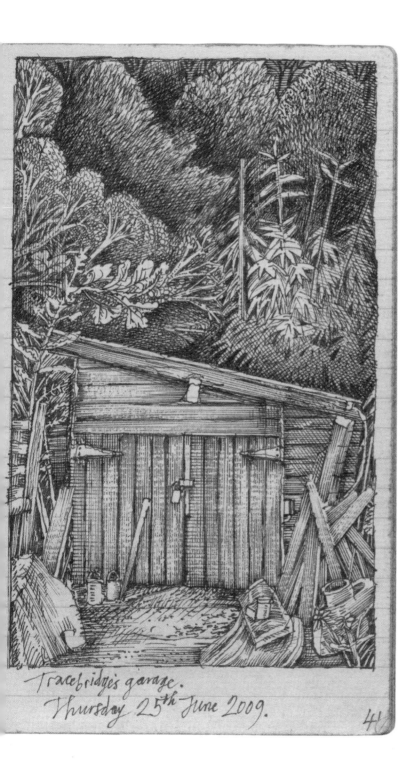

Tracebridge's garage.
Thursday 25th June 2009.

41

**Garages at
Peterchurch
and Tracebridge**
Pen and ink

23 and 25 June 2009

ALICE: 'Looking-Glass' illustrations yet to do.
at 21 September 2010

			Size	Actual time hrs:m.
30	• Title page		• 120/232	— 26:49
10	• Chapter 2 • Red Queen measuring ground		— 120/90	10:08
5	• Chapter 7. (Complete) dp spread of soldiers		— dp spread	— 53:34
30	• " • Lion & Unicorn fighting		— 120/232	26:05
10	• " • King Writing in memo book		— 120/50	4:23
	• Chapter 8 • White Knight upside down		— 120/70	3:07
	• " • White Knight falling off horse		• 120/50	9:46
	• White Knight in ditch		— 120/40	4:19
	• Chapter 9 • Arithmetic sum		— margin	2:17
changed size	• " • 7 Queens & lightning		— 120/80	10:38
	• " • Humpty-Dumpty with corkscrew		• 120/80	7:46
	• " • Queen Alice's archway with bird		— 120/75	9:43
	• " • Frog		— 120/75	3:36
	• " • Arithmetic sum? 30×3=90		margin	2:30
	• " • Mutton leg bowing		• 120/65	6:44
	• " • Plum pudding		• 120/95	7:13
	• " • Queen drinking health + chaos		• 120/95	18:36
	• " • Alice pulls table cloth		— 120/232	30:23
	• Chapter 10 • Red Queen merged with black kitten		— 120/55	4:37
	• Chapter 11 • Black Kitten merged with red queen		— 120/55	6:44
30	• Chapter 12. Kitten among chess pieces / collage of King & Queen chess squares/cream		— 275/80	16:52
30	• Extra Wasp in a Wig		• 120/232	— 20:50
	White Queen		•	✓

queen in hours

304

304 / 5 = 61 days
achievable
in 6 months
say by
late March
2011
worked on
Lg illustrations
31.59% of the
available days

40

'Through the Looking-Glass and What Alice Found There'

Started illustrating: 7 May 2009
Completed illustrations: 31 Jan 2011

There are about 110 illustrations altogether.

The illustrations were carried out during a period of 630 days
(1 year, 8 months and 20 days). Of these days available,
I worked during 199 of them / and took
994.11 hours to complete the illustrations. (ave 5 hrs per day)

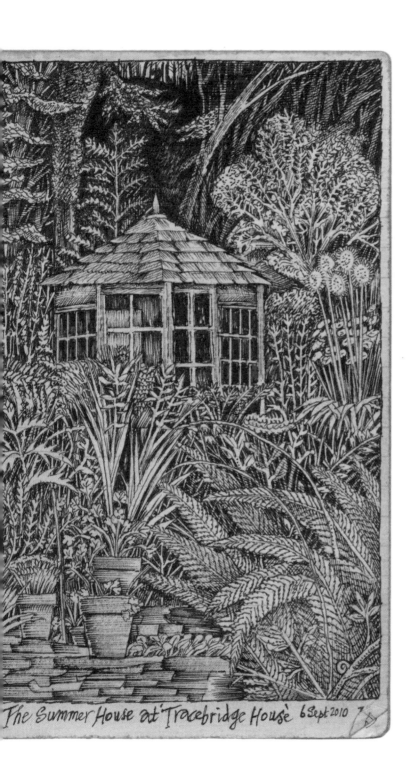

The Summer House at 'Tracebridge House' 6 Sept 2010

**The summerhouse
at Tracebridge**
Pen and ink

6 September 2010

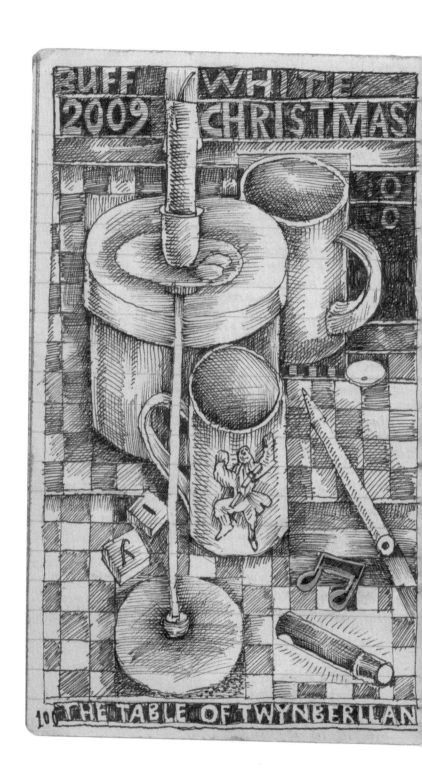

268

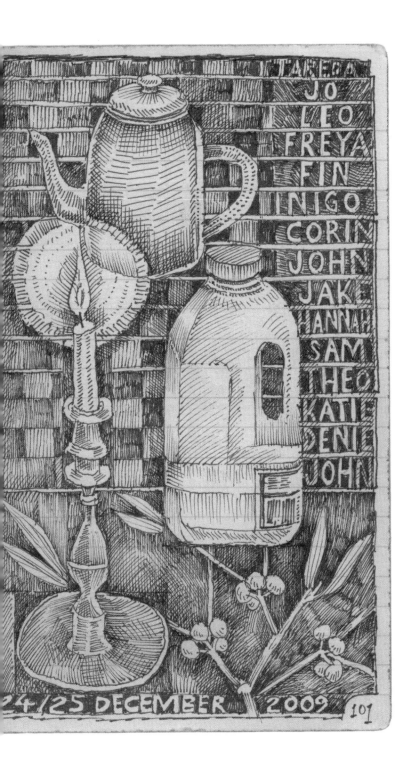

The kitchen table at Twynberllan, Peterchurch
Pen and ink
24/25 December 2009

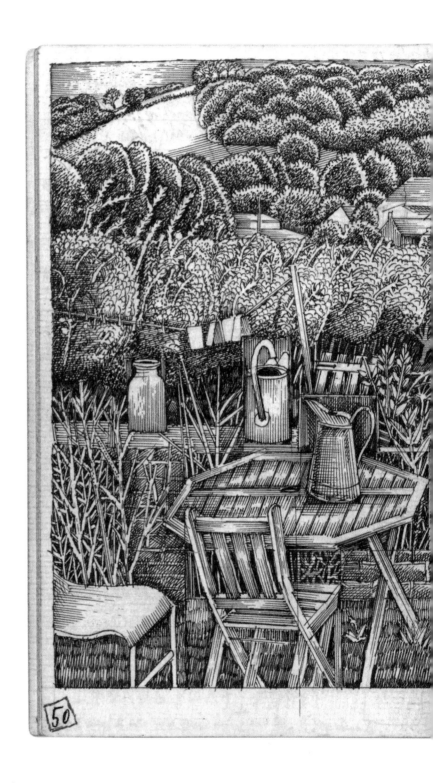

50

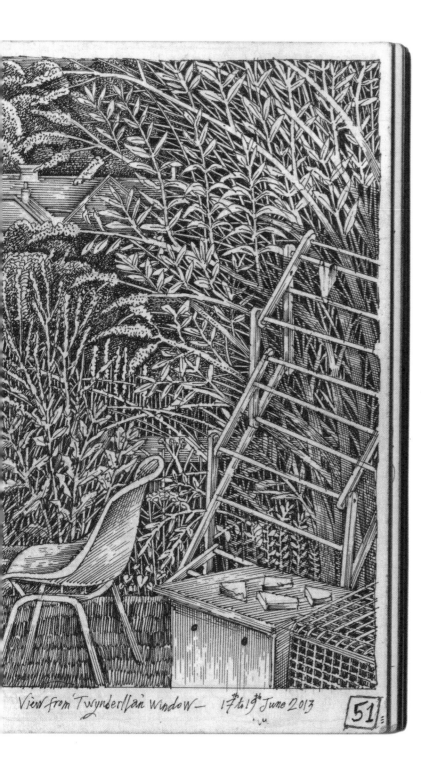

View from 'Twynberllan window — 17th to 19th June 2013

51

View from Twynberllan window

Pen and ink

17/19 June 2013

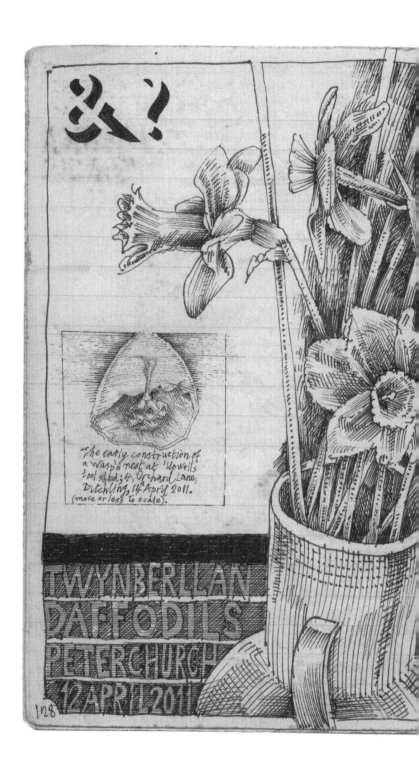

The early construction of
a wasp's nest at 'Upwell's
tool shed; 4, Orchard Lane,
Ditchling, 14th April 2011.
(more or less to scale).

TWYNBERLLAN
DAFFODILS
PETERCHURCH
12 APRIL 2011

ing

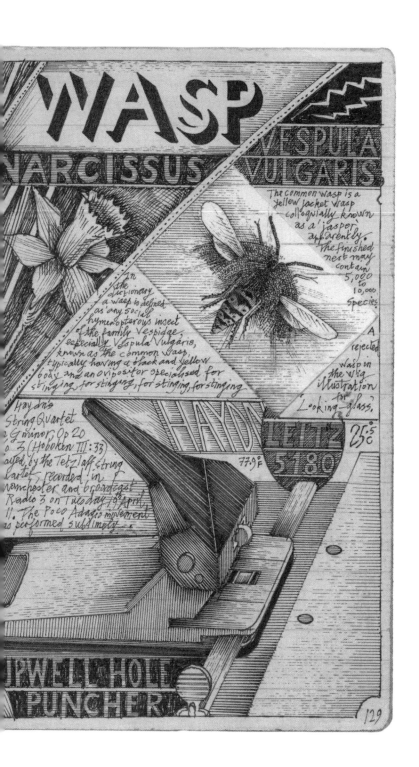

Daffodils and wasp

Pen and ink

12 April 2011

The wasp wearing a wig was a trial drawing for an episode in Lewis Carroll's *Through the Looking Glass*, which I illustrated for an Artists' Choice Edition, published in 2011. The episode was rejected by Carroll's original illustrator John Tenniel as being 'beyond the appliance of art'! It is more than likely though that Tenniel just didn't want to illustrate it.

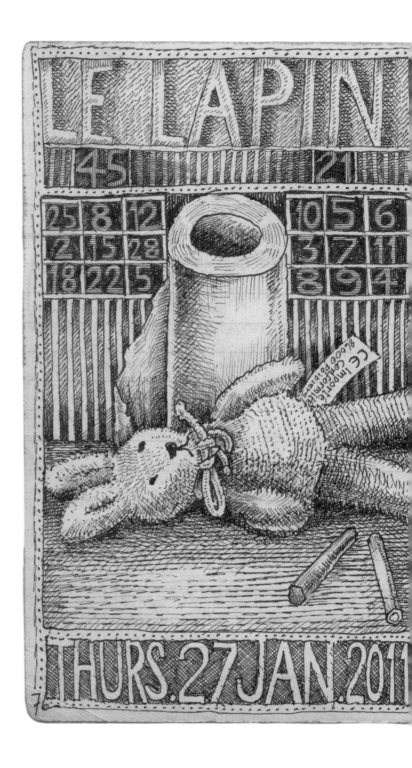

A Selection of music for Tony Byrne & Roger Broadbent
(ES) (with an emphasis on the viola) for 28 Nov 2010

(1760s)
Abel — Prelude V de G - student of JSB composed in England; concerts with JCB
Elgar - 'Owls' from 4 choral songs Op 53 — a song about nothing (1907)
heyley. It is about death (what happens to the body in the coffin?)
Encina? — 'La mi sola' (1920) — A love song to one called Laureola
by the captivated Leriano — completely smitten by her
Shostakovich. — Symphony No.4 (1935-6) an extract from the first movement.
a wild bit of strings from a symphony that didn't get an airing
until the 1960s (after 25 years). He was scared that the Soviet Authorities
might not like it.
Valente — Gallarda Napolitana (c 1575) — a piece by a blind Italian
organist & composer who was blind from childhood
Monteverdi — 'Adiagiati Poppea' — a lullaby sung by Poppea's
maid Arnalta in an old Glyndebourne recording. (1640)
Dittersdorf — Sinfonia Concertante for double bass & viola —
(late 1700s) a rare combination
Hindemith — Viola Sonata Op 25 No 1, 4th movement — (1922)
a typical piece from a composer who could play all the instruments
of the orchestra
J.S. Bach — Capriccio in B flat (1724) - Bach's lament when
his brother left home — 'Adagiosissimo' movement 3.
Rodrigo — 'Con que la lavaré (1948) — This is song based on
a medieval piece. The singer seems to be complaining
about her lot as a married woman.
Saint-Colombe le père — Les pleurs from a series of pieces for
'2 violes esgales' entitled 'Tombeau Les Regrets (composed c 1685)
Bach J.S.- Cantata No 5/3 - the only instance which has a
viola obbligato in an aria expressing intense gratitude for
the existence of God.
Kodaly — Fantasia Cromatica (after JSB) set for Viola (c 1950)
Biber — Partita in C minor for 2 violas d'amore.
Purcell — 'What power art thou' from King Arthur (1691)
genius is reluctant to rise out of the snow, when instructed
by Cupid
Bloch — 'Baal Shem' (ii) 'Nigun' for viola & piano.
Purcell - Two in One upon a Ground (1680s/90s)
composing upon a ground was something that Purcell said was
'a very easie thing to do'!
Haydn M — Duo Concertante for Viola & Organ (1760s/70s)
Penderecki — Adagietto from 'Paradise Lost' (1976)
Anonymous (Edwards) (17th c) - When gripping grief the
heart doth wound and doleful dumps the mind opress,
Then music with her silver sound with speedy help
doth lend redress.

Le Lapin at Twynberllan
Pen and ink

27 January 2011

The soft-toy rabbit (belonging to Sam, my grandson) and the paper kitchen roll were items on a kitchen table at the home of one of my daughters.

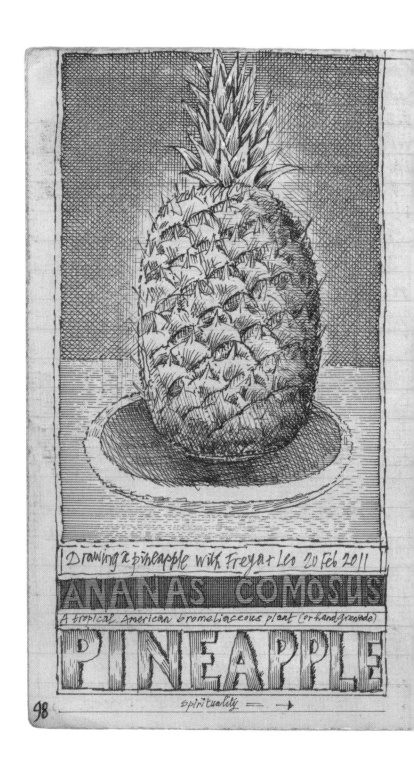

Drawing a pineapple with Freya + Leo 20 Feb 2011

ANANAS COMOSUS

A tropical American bromeliaceous plant (or hand grenade)

PINEAPPLE

98

spirituality

276

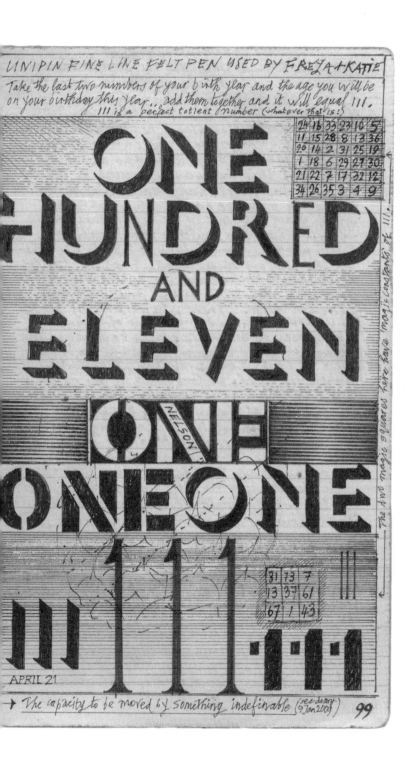

Pineapple

Pen and ink

20 February 2011

The pineapple drawing was a challenge set by illustrator and my son-in-law, Leo Hartas. He and I, and my granddaughter Freya (an illustration student at Falmouth), took up the challenge and we set up a pineapple before us.

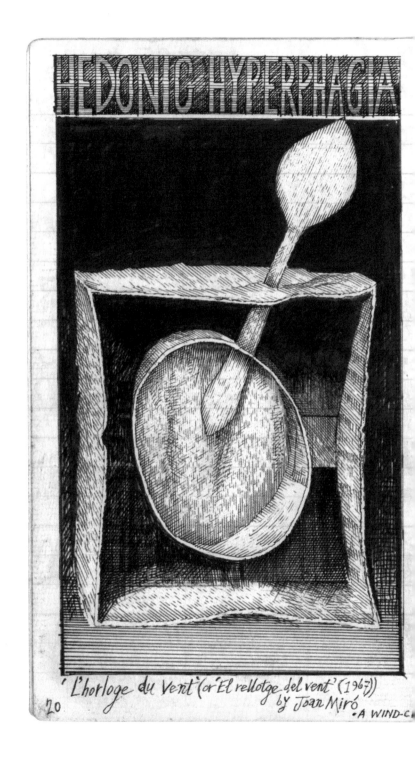

'L'horloge du Vent' (or 'El rellotge del vent' (1967))
by Joan Miró
·A WIND-C·

20

278

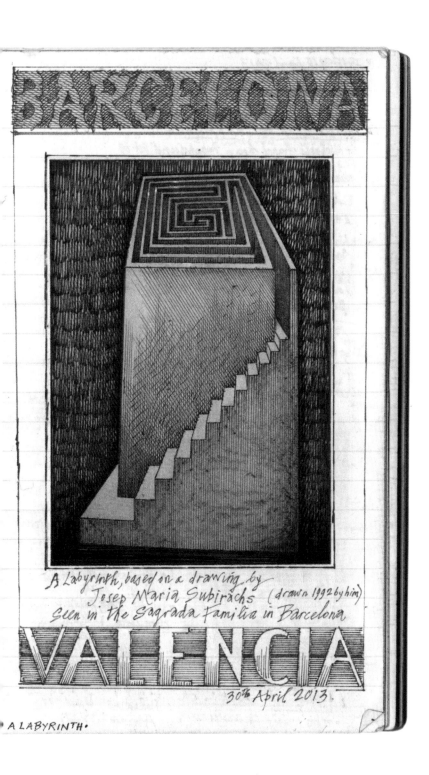

A labyrinth, based on a drawing by Josep Maria Subirachs (drawn 1992 by him) seen in the Sagrada Familia in Barcelona

VALENCIA

30th April 2013.

• A LABYRINTH •

Hedonic Hyperphagia and Barcelona
Pen and ink

30 April 2013

These illustrations were drawn after a trip to Barcelona. I was attracted by Miro's sculpture 'El rellotge del vent' (1967) and, on the right, a drawing of a labyrinth by Josep Maria Subirachs, seen in the Sagrada Familia in Barcelona.

When griping grief the heart would wound,
And doleful dumps the mind oppress,
Then Music with her silver sound
Is wont with speed to give redress:
Of troubled mind, for every sore
Sweet Music hath a salve therefore.

In joy it makes our mirth abound,
In grief it cheers our heavy sprites,
The careful head relief hath found
By Music's pleasant sweet delights:
Our senses, what should I say more,
Are subject unto Music's lore.

Richard
Edwards

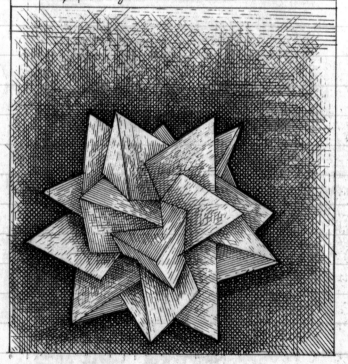

70

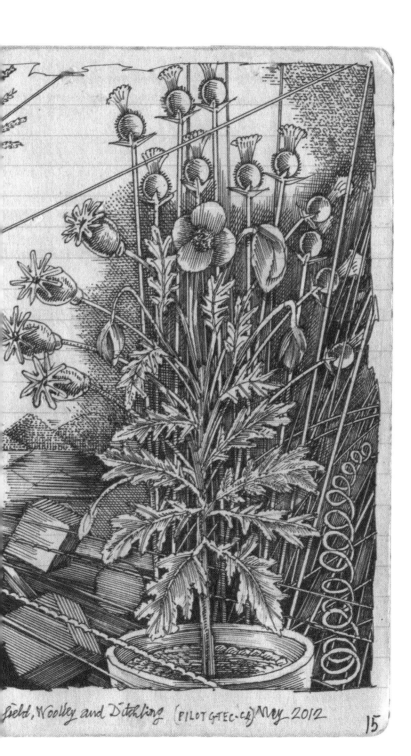

field, Woolley and Ditchling (PILOT G-TEC·C4) May 2012

15

£$€
Brown Pilot pen

May 2012

The symbols of £$€ in
the bottom of this drawing
seemed to be an appropriate
acronym for the London
School of Economics.

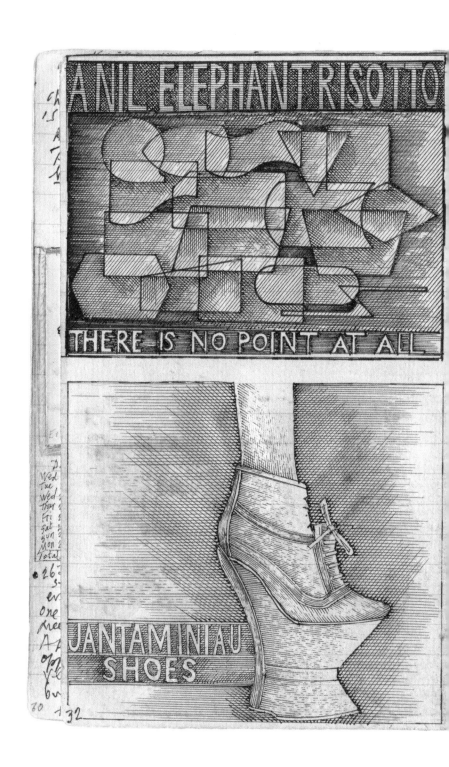

ANIL ELEPHANT RISOTTO

THERE IS NO POINT AT ALL.

JANTAMINIAU
SHOES

284

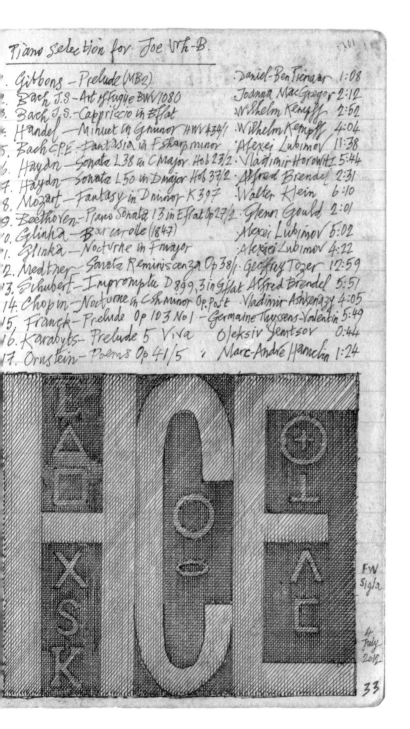

Piano selection for Joe Wh-B.

1. Gibbons – Prelude (MB2) — Daniel-Ben Pienaar 1:08
2. Bach J.S. – Art of Fugue BWV 1080 — Joanna MacGregor 2:12
3. Bach J.S. – Cappriccio in E flat — Wilhelm Kempff 2:52
4. Handel – Minuet in G minor HWV 434/1 — Wilhelm Kempff 4:04
5. Bach C.P.E. – Fantasia in F sharp minor — Alexei Lubimov 11:38
6. Haydn – Sonata L38 in C Major Hob 23/2 — Vladimir Horowitz 5:44
7. Haydn – Sonata L50 in D major Hob 37/2 — Alfred Brendel 2:31
8. Mozart – Fantasy in D minor K397 — Walter Klein 6:10
9. Beethoven – Piano Sonata 13 in E flat Op 27/1 — Glenn Gould 2:01
10. Glinka – Barcarolle (1847) — Alexei Lubimov 5:02
11. Glinka – Nocturne in F major — Alexei Lubimov 4:22
12. Medtner – Sonata Reminiscenza Op 38/1 — Geoffrey Tozer 12:59
13. Schubert – Impromptu D899, 3 in G flat — Alfred Brendel 5:51
14. Chopin – Nocturne in C sharp minor Op.Post — Vladimir Ashkenazy 4:05
15. Franck – Prelude Op 103 No1 — Germaine Thyssens-Valentin 5:49
16. Karabyts – Prelude 5 Viva — Oleksiv Yemtsov 0:44
17. Ornstein – Poems Op 41/5 — Marc-André Hamelin 1:24

FW
Sigla

4 July 2012

33

A nil
elephant risotto
Pen and ink

4 July 2012

'A nil elephant risotto' is an anagram of 'there is no point at all'. The 'Jantaminiau' shoe was a *haute couture* shoe brought out for the Autumn/Winter period of 2012. It was designed by the Dutch designer Jan Taminiau. The drawing on the bottom right hand page shows the initials HCE, which stand for Humphrey Chimpden Earwicker, the main character in James Joyce's *Finnegans Wake*. The symbols between the letters are the main sigla that Joyce adopted when writing the novel.

If found, please send to:

Professor John V Lord ←

LOOK FOR THE NAME
Book began 1 July 2011
+ finished

! !

42

ALWYCH

All weather Cover

Ref. No.	Size		Leaves
A618/80†	5¼" × 3½"	(133 × 83mm)	80
A 18/80	6⅜" × 4"	(162 × 102mm)	80
A 38/90	7" × 4½"	(178 × 114mm)	90
A 68/90	8" × 5"	(203 × 127mm)	90
A68/140*	8" × 5"	(203 × 127mm)	140
A 34/120	9" × 7"	(229 × 178mm)	120

'Equality is the
great thing,
equality is everything.'
M. Peake

† and indexed 60 leaf

Ruled Faint, Faint and Single Cash
*Faint & Double Cash

Indexed All sizes
Faint Ruling Only

When re-ordering
this book ask for number:—

A18/80 Faint
State INDEXED
if required

PURCHASED
JOHN BEAL
Brighton
£1·15
Aug 1990

Professor John V Lord

END

286

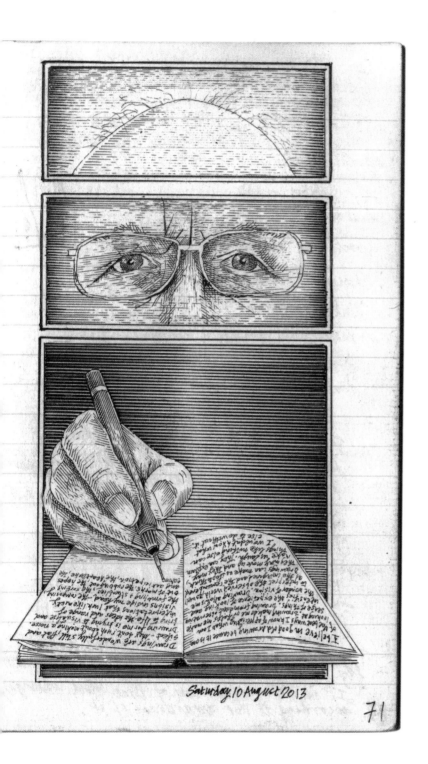

Saturday 10 August 2013

71

Self-portrait
Pen and ink
10 August 2013

'£$€ — drawn in Bampton Grange, Kendal, Shibden Mill Inn

14

Shem the Penman
Pen and ink

1 July 2011

This was the first of three
drawings carried out as a
preparation for designing
the frontispiece in the Folio
Society's edition of
Finnegans Wake by
James Joyce.

Keep my raven = Mervyn Peake
crèche shit = Chichester

'Irma, directly she had reached the door and had swept out into the hall, flew, a silken spinster, up the flight of stairs to her room. Slamming the door behind her she gave vent to the primeval jungle in her veins and screamed like a macaw, and then, prancing forward towards the bed tripped over a small embroidered foot-stool and fell spreadeagled across the carpet'. (end of ch. 34 of Peake's Gormenghast)

Second-hand bookshops in Chichester: Kim's Bookshop 28, South Street and Chichester Gallery 39, East Street, Chichester.

Giambattista Vico wrote: 'Men first feel necessity, then look for utility, next attend to comfort, still later amuse themselves with pleasure, thence grow dissolute in luxury, and finally go mad and waste their substance.' The quotation is most likely from: 'Principi di Scienza Nuova d'intorno alla Comune Natura delle Nazioni' or perhaps from - 'De antiquissima italorum sapientia'. Who knows

HAPPENSTANCE

XYZ

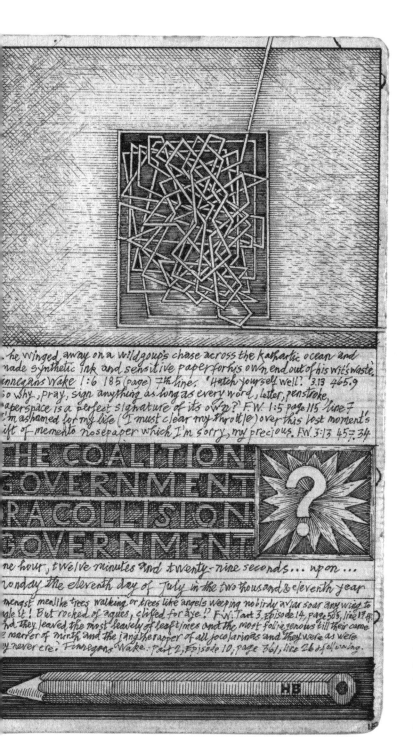

*he winged away on a wildgoup's chase across the kathartic ocean and
made synthetic ink and sensitive paperforhis own end out of his wit's waste.
Finnegans Wake 1:6 185(page) 7th line. 'Hatch yourself well? 3.13 465.9
So why, pray, sign anything as long as every word, letter, penstroke,
paperspace is a perfect signature of its own? F.W. 1:5 page 115 'line 7
I'm ashamed for my life (I must clear my throttle) over this lost moment's
gift of memento nosepaper which I'm sorry, my precious. FW 3:13 45.7 34*

THE COALITION
GOVERNMENT
OR A COLLISION
GOVERNMENT

*ne hour, twelve minutes and twenty-nine seconds... upon ...
Monday the eleventh day of July in the two thousand & eleventh year
amongst mealike trees walking or trees like angels weeping nobirdy aviau soar anywing to
ngle it! But rocked of aques, clifsed for aye!? FW: Tart 3, Episode 14, page 505, line 17 ff.
And they leaved the most leavely of leaftimes and the most foliagenous till their came
a marter of mirth and the jangthe rapper of all jocojarimas and they were as were
y never ere? Finnegans Wake. Tart 2, Episode 10, page 361, line 26 & following.*

Happenstance
Pen and ink

11 July 2011

The maze-like drawings
were designs in preparation
for the frontispiece in the
Folio Society's edition of
Finnegans Wake by
James Joyce.

13 March 2012 - Glasney Park Student Village, Tremough (Freya's digs)

**The trumpet
involuntary
and Belbake**
Pen and ink

1 September 2011

The drawing of a bird on an
elephant's trunk, with the
elephant balancing on a
skeleton, was a response to
one of my grandchildren's
specifications when asking
me to do a drawing.
A 'Belbake' is a chocolate
flavoured Swiss roll, which
was purchased in Hayle,
Cornwall. We served this for
up to 15 people at a family
gathering and such was its
intense and horrid chocolaty
taste we could hardly eat it.

•Thursday, 8 December 2011 — To London with Tony/Christine Byrne. Pret a Manger snack before going to see the Leonardo da Vinci exhibition at the National Gallery. Wait in long queue. Woman fainted. Started by looking at the ventricles of the brain and layers of the scalp. Portrait of musician in red beret holding small sheet of music. Paintings by pupils of Leonardo, viz: Gialli, Boltraffio & d'Oggiono. 'Lady with Ermine' from Cracow. The 'Belle Ferronnière' from Paris. Drawings of hands & human skull plus drapery. Sketches of the 'Adoration of the Christ child'. The Madonna 'Litta' from the Hermitage in St Petersburg. One of Leonardo's complex knot patterns plus the grotesque portraits of five men in 'A Man tricked by gypsies'. The monumental charcoal drawing of 'The Virgin with the children — Jesus & St John — with St. Anne'. The amazing smaller sketch of the same subject, showing fumblings and adjustments by the artist. Two versions of the 'Virgin on the Rocks', sorry 'Virgin of the Rocks'. (The first one sounds like a drink!) The National Gallery and the Louvre version. Leonardo's 'Last Supper' as copied by Rizzoli. Coffee on Duncannon Street near St. Martin's in the Fields. Parted company at Ch X station. To Nat Portrait Gallery then walked up Ch X road (2nd hand bk shops); Soho & Cecil Court — down St Martins Lane. Along the Strand & Wellington Street, through Covent Garden & down Bedford Street (oh yes also the Dover Bookshop on Earlham Street before that). Break for a coffee & a read before going to the Royal Society of Arts building on Durham House Street off the Strand to the Andersen Press party. Didn't stay long — far too noisy. Train back to Hassocks from Charing Cross station. Finally — a lift homewards

80

Leonardo da Vinci. Any one who conducts an argument by appealing to authority is not using his intelligence he is just using his memory'

Iron rusts from disuse; stagnant water loses its purity and in cold weather becomes frozen; even so does inaction sap the vigour of the mind.
Leonardo da Vinci 1452-1519

Back to France

LEONARDO DA VINCI

VINDALOO AND RICE

Eat a missal leaf. Nuts for the nerves, a flitch for the flue and for to rejoice the chambers of the heart the spirit of the spice isles, curry and cinnamon, chutney and cloves.
Joyce F.W. 3:13 456.20).

7 December 2011

81

Leonardo da Vinci; Vindaloo and Rice
Pen and ink

7 December 2011

This drawing was prompted after a conversation at a friend's dinner table. There was a discussion about anagrams and whether there was any point to them. "Fun" was the main response. We went round the table, each of us telling our favourite anagram to the assembled company When I mentioned that 'carthorse' was an anagram of 'orchestra' they were intrigued. Then came the last contribution from an elderly woman, who said, "I think mine is the best", and it certainly was, for 'Vindaloo and Rice', she revealed, is an anagram of 'Leonardo Da Vinci'!

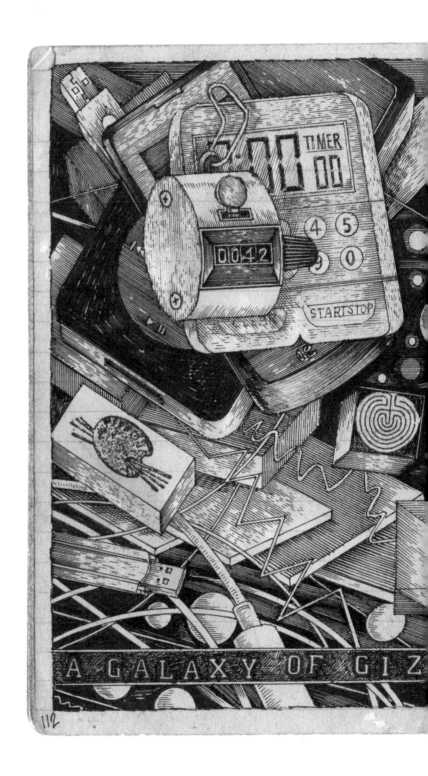

A·GALAXY·OF·GIZ

**A galaxy of
gismos galore**
Pen and ink
7 March 2012

THE SHED AT

TWYNBERLLAN

30/31 March & 1 April 2012

The shed at Twynberllan
Pen and ink

1 April 2012

This is one of my son-in-law and daughter's sheds at their home in Peterchurch.

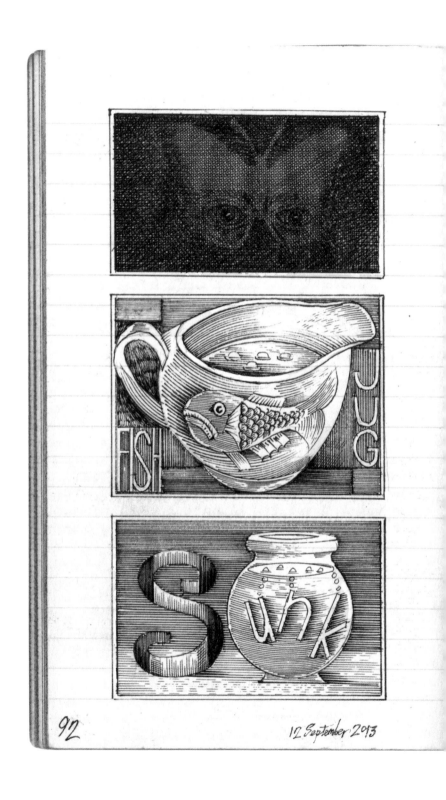

92

12 September 2013

93

Fish, jug, sunk
Pen and ink
12 September 2013

BIBLIOGRAPHY

Selected Publications written and/or illustrated by JVL

1965 *A Visit to Bedsyde Manor*, by Stanley Penn, illustrated by JVL, Guinness Publications.

1967 *Biology and the Social Crisis*, by J.K. Brierley, illustrated by JVL, Heinemann.

1968 *Success with English*, by Geoffrey Barnard, illustrated by JVL, Penguin Books.

1968 *Adventures of Jabotí on the Amazon*, by Lena F. Hurlong, illustrated by JVL, Abelard-Schuman.

1969 *Reynard the Fox*, by Roy Brown, illustrated by JVL, Abelard-Schuman.

1970 *A Natural History of Man*, by J.K. Brierley, illustrated by JVL, Heinemann.

1970 *The Truck on the Track*, by Janet Burroway, illustrated by JVL, Jonathan Cape.

1970 *Dinosaurs Don't Die*, by Ann Coates, illustrated by JVL, Longman.

1970 *Inquiry*, edited by Simon Clements, illustrated by JVL, BBC Radio for Schools, BBC. Printed by Hill & Tyler, Ltd (3 booklets 1970/71).

1971 *(Forward!)*, a Schools Council Continuation Russian Course, Stage 4 Reader Book 1, Schools Council Modern Language Project, illustrated by JVL, EJ Arnold & Son Ltd.

1972 *The Giant Jam Sandwich*, story and illustrations by JVL, set to verse by Janet Burroway, Jonathan Cape.

1972 *The Adventures of Brer Rabbit*, after Joel Chandler Harris, illustrated by JVL, BBC Jackanory.

1973 *The Runaway Roller Skate*, story and illustrations by JVL, Jonathan Cape.

1974 *Mr Mead and his Garden*, story and illustrations by JVL, Jonathan Cape.

1975 *Sword at Sunset*, by Rosemary Sutcliff, illustrated by JVL, (Edito-Service), Geneva.

1977 *Who's Zoo*, poems by Conrad Aiken, illustrated by JVL, Jonathan Cape.

1979 *Miserable Aunt Bertha*, story and illustrations by JVL, set to verse by Fay Maschler, Jonathan Cape.

1984 'Child as Parent to the Illustrator: Drawing and Painting with Words', a paper by JVL in *Research in Illustration 2: Illustration for Children*, Brighton Polytechnic Conference Proceedings, pages 37-108.

1984 *The Nonsense Verse of Edward Lear*, edited, introduction and 330 illustrations by JVL, Jonathan Cape.

1985 *The Nonsense Verse of Edward Lear*, an Essay and illustrations by JVL, including a list of the exhibits in a solo show, printed by East Sussex County Council Printing Unit, Newhaven.

1986 *The Doodles and Diaries of John Vernon Lord*, 200 drawings by JVL, Camberwell Press.

1988 'Afternoon tea with Alfred Bestall' (the 'Rupert' illustrator between 1935-65), an article by JVL in *Nutwood*, the Rupert Followers periodical.

1989 *The Song that Sings the Bird*, poems chosen by Ruth Craft and illustrated by JVL, Collins.

1989 *Aesop's Fables*, edited, introduction and 110 illustrations by JVL, verses by James Michie, Jonathan Cape.

1990 'An Author's View: John Vernon Lord talking about writing picture books', *Reflections on Early Reading*, edited by Roger Beard, Collins Educational, pages 36-41.

1991 *Illustrating Lear's Nonsense*, [Inaugural Lecture of 1986] by JVL, Brighton Polytechnic.

1991 *John Vernon Lord, Illustrator: Journeyman*, an Essay by Chris Mullen; including a Chronology, and an Essay and illustrations by JVL about 'Creating The Giant Jam Sandwich', Brighton Polytechnic, printed by KP Litho.

1994 *Dreams*, text and illustrations by JVL, printed at the University of Brighton.

1994 *The Squirrel and the Crow*, by Wendy Cope, with illustrations by JVL, 'Prospero Poets' series, Clarion Press.

1995 *King Arthur's Knights*, by Henry Gilbert, with illustrations by JVL, Macmillan.

1997 *'Some Aspects of What an Illustrator has to Think About When Creating Children's Picture Books'.* Premi VII Internacional Catalònia D'Il.lustracio, Universitat Pompeu Fabra/Enciclopèdia Catalana, Barcelona, pages 163-170.

1998 *Myths and Legends of the British Isles*, edited by Richard Barber, with 17 illustrations by JVL, The Folio Society, 1998.

1999 *Pondering Upon Pomegranates*, text and illustrations by JVL, a self-published edition of 110 copies, 1999.

1999 'Teaching Illustration', a paper by JVL given at a Children's Book Seminar, an abridged extract of the paper entitled *'Illustrating Books for Children'* was published in three parts in the Association of Illustrators' magazine *Illustrator*, February, March and April 1999.

1999 *'A Sandwich, Nonsense, Fables, Myths and Legends'* a paper by JVL given at the 1ª Setmana de la Il.lustració a Barcelona hosted by the Associacó Professional d'Il.lustradors de Catalunya at the Museu d'Història de Catalunya, Barcelona on 26th November 1998.

2002 *The Pink House*, by Olive Cook with illustrations by JVL, Inky Parrot Press.

2002 *Icelandic Sagas*, Volume 2, translated by Magnus Magnusson, with 16 illustrations by JVL, The Folio Society.

2005 'A Journey of Drawing: an Illustration of a Fable', an abridged version by JVL of a paper given at Kingston University. Published in *Drawing: The Process*, edited by Jo Davies and Leo Duff, Intellect Books, Bristol UK and Portland Oregon USA, pages 29-37.

2005 *Epics of the Middle Ages*, with 16 illustrations by JVL, The Folio Society.

2006 *The Hunting of the Snark*, by Lewis Carroll, with 80 illustrations by JVL, foreword and afterword by JVL, Artists' Choice Editions, The Foundry, Church Hanborough.

2006 'Fifty Years of Illustration', *Studies in Illustration*, No 33, Imaginative Book Illustration Society, Summer 2006, pp 5-10. (The IBIS midsummer lecture given by JVL).

2007 *Drawing Upon Drawing: 50 Years of Illustrating*, by JVL (with an introduction by Quentin Blake), with text and 396 illustrations by JVL, University of Brighton, 2007.

2009 *Alice's Adventures in Wonderland*, by Lewis Carroll, with 80 illustrations and an introduction by JVL, Artists' Choice Editions, The Foundry, Church Hanborough.

2009 *Art and Design at Brighton 1859-2009*, edited by Philippa Lyon and Jonathan Woodham, University of Brighton's Centre for Research and Development. JVL contributed three essays entitled: 'Brighton College of Art in the 1960s' (p235-262), 'Post-war Curriculum and Assessment' (pp287-298), and 'The Pottery Party and Sean Hetterley's Murals' (pp368-371).

2009 *John's Journal Jottings*, with 40 illustrations by JVL, Inky Parrot Press.

2011 *Through the Looking-Glass and What Alice Found There*, by Lewis Carroll, with 106 illustrations and an afterword by JVL, Artists' Choice Editions, The Foundry, Church Hanborough.

2011 *Lord's List: A Selection of Publications*, Artists' Choice Editions, The Foundry, Church Hanborough.

2013 'A Tutorial with Mervyn Peake', *Miracle Enough: Papers on the Works of Mervyn Peake*, a paper from a conference at the University of Chichester, edited by G. Peter Winnington, Cambridge Scholars Publishing.

2013 *Finnegans Wake*, by James Joyce, with 12 illustrations and endpapers by JVL, The Folio Society.

2014 *Drawn to Drawing* by John Vernon Lord, Nobrow Press.

SIZES

To give an idea of the size of these drawings; the largest here is the one entitled 'Beneath the Tree' (page 89), executed in 1966. It measures 2.21m × 1.29 m (7 feet × 3 feet 11 inches). Another large drawing, carried out in 1962, is the 'Studio/bedroom of 76 Charlotte Street' (page 91), which is 2.01m × 0.94m (6 feet 7 inches × 3 feet 1 inch). Other large images include: and the 'Aerial view of London' (1965, page 59) is 72cm × 41cm (28 inches × 16 inches); the orange and blue stripe painting, entitled 'Joke' (1964, page 84), which is 52 cm × 77.5 cm (20.5 inches × 30.5 inches); the red and green stripe painting (1965, page 85) is 49.5cm × 61cm (19.5 inches × 24 inches) and the black and white stripe painting, entitled 'Help!' (1964, page 87) is 60.5 cm × 52.5 cm (23.75 inches × 21 inches). Most of the diary and notebook drawings are drawn in Alwych Notebooks, with single page sizes measuring 102 mm × 162 mm (4 × 6.4 inches) enlarged by 10%. I have been buying these Alwych notebooks for more than 50 years. Others are in Filofax Organisers, with punched holes and single page sizes measuring 95 mm × 172 mm (3.74 × 6.77 inches). The rest of the drawings are between A3 and A4 size. Nearly all the doodles are A4 size: 210 mm × 297 mm (8.27 inches × 11.69 inches).

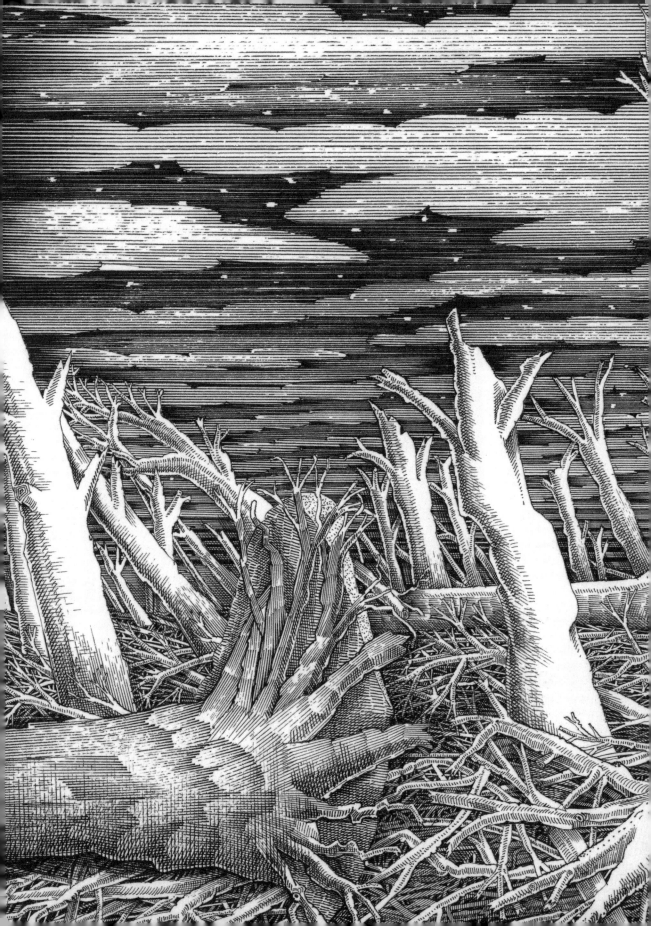